THE VITAL GESTURE
FRANZ KLINE

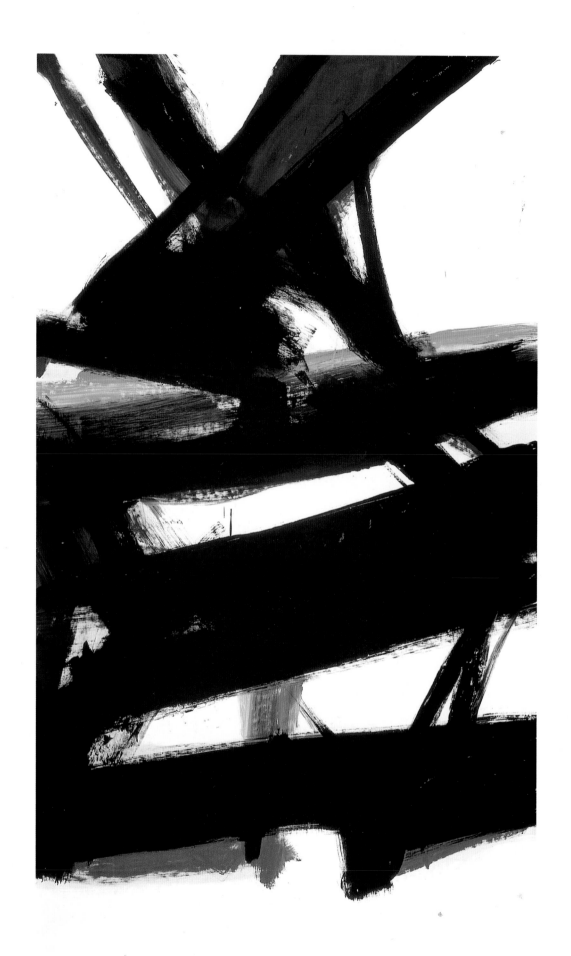

HARRY F. GAUGH

THE VITAL GESTURE

FRANZ KLINE

CINCINNATI ART MUSEUM
ABBEVILLE PRESS NEW YORK

FOR DAVID, MIRIAM, AND SUE

Cover:
ANDRUS, 1961 (Plate 139)

Frontispiece:
1. **HORIZONTAL RUST**, 1960
Oil on canvas, 86¾ × 49 in.
Cincinnati Art Museum

Editor: Nancy Grubb
Production manager: Dana Cole

Library of Congress Cataloging in Publication Data
Gaugh, Harry F.
 The vital gesture.
 Accompanies an exhibition organized by the
Cincinnati Art Museum.
 Bibliography: p.
 Includes index.
 1. Kline, Franz, 1910–1962—Exhibitions. I. Kline,
Franz, 1910–1962. II. Cincinnati Art Museum.
III. Title.
N6537.K573A4 1985 759.13 85-7503
ISBN 0-89659-571-4 (cloth)
ISBN 0-89659-577-3 (pbk.)

First edition

This book was published on the occasion of the exhibition
The Vital Gesture: Franz Kline in Retrospect at the Cincin-
nati Art Museum, November 27, 1985–March 2, 1986. The
exhibition also appeared at the San Francisco Museum of
Modern Art, April 17–June 9, 1986, and at the Pennsylva-
nia Academy of the Fine Arts, Philadelphia, June 26–Sep-
tember 28, 1986. The following plate numbers refer to works
that were included in the exhibition. A parenthetical C, S,
or P after a number indicates that the work was shown
only at Cincinnati, San Francisco, or Philadelphia. 1, 2 (C),
3 (C), 5–9, 11–15, 25, 35–39, 40 (C, S), 41–45, 47–49, 51,
53, 54, 58, 62–66, 68–70, 73 (C, S), 75–78, 83–86, 89 (C),
91, 95–103, 105–9, 111, 112 (C, P), 113, 114, 115 (C, P),
116, 117 (C), 118 (C, S), 119–22, 125 (C, S), 128, 129,
132–36, 137 (P), 138–41, 143, 144, 148, 149 (C, S), 150–53,
157, 160 (C, P), 171.

CONTENTS

2. **SCUDERA**, 1961
Oil on canvas, 110½ × 78 in.
Dr. and Mrs. Edward Massie

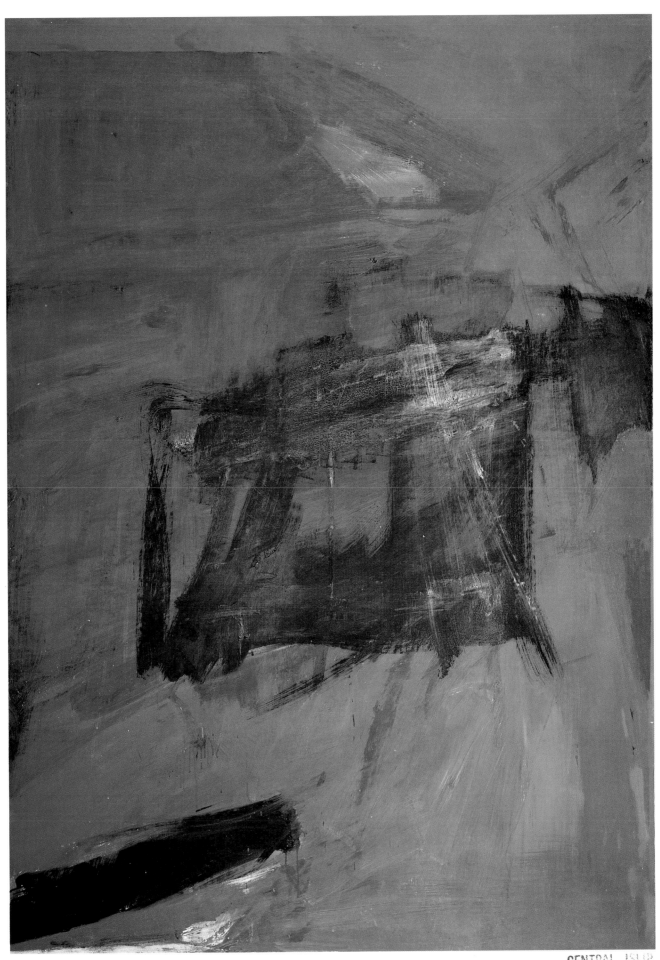

FOREWORD

Abstract Expressionism, an American movement, was a dominant international presence in painting during the 1950s and '60s. Its artists turned away from the regionalism, storytelling, and literalism that had previously characterized the art of this country. The New York School painters were never grouped formally, nor were they united by a homogeneous style, yet their paintings and drawings generally shared abstraction, large scale, and immediate assertiveness.

Franz Kline (1910–1962) was a giant figure among the Abstract Expressionists. His place in art and in the history of twentieth-century painting has not previously been the subject of a major monograph nor an extensive exhibition showing such a wide range of high-quality work. We are grateful to Harry F. Gaugh, associate professor of art history at Skidmore College and noted scholar on Kline and de Kooning, for writing this study and for serving as guest curator of *The Vital Gesture: Franz Kline in Retrospect*.

The exhibition's itinerary—the Cincinnati Art Museum, the San Francisco Museum of Modern Art, and the Pennsylvania Academy of the Fine Arts —makes it accessible to appreciative audiences from

east to west, and it introduces Kline to generations who have heard about this present-century "old master" but have never seen such an impressive array of his works. That so many private collections, museums, foundations, and corporations would part with their Kline paintings and drawings for the duration of the exhibition deserves our heartfelt thanks.

An exhibition on this scale would not be possible without significant financial support from several sources. We are exceedingly grateful to the Central Trust Company, the National Endowment for the Arts, and A. M. Kinney, Inc., for their generous contributions.

The coordinator of the monograph and exhibition and, indeed, the individual responsible for the initiation and implementation of this project was Denny T. Young, curator of painting at the Cincinnati Art Museum. We are indebted to her for all her efforts. We also greatly appreciate the assistance of Frances Martindale, curatorial assistant, Painting Department, and the many others whose work has brought this project to fruition.

Millard F. Rogers, Jr.
Director, Cincinnati Art Museum

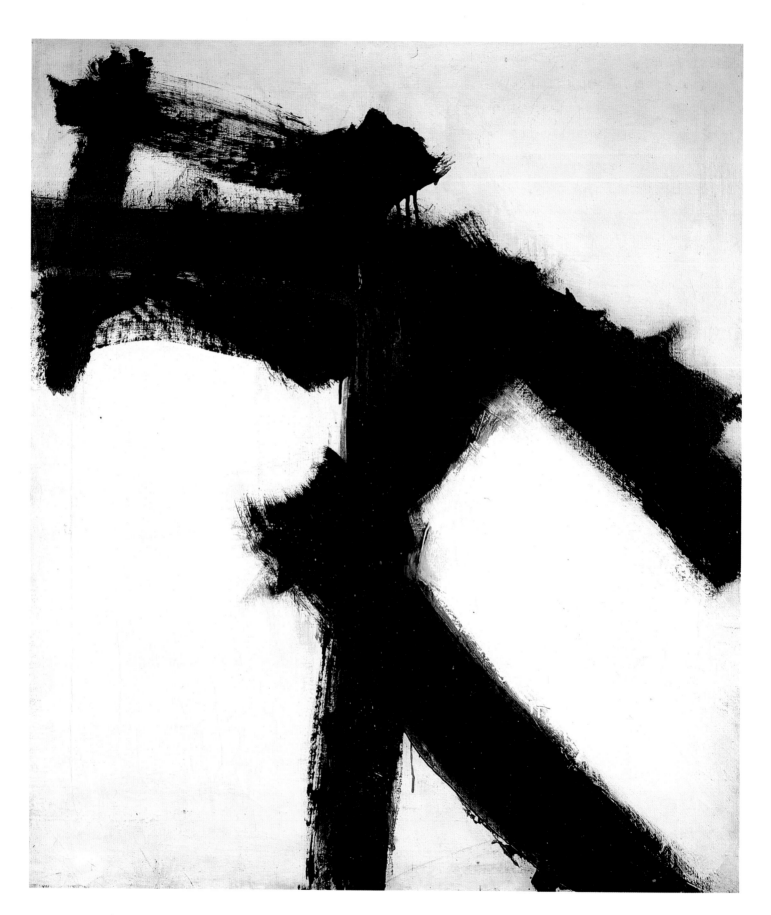

INTRODUCTION

Like his famous black and white paintings, Franz Kline could come on strong, but he was far more complex—as man and artist—than many realized. "There were two Franzes—no, not two—there were a thousand Franzes."[1] Unlike the often uncommunicative Jackson Pollock and the sometimes irascible Willem de Kooning, Kline seemed always accessible, endlessly good-natured, and, like the high school athlete he had been, in top physical shape. The New York art world was stunned when a rheumatic heart led to his death in 1962 at the age of fifty-one. One of the few writers to understand Kline's individuality as well as his true contribution to post-World War II art is Elaine de Kooning, who noted shortly after his death: "He was never silent or secret. Everything he said, the wisecracks, the miscellaneous bits of lore, the hilarious reminiscences are pertinent to his creation and our understanding."[2]

Kline's paintings offer an encyclopedic range of concentrated expression based on human emotion and realized through muscular articulation of abstract form. Much of his most successful art generates strong physical sensation in the viewer, yet subtleties of structure, light, and atmosphere may not be readily perceived. A first-rate Kline reveals its complexity —and richness—over time. At once intimidating and seductive, physically assertive and psychologically puzzling, devastating and ingratiating, Kline's paintings rank in historical importance with those by his

3. **HAMPTON**, 1954
Oil on canvas, 43¼ × 37½ in.
Private collection

11

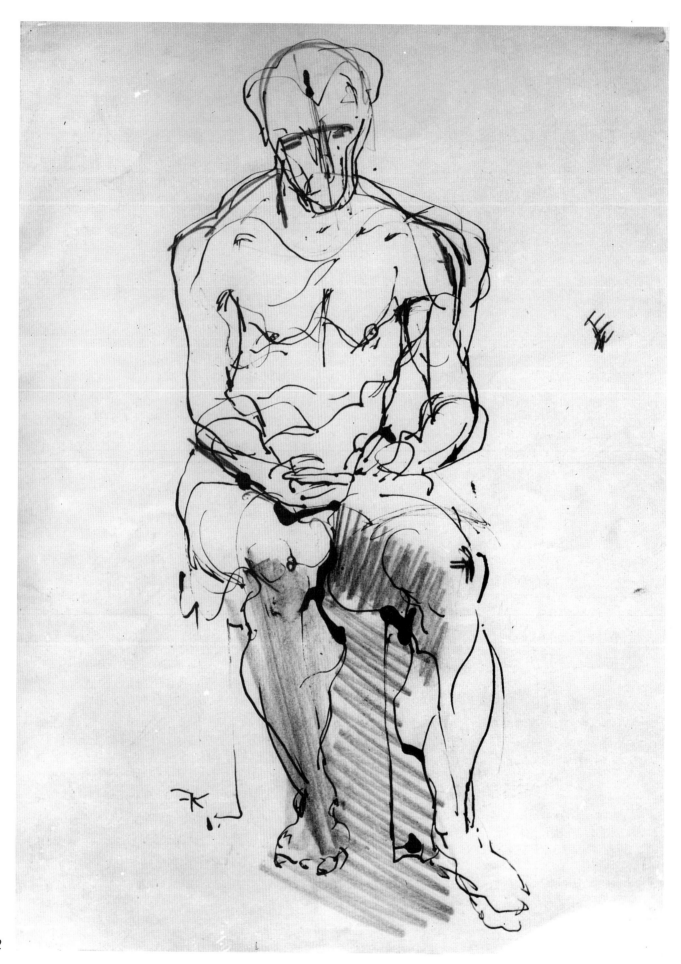

Opposite:
4. **SELF-PORTRAIT, NUDE**, mid-1940s
Ink and pencil on paper
11¾ × 8½ in.
The Williams Companies Art Collection,
Tulsa, Oklahoma

5. **SELF-PORTRAIT**, 1945
Ink on paper, 6 × 6¾ in.
Collection of
Mr. and Mrs. I. David Orr

fellow Abstract Expressionists de Kooning, Pollock, Barnett Newman, and Mark Rothko. Kline's mature abstract mode seems so straightforward that, as with Pollock's allover pouring technique, anyone seeing it should immediately grasp its significance. Yet its ultimate meaning eludes instant understanding. When asked to explain his abstraction, Kline replied: "I'll answer you the same way Louis Armstrong does when they ask him what it means when he blows his trumpet. Louie says, 'Brother, if you don't get it, there is no way I can tell you.'"[3]

Born in Wilkes-Barre, Pennsylvania, in 1910, Kline developed an interest in drawing during high school and decided to study for a career in cartooning or illustration. He moved to Boston's Back Bay in 1931 and began training as an illustrator. When not in class, he spent much time roaming the streets, frequently at night, looking for picturesque subjects to draw. Lightning sketches were his forte.[4] Kline's tastes were eclectic, tending toward fancy, upper-class English. Knowing poverty again and again, he still could play the dandy. While in Boston, he and his companion-model, Martha Kinney, saved diligently to buy him a brown felt hat and all-weather Burberry coat. "He looked very much the gentleman."[5]

Kline continued his art education in London, at Heatherley's School of Fine Art, from 1936 to 1938. Always a ladies' man, he met his future wife, Elizabeth, when she was a model in his drawing class. She later recalled that he had a "Siegfried/Brünnhilde/Wotan idealism. He wanted to meet persons whom he could put on the Wagnerian pedestal."[6] When Elizabeth met Kline in 1937, there was a trace of conceit in his personality. "Originally, he had the proportions of the Hermes of Praxiteles, although he was shorter. Later, he got heavier. Looking at himself nude in the mirror he comforted himself that at least he had a beautiful body—something to be proud of."[7] Throughout his career, as both figurative and abstract artist, Kline drew and painted self-portraits. One pen and ink drawing from the mid-1940s shows him nude, seated, making a sketch (plate 4). In 1961, in a rare return to figurative drawing after working abstractly

for more than ten years, he drew for a girlfriend on the two sides of a menu *his* two sides—one laughing, the other long-faced and sad.

Kline's idealism and vanity were tempered during the 1940s after he settled in New York, and people were attracted to his open-handed public personality. By the time he was a Cedar Bar celebrity in the late 1950s, hangers-on took advantage of his good will. As his friend *Artnews* editor Thomas B. Hess observed: "Franz collected lame ducks, male and female. That was his nature. He was also very impatient with them. They would follow him around like a little platoon. But as soon as he met a friend, he'd shed them, and he used to complain quite bitterly about what a pain in the ass they were."[8]

Kline's reputation as irresistible storyteller persists. "Franz would entrance you for hours. But when he stopped talking, like gossamer wings the conversation was gone. You couldn't repeat it or even remember it in detail. It was quite unlike de Kooning's more

6. **ENTRANCE TO STUDIO**, 1947
Oil on canvas, 21 × 32 in.
Collection of
Mr. and Mrs. I. David Orr

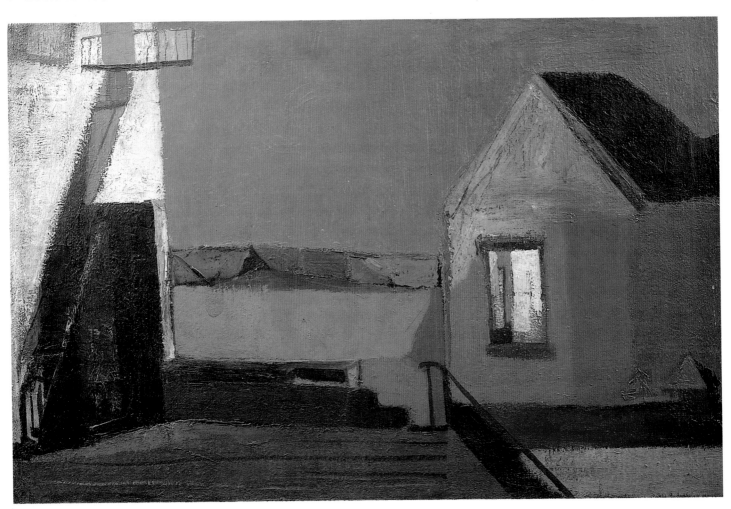

intellectual talk which would stick with you and was more meaty—or at least seemed to be."[9] Kline could talk about little-known English illustrators, the life of Baron Gros or Sir Joshua Reynolds, how Géricault painted horses, about vintage cars, pewter, and old silver. He would glide from one topic to another, and the movies frequently came in. "Franz really dug Wallace Beery and often did hilarious take-offs of him. Also, he sometimes used the phrase, 'You know, like the *Message to Garcia*,' to emphasize a breakthrough."[10]

Struggling to survive as an artist in the 1940s, Kline liked painting pictures better than selling them. "The only reason he ever sold a picture was because we had to live. Parting with his pictures was like parting with a child. He'd run his hand around the canvas before letting it go."[11] In later years, after Sidney Janis became his dealer, Kline remarked that he never understood why people would pay so much for his paintings.[12] Supposedly, he had a nightmare in which Janis told him to hurry and clear all his work out of the gallery.[13] Such fears reflect Kline's experience with garret poverty, a fact of life until the late 1950s. Grace Hartigan recalls that in about 1957 Kline had to rush uptown from her studio one morning: he needed to

7. **TRANSITION**, 1948
Oil on canvas, 23 × 28 in.
Collection of
Mr. and Mrs. I. David Orr

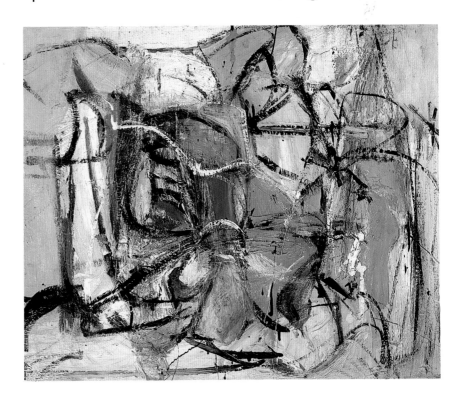

meet his longtime friend David Orr and pick up a check to pay his rent—due that day. Since neither she nor Kline had a cent, they cashed in soda bottles for his subway fare.[14]

Kline was a night person, drinking with friends first, painting later, and sleeping during the day. "He would stay up thirty-six hours on end, then say: 'I'm going to bed and die.'"[15] Kline's nighttime joy, his love of night as a congenial time permeates the warm, expansive blacks in several of his abstractions. Like night itself, these paintings are filled with unpredictable encounters with light: incandescent flashes and glowing reflections.

Kline approached painting directly, emphatically, with no hesitation—which does not mean that he rapidly completed every work.[16] He once remarked: "When I paint a picture, I don't know every line in advance, but I know in general what I'm about." He compared picture making to kicking a goal in football: "I knew when I would kick a goal because I could see the ball going over." He had the gift of "seeing into things," a psychological way of looking at objects, people, and situations.[17] Kline's technique was very much a *process*. There was a correspondence back and forth between a small sketch and a large canvas, as there was continuity of thought in his conversation.[18] Painting and talk both ran on repartee.

Kline's figurative work has frequently been disregarded or dismissed as mere prologue for the black and white paintings, an attitude needing to be revised by careful consideration of the pictures themselves—as the opinion that Kline couldn't paint in color was countered by *The Color Abstractions* exhibition at the Phillips Collection in 1979. His early views of Village life and the Pennsylvania coal country and his accomplished portraits, landscapes, and still lifes, while certainly not as innovative or crucial for American painting as the later abstractions, are honestly affecting and make their own forthright statement about continuity of traditional subject matter in New York art during the 1940s.

James Brooks has noted that Kline, like many other

New York artists, produced for years what were disparagingly called "buckeye paintings," which helped to pay the rent.[19] While a student in Boston, Kline painted a mural, *Diana and the Hunt*, for the Diana Café. Based on sketches made at home, and finished in a day or two, the mural earned two months of meals at the café for himself and Martha Kinney, who posed as Diana.[20] Later in New York, he painted bar murals to earn a few dollars and was commissioned in 1946 by Lehighton's American Legion to cover a wall in its headquarters with a town panorama (plate 55). While limited in aesthetic merit, these murals introduced Kline to the problem of adapting his basic drawing technique to large-scale painting.

Always restless as a young artist, yet determined to make art support him, Kline moved from job to

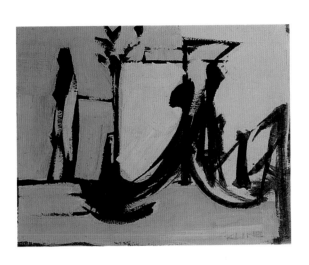

8. **STUDIO INTERIOR**, 1949
Gouache and ink on boxboard,
9⅞ × 7¾ in.
Collection of
Mr. and Mrs. I. David Orr

Right:
9. **UNTITLED**, 1950
Oil on canvas, 11 × 8½ in.
Allan Stone Gallery, New York

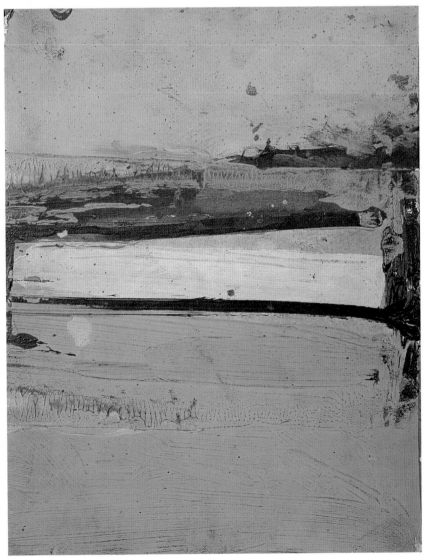

job and style to style until gradually turning toward abstraction in 1946–47. Working his way through several styles of colored planar abstraction, he crystallized the black and white idiom in 1949–50. It led almost immediately to an art of no return. Unlike Philip Guston, who made a surprising late turnabout, Kline would not return to the figurative mode. Yet from time to time he did look back: some late abstractions were based on small sketches made years before in the 1950s.

Impressed by Kline's first one-man shows at the Charles Egan Gallery in 1950 and '51, Clement Greenberg noted that Kline had "stripped his art down, in order to be sure of it—but for his own sake, not for the sake of the public."[21] Greenberg recently recalled that Kline's early black and white abstractions made "damn good shows" at the Egan Gallery. Implying a later decline in quality, he added: "Then his work turned *malerisch.*"[22]

William C. Seitz observed in 1955 that Kline had "staked everything on single units of black-and-white calligraphy,"[23] a statement that points up the risks Kline had taken in creating his inimitable style. In the same year Greenberg noted "Kline's apparent allusions to Chinese or Japanese calligraphy" but explained that "not one of the original 'abstract expressionists'—least of all Kline—has felt more than a cursory interest in Oriental art."[24] Most critics were not this discerning; desperate for shortcuts to meaning, they claimed that Kline's art was primarily blown-up calligraphy. Kline fought this Oriental interpretation throughout his career, and one of the few things that angered him was having his painting compared to Japanese calligraphy.[25]

While Kline's work is part of major public and private collections in the United States, Canada, Europe, and Japan, it has not received careful or sustained scholarly attention. In fact, more than any other first-generation Abstract Expressionist, Kline has been subject to cursory, sometimes inaccurate accounts of his life and clichéd, superficial interpretations of his art.[26] The most informative Kline articles remain those by Elaine de Kooning, Robert Gold-

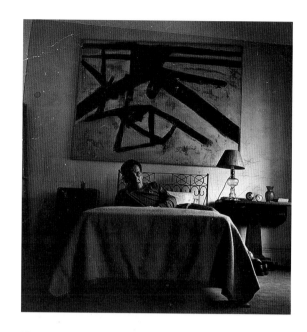

10. Franz Kline in his studio, early 1950s. On the wall behind him is **HIGH STREET** (1950), which was included in his first one-man show.

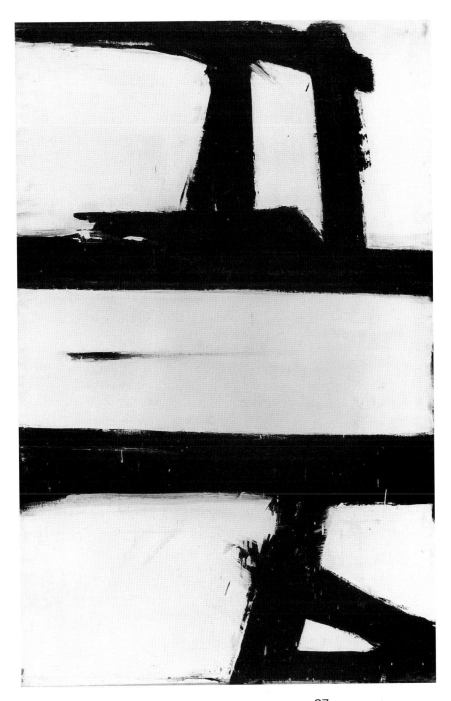

11. **PAINTING**, 1952
Oil on canvas, 65 × 41¾ in.
Wadsworth Atheneum,
Hartford, Connecticut;
Gift of Mr. Walter K. Gutman

water, Tom Hess, and Leo Steinberg.[27] Still of prime importance are four interviews with Kline conducted by Selden Rodman (1957), Frank O'Hara (1958), David Sylvester (1960), and Katharine Kuh (1961). Although replete with disjunctive repartee and Klinesque allusions, the 1958 interview was actually a fabrication by O'Hara, which Kline went along with.[28] Less suspect is O'Hara's description of Kline as the "Action Painter *par excellence*."[29]

During his lifetime, Kline's influence was felt by his peers, above all de Kooning, who considered Kline "my best friend."[30] De Kooning's "abstract land-

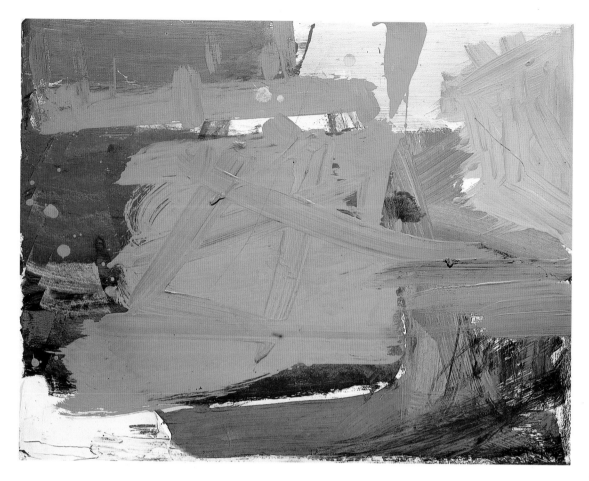

scapes" (1957–60), and the Black and White Rome Drawings (1959–60), clearly reflect Kline's space-devouring strokes. Second-generation Abstract Expressionists Joan Mitchell and Grace Hartigan have acknowledged Kline's impact on their work. Mitchell visited Kline's studio in 1950: "I saw those black and white paintings on a brick wall and it blew my mind."[31] Hartigan's work from 1957 to 1959 manifests Kline's influence in large areas of directly brushed color, less impacted than her earlier de Kooning-influenced paintings. So committed was Kline to abstraction that he once got angry with Hartigan for putting figurative forms in her work.[32] Al Held and Alfred Leslie remade Kline in their own image, packing abstractions with raw, blunt energy expressed through heavily painted, widely brushed gestures.[33] Cy Twombly also passed through a black and white "Kline phase" in the early 1950s.[34]

Artists whose figurative pictures seem totally removed from Kline's have also learned from his work. Alex Katz's strong, positive response to Kline's subtle edges led him to appreciate Manet's contour

12. **UNTITLED**, 1957
Oil on paper, 16¹⁵/₁₆ × 21¹⁵/₁₆ in.
Hirshhorn Museum and Sculpture Garden,
Smithsonian Institution, Washington, D.C.

Opposite:
13. **RED CRAYON**, 1959
Oil on canvas, 35½ × 32 in.
Kalamazoo Institute of Arts,
Kalamazoo, Michigan

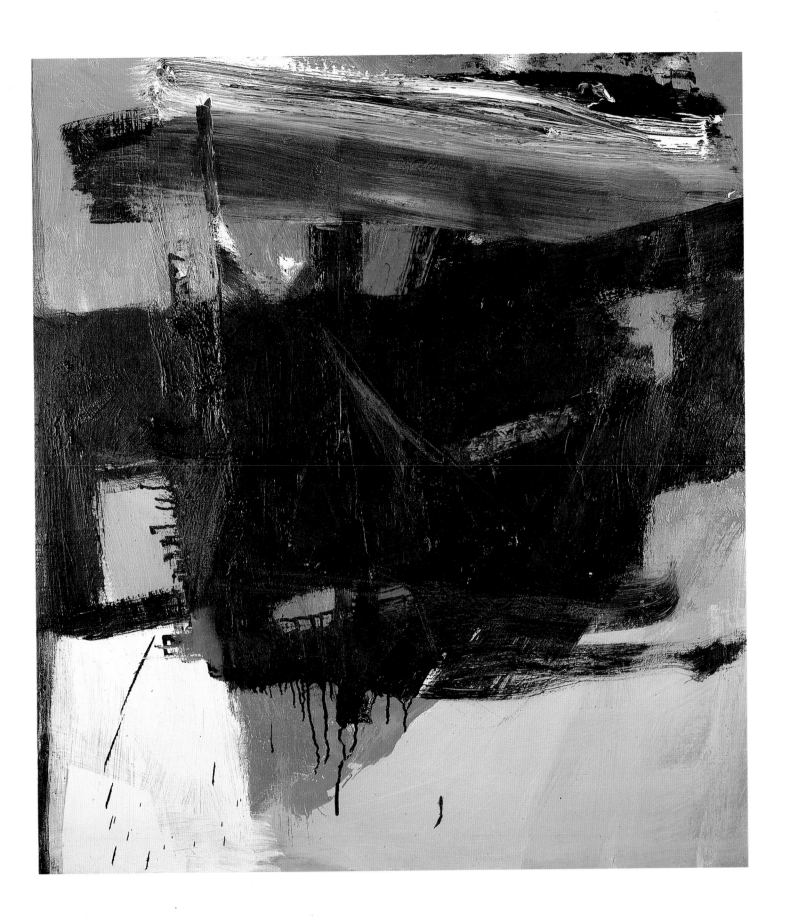

drawing.[35] Philip Pearlstein's admiration for Kline may have helped him to infuse his own work with forceful composition and to extend forms beyond the frame.[36]

One of the most visionary and successful younger artists to hold Kline's work in high regard is Brice Marden. As a student at Yale he was attracted to Kline's mastery of black and white and their generation of expressive space. He was equally impressed that Kline didn't repeat himself: "Every Janis show was different." Marden based a series of drawings on *Zinc Door* (plate 148), one of Kline's great paintings. Although he continues to admire Kline, Marden notes that in a way some of his paintings have taken on "a funky look."[37]

Dorothy Miller, who included Kline in her 1956 *12 Americans* show at the Museum of Modern Art, remembers him well: "He had a superb sense of humor and gift for amusing people—qualities which can sometimes conceal a serious human being beneath. That surely never happened with anyone who knew the absolute seriousness of his work and his total devotion to it, but new acquaintances may possibly have wondered sometimes how someone so gifted as a 'funny man' could also bring forth that grand painting."[38]

Kline's art occupies a unique position in the New York School. It doesn't oscillate between abstract and figurative modes, as does that of de Kooning and Pollock, nor does it rest on the austere metaphysical plane established by Newman and Rothko. Although frequently severe, Kline's art is usually accessible. Between 1950 and 1956 he set black and white on fire, respecting their independence as elemental forces, yet fusing them in passionate and ever-changing manifestations of human emotion. At the time of his death he had begun to structure color, shaping it plastically while amplifying its expressive range from sharply defined planes to translucent epiphanies. Having had seven one-man shows in New York and won a special award at the 1960 Venice Biennale, where ten of his paintings were shown, Kline had become an acknowledged master of Abstract Expressionism, at once acclaimed and self-effacing.

14. **BLACK AND WHITE NO. 2**, 1960
Oil on canvas, 89½ × 60¾ in.
The Archer M. Huntington Art Gallery,
The University of Texas at Austin;
The James and Mari Michener Collection

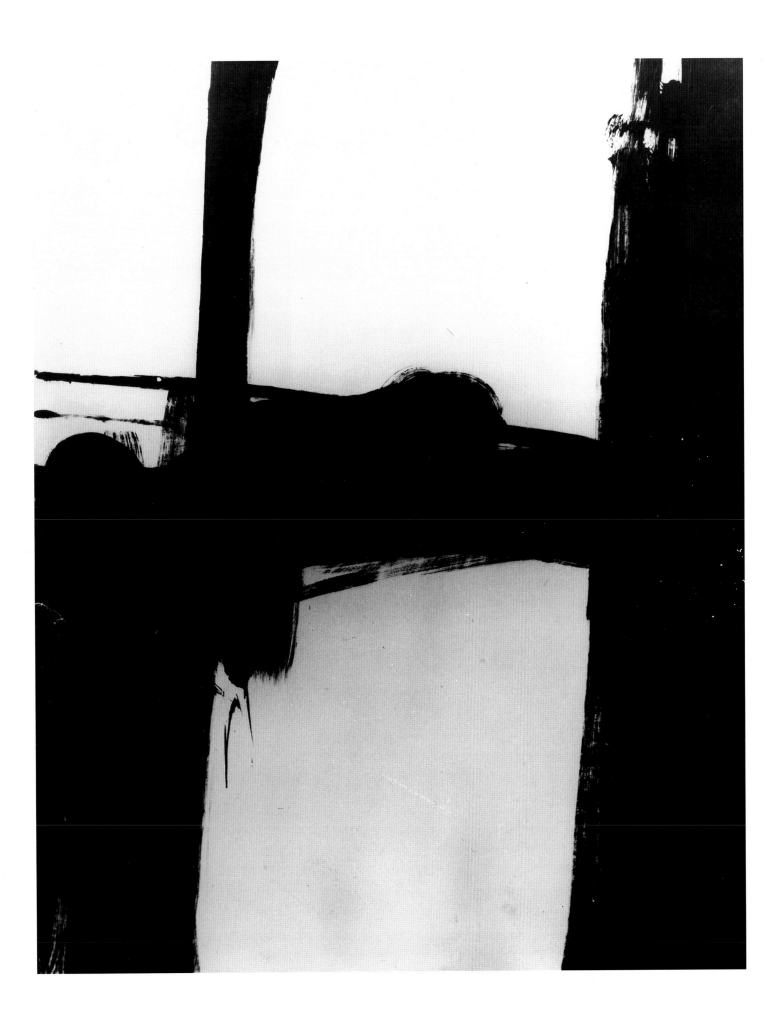

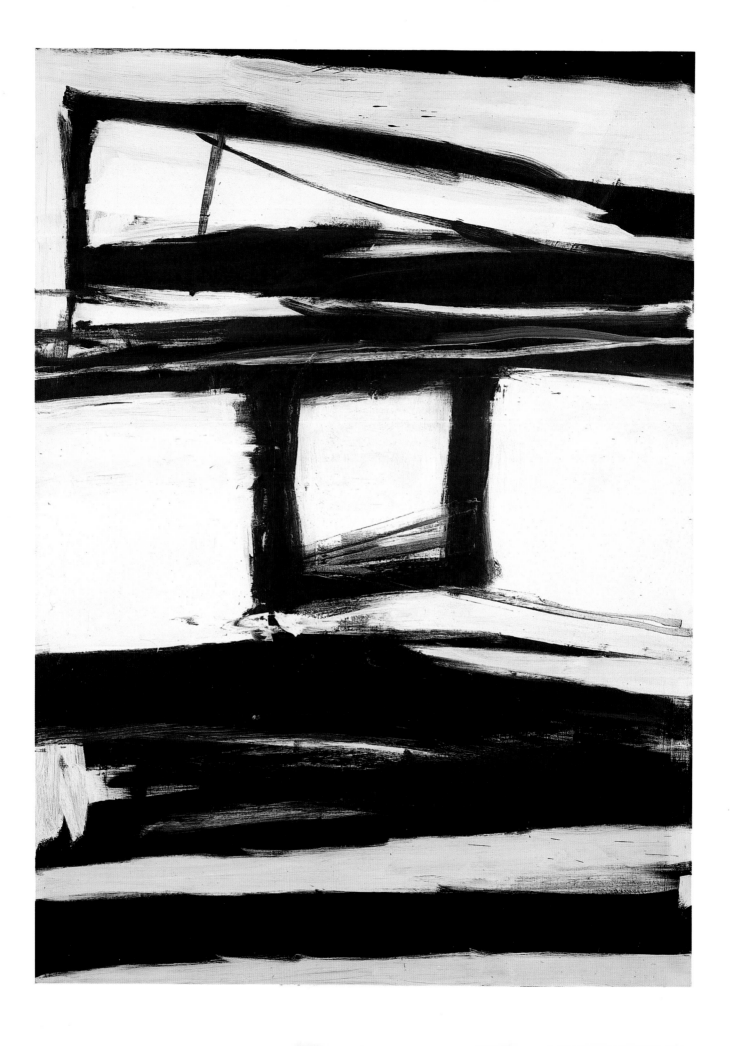

1.

STUDIES: LEHIGHTON, BOSTON, LONDON

Kline was always a draftsman. Even in his late abstractions, such as *Palladio* and *Zinc Door* (plates 15, 148), one confronts drawing—to be sure, often on a colossal scale and transformed from line into planar definition. Drawing generates the structure in a Kline painting as surely as in a Mondrian. "Kline's black and white paintings were called with some reason, 'melted Mondrians,' when they were first exhibited in 1950."[1]

As a master draftsman, Kline may be compared to other major Abstract Expressionists, namely Arshile Gorky, Willem de Kooning, and Jackson Pollock. Each extended the limits of drawing by amplifying it in a painting context. Kline comes closest, perhaps, to Pollock's classic poured paintings of 1947–50 in fusing the linear nature of drawing with direct, generally unreworked application of paint. Albeit looser in appearance, Pollock's drippings and pourings of paint are counterparts to Kline's strokes laid across unstretched canvas with one- to five-inch brushes. As individual expressive marks in a painting, Kline's

15. **PALLADIO**, 1961
Oil on canvas, 104⅜ × 75⅞ in.
Hirshhorn Museum and Sculpture Garden,
Smithsonian Institution, Washington, D.C.

massive brushstrokes meld drawing with painting, something Pollock achieved with totally different effect. Of course, Kline's wide strokes break less from the history of painting than Pollock's filaments and skeins. But both pushed creation of wall-size paintings toward a private, gestural choreography and away from traditional means of composing pictures.

Kline's first serious interest in drawing was indirectly stimulated by an accident during football practice at Lehighton High School. As a senior in 1930 he suffered a knee injury that required an operation and kept him out of sports until baseball season the following spring. Recuperating at St. Luke's Hospital in Bethlehem, Pennsylvania, he began to think of cartooning as a career.[2] His father had died in 1917, and Kline had been a student at Girard College in Philadelphia from 1919 until 1925. He now wrote to Girard's Dr. Frank D. Witherbee:

> I am undecided as to where I shall go to school next year. However I am seriously thinking of going to an art school. I do all the art work for my high school and I was cartoonist and artist on our annual staff which published a yearbook last May.
>
> I am especially interested in cartooning and would like to enter a school with cartooning as its main art subject. I should be very happy if you can give me information in regards to good cartooning schools.[3]

Thinking of art as a possible career, the twenty-year-old Kline did not consider the "fine arts." Two reasons may account for this. First, his experience with oil and watercolor painting—not to mention sculpture—would have been minimal, if he had worked in these media at all. Second, because of the family's limited financial means and his mother's interest in her children's well-being, an art career would have to be linked to a fairly dependable income.[4]

Kline's strong affection for cartooning lasted all of his life. His friend the writer Emmanuel Navaretta has recalled that in the early 1950s Kline preferred the *Daily News* to the *New York Times* because the *News* had comics.[5] Philip Guston remembered enthusiastic conversations with Kline about George Herriman's "Krazy Kat" and Bud Fisher's

16. Franz Kline (with ball, center) at Lehighton High School, 1929

17, 18. Cartoons by Franz Kline from the *Gachtin Bambil* (Lehighton High School annual), 1931

"Mutt and Jeff," in which Kline would describe the unique way that Fisher drew details such as pants and smoke.[6]

One of the most popular and sophisticated cartoonists during Kline's high school days was John Held, Jr.; his work was published in *Scribner's, Harper's Bazaar, Life, Vanity Fair,* the *New Yorker,* and *Cosmopolitan,* and by 1927 his cartoon strips "Margie" and "Ra Ra Rosalie" were syndicated.[7] Kline chose Held's polished figures as models for the characters with which he populated his high school annual, the *Gachtin Bambil* (whose title is an American Indian phrase loosely translated as "year book"). By studying Held and copying his style,[8] Kline learned a dynamic composition that years later would become one of the fundamentals of his abstract painting. In Kline's largest works, such as the apocalyptic *New Year Wall: Night* (plate 159), volatile yet cohesive massing of form generates a physical presence immediately felt by the viewer. It is, then, not surprising to note that Kline's early cartoon athletes are schematized representations of muscular energy (plates 17, 18).

It was partly the popularity of his cartoons, admired by high school faculty and students, that encouraged Kline to study art. Eager for art training —and to get away from home—he enrolled in Boston University's School of Education during 1931–32, where he took only one English composition course.[9] He may have thought that he would earn a teacher's degree. If so, he soon changed his mind. Kline never regarded himself as a teacher, although he taught during the 1950s at Black Mountain, Pratt Institute, and the Philadelphia Museum School of Art.[10]

The Depression helped put an end to any idea of getting a degree in art. Kline had been attending life-drawing classes taught by Frank C. Durkee, a native of Swampscott, Massachusetts, and a former student of George Bridgman. As an economy measure these classes were canceled, and Kline continued his education at the Boston Art Students League. Located in a basement of the Fenway Studio Building on Ipswich Street, the league was made up of

Durkee's students, who attended classes there for three years.[11] Figure drawing predominated. Students drew in charcoal from the nude every morning from nine until noon. A model frequently held only one pose, sometimes repeating it several mornings in a row. In the afternoon, students experimenting with different kinds of pencils made twenty-minute sketches of a model who took a new pose for each sketch. Kline developed a fashionable style of drawing female figures suitable for magazine illustration. He also specialized in male character studies, some resembling W. C. Fields, one of his favorite comedians. Like his high school work, his Boston studies were almost wholly limited to mastering a readily identifiable drawing style. Durkee once told him, "You have a great deal of facility, but if you don't look out it's going to ruin you."[12]

To supplement the league's life classes, Kline took pen and ink lessons from the illustrator John H. Crosman. In addition to lending him his own work to study, Crosman introduced Kline to the art of the American illustrators Edwin Austin Abbey and Joseph Clement Coll. "The smaller the drawing the better Franz liked it."[13] He admired Abbey's work and was impressed by its tonal range.[14] In a 1936 letter from England, Kline made it clear that he was as preoccupied with pen and ink in London as he had been in Boston: "Forgive the scribble but this is a pen I picked up to-day for 5/ to draw with on the streets. An ordinary fountain pen. Shall I give you a sample of its scratches. Here they are. Not bad for $1.25 is it Fred?"[15] Kline closed the letter: "Good luck and many strong lines From your Sincere Pal, Franz."

Although Kline's first love in Boston was drawing and illustration, he admired the Public Library murals by Abbey and John Singer Sargent. Yet he preferred Abbey's ink drawings and Sargent's easel pictures.[16] Kline's formal education in painting at the league was limited to demonstrations by Henry Hensche of Provincetown, who concentrated on still lifes and portraits. A student of Charles W. Hawthorne, Hensche was Kline's first painting teacher, a fact Kline celebrated in 1959–60 by entitling two color

19. Franz Kline (far right) aboard the S.S. Georgic en route to England, 1935

abstractions *Henry H.*[17] Following Hawthorne's principles, Hensche had students build up forms from large color patterns; they were then to refine more subtle areas, leaving modeling until the end.[18] Kline's flat color planes in his later abstractions—at times with few modulations—as well as his direct, non-finicky brushwork have their roots in this straight-forward approach.

By mid-1935 Kline appreciated the abstract essence of line in drawing, but abstraction in painting did not enter the picture at all. It took him at least five years, after returning from England and moving permanently to New York, to commit himself as thoroughly to painting as to drawing. Boston made him at home with the pen and pencil, but only introduced him to the brush.

In October 1935, Kline went to England to continue his education at Heatherley's School of Fine Art.[19] London was the logical place for him to study abroad, not only because of the reputation of its art schools and the absence of any language barrier, but also because of his mother's background. He recalled in 1961: "My mother was English. I'd hoped to go to England and then on to study in Paris, but I never got to Paris at that time."[20] His mother maintained an interest in his studies throughout his stay. A. Gordon Eames, then managing director of Heatherley's, has recalled that she corresponded with him, "concerned that her son's future would justify the expense of his training."[21] Kline received the equivalent of about one pound a week from home to help meet school expenses.[22]

Another reason for Kline's decision to study in London was his growing interest in English painters and, above all, illustrators. He expressed his fascination with London after he had been in England about ten months: "It's no use going on 'On how much I like London,' you can imagine it all. From every standpoint it's great. Subject matter of all types and the home and working grounds of all our illustrator masters, Whistler, Abbey, May, etc. And if Sargent, Whistler and Abbey liked it enough to work here I certainly would be a Jerry Milliken if I wouldn't."[23]

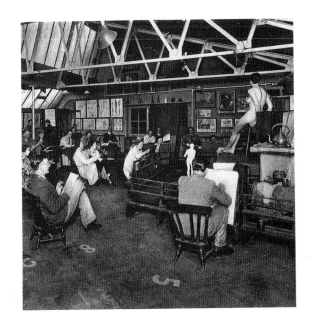

20. Life-drawing class
at Heatherley's, London, c. 1933

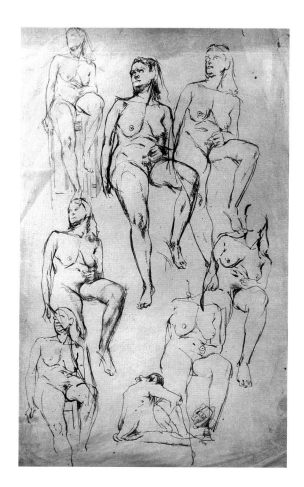

21. **NUDE STUDIES**, 1937
Pen and ink on paper, 14⅞ × 9½ in.
Mrs. E. Ross Zogbaum

Like Whistler in 1859 and Sargent in 1884, Kline became an Anglicized American. In the 1940s and '50s he sometimes put on a personal English style. Willem de Kooning remembers, "He was an Anglophile in a nice way."[24] Kline also liked English actors—Ronald Colman was one of the best. Combining a British accent with staccato delivery, he would imitate the actor, saying: "You don't take any shit from Ronald Colman."[25]

The London art world that Kline soon knew was hardly avant-garde. It consisted in part of conservative organizations such as the Royal Institute of Oil Painters, the Royal Society of Painters in Water-Colours, and the New English Art Club. If these groups did not wholly dominate the London scene, they constituted an aesthetic aristocracy claiming a large amount of exhibition time and space. Their art often repeated, with minor variations, well-established formulae for portraits, landscapes, and still lifes. To someone attracted to Surrealism—the latest major European development—London's art in the mid-1930s would have looked technically proficient but conceptually old hat.

The *International Surrealist Exhibition* filled London's New Burlington Galleries from June 11 to July 4, 1936, but had no positive impact on the English painting establishment. The local stars were not Max Ernst, Joan Miró, Jean Arp, Yves Tanguy, but Augustus John, for portraits; Frank Brangwyn, for large figure compositions; J. Arnesby Brown, for landscapes and seascapes; and Dame Laura Knight, for paintings of "show life and show people." All four, naturally, were members of the Royal Academy.[26] Augustus John was the artist that students were urged to emulate at London art schools, including Heatherley's.[27] For Kline and his fellow students, the English art scene was tripartite: the honored realm of the royal societies, the avant-garde,[28] and the world of illustrators, which was Kline's immediate goal. He was not interested in avant-garde art—it had been remote from his Boston training and was unrelated to illustration—but he would by no means have re-

jected the idea of becoming a prominent portrait painter like Sargent or Whistler.

Not surprisingly, Kline's major interest at Heatherley's was drawing. The school stressed working from the model to achieve a solidity of form. "Draw as if you were a sculptor" was a comment frequently made to students.[29] Kline's mastery of the standard repertoire of academic poses is obvious in a sheet of seven nude sketches of a Heatherley model (plate 21). Drawings from Kline's stay in England are now scarce. "He brought back a lot of pencil drawings and sketches. . . . He kept them mostly inside hard-cover folders. . . . He matted and framed a few, I remember, the first year of our marriage . . . I think to pay rent, eat, etc."[30] The major compendium of his English work was a small sketchbook that has now been broken up, with drawings dispersed to several collections. Included in the sketchbook was an indoor-outdoor scene with a view through an open door into a small garden, his only sketchbook drawing with "impressionistic" light (plate 22). Noteworthy because of Kline's interiors of the 1940s and his later abstractions is the picture frame outlined on a wall at upper left. It is reduced to a white rectangle, inside of which several sketchy strokes stand for what would have been a representational painting.

While in some small drawings Kline bound details together with parallel strokes and cross-hatching, he also made free outline sketches influenced by Steven Spurrier, a teacher at Heatherley's.

Spurrier is without doubt London's or England's most popular and best illustrator and a very versatile man indeed. . . . The Victoria & Albert Museum have a collection of his studies, illustrations and water colours. So he carries some weight. . . . The photograph and drawing from it doesn't interest him in the least, so he wasn't very impressed with my collection of Crosman's work. . . . He handles humorous subjects as well, so naturally I became very interested in his ideas and methods of building an illustration. Sketchbook, the model and invention are the forms of reference he uses. So as a result I have rafts of sketches from the streets and a gang of incomplete illustrations, etc. The technical side of the thing and so-called flair seem of very little interest to him. . . . Hence I

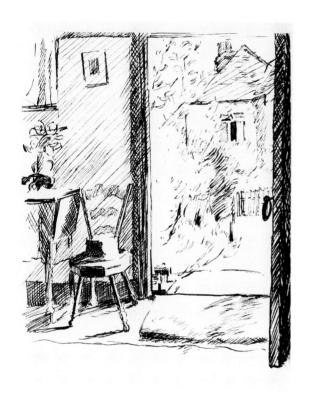

22. **INTERIOR AND GARDEN**, 1935–37
Ink on paper, 6¾ × 4¾ in.
Private collection, Boston

am trying to let good drawing predominate the otherwise technical "smartness" my work seemed to have. And is it tough![31]

The sketch of a rotund woman, probably made in a London street with the artist fixing his gaze on the subject without glancing at the paper, exemplifies Kline's denial of "smartness" or polish (plate 23). He surely never considered this to be as finished as others in the sketchbook, yet it is not idle doodling. Kline sought a deliberate coordination between his hand and eye, between the subject seen and its quick transference to paper. (Such lack of conventional precision with emphasis on seemingly rapid execution also permeates some of his 1950s abstractions.) Yet Kline struggles with contour line in drawing the woman's right foot and shoulders. Reflecting Spurrier's influence, this drawing points up Kline's awkward efforts to learn another, less cliché-clogged drawing style.

Street subjects are plentiful throughout the history of English illustration. One nineteenth-century draftsman working in this tradition and greatly admired by Spurrier and Kline was Charles Samuel Keene. "Spurrier's masters consist of —First— Rembrandt, the French school, and Keene of *Punch* fame. In books he has written he claims Charles Keene a master of all time and Rembrandt *the* master of all time."[32] In the 1940s and even after developing his abstract style in the early 1950s Kline experimented with ways to sign drawings and paintings. Influenced by Keene, he set his initials back to back, creating a striking monogram. He also turned his name into variations on Whistler's famous butterfly signature.

Kline's favorite pen and ink artist was Phil May (Phillip William May, 1864–1903), an English draftsman whose drawings he had first admired in Boston. He talked often in London about May and Keene, but believed May the greater artist because with a single stroke, rather than cross-hatching, he could convey the shape and shadow of a form.[33] Kline collected books filled with reproductions of May's drawings of seedy old men, dowdy ladies, and street ruffians.[34] He also received three original May pen-

23. **WOMAN**, 1935–37
Ink on paper, 6 × 4½ in.
Allan Stone Gallery, New York

cil drawings as gifts from his former high school English teacher, Mathilda A. Roedel, who visited him in London.[35]

Kline referred to himself in London as a "black and white man," adding that he tried to draw with the fewest lines.[36] One of his most tightly structured drawings from the English sketchbook shows the exterior of a small shop, possibly a food store (plate 24). The drawing is significant because it contains in representational context two forms that would recur in Kline's abstract paintings of the 1950s: the open triangle and the open rectangle or square. Obviously, these forms should not be identified as specific sources for his later abstract imagery. They indicate, rather, Kline's ability early in his career to pare down naturalistic subjects to a few quasi-geometric shapes. The English sketches document the eclectic range of Kline's drawing styles. Within this range one also observes certain constants: a love of picturesque English subjects; placement of subjects close to the picture plane; editing of detail for overall shape; an interest in pattern, evident in both the sketching technique and the relationship of form and shadow; and, above all, a profound dedication to drawing.

Although the uncertain political situation in Europe was one reason for Kline's decision to return to the U.S., a more personal one was financial. As an alien he could not be legally employed. In 1935 or '36 he had applied for British citizenship, but this would have required him to establish residence for eight years without a job.[37] He was able to earn very little from commissions because of employment restrictions. In 1937 his future father- and mother-in-law asked him to make copies of portraits by Edmund Havell, which he reproduced faithfully, down to the artist's signature and date.[38] Trying to earn a little money, Kline also worked briefly as a display artist in Selfridges Department Store. Steady work, however, was out of the question and, his student days over, he left for New York aboard the S.S. Washington on February 11, 1938. He would later recount that even though he was traveling third class, he managed to take his meals in first.[39]

24. **SHOP FRONT**, 1935–37
Ink on paper, 6¾ × 4¾ in.
Allan Stone Gallery, New York

34

2.

NEW YORK, PUBLIC AND PRIVATE

25. **HOT JAZZ**
(BLEECKER STREET TAVERN MURAL), 1940
Oil on board, 45½ × 46½ in.
The Chrysler Museum, Norfolk, Virginia;
Gift of Walter P. Chrysler, Jr.

Kline was an adopted New Yorker. He did not settle permanently in the city until late summer 1938, after a dissatisfying stint in Buffalo as a display designer for Oppenheim Collins, a women's clothing store.[1] (He was fired after falling through a bridal window display.) Once he arrived in New York, however, it was home for the rest of his life. He did not move out of the city, as did Pollock, and think of New York as somewhere to visit from time to time. Even near the end of his life, when he was widely recognized as an important artist and jolly-good-fellow, Kline did not feel the urgency of de Kooning or Guston to escape to a more private place such as East Hampton or Woodstock.[2] While Kline spent summers at Bridgehampton, East Hampton, and Provincetown, and in 1959 bought a house and studio in Provincetown, these were temporary holiday intervals; the pull of New York never diminished.

When asked in 1961 if he considered himself an American painter, Kline replied: "Yes, I think so. I can't imagine myself working very long in Europe or, for that matter, anywhere but New York. I find Chicago terrific, but I've been living in New York now for twenty-odd years and it seems to be where I

belong."[3] Nor is it surprising that he settled in Greenwich Village. It had its artist-bohemian character, but it was also one of the most English-looking places in the city. Like London, the Village had row houses and closely packed brownstones, cut-up streets with illogical routes, and a provocative assortment of antique and junk shops. Like de Kooning and Pollock, Kline was thoroughly a "downtown artist." Although he and Rothko, for example, were friends, Rothko remained an "uptown artist," one whose milieu was more intellectual and settled.[4]

Art and beer went hand in hand for Kline. Both in camaraderie and in the hope of earning a few dollars, during the 1940s he often sketched individuals who frequented the Cedar Bar and Minetta Tavern. Drawings such as *Nellie* (plate 26) were made in a few minutes at the Minetta Tavern while Kline sat at the bar. The artist's ability to transcribe quickly his subject's most descriptive features was the result of studying English illustrators as well as drawing in the London streets. Similar "portraits" hung for years in the Minetta Tavern at the corner of Macdougal Street and Minetta Lane. Sketched from life, they included Tony Bones, Andrew the Moving Man, Al of the Apes, and Good Look'n George. Drawings of Jimmy Durante, Al Smith, and Billy Rose were made from photographs.[5] Among the finest of these celebrity portraits is that of Fiorello La Guardia, one of the few politicians Kline paid attention to.

In 1940 Kline was commissioned to paint a series of eight or nine murals for the Bleecker Street Tavern.[6] The theme was entertainers: apache dancers, circus acrobats, a torch singer, and a bubble dancer. In one panel a bare-breasted woman lifted by two men holds a pose reminiscent of George Petty's calendar cuties (plate 27).[7] From the side a W. C. Fields character in bow tie and top hat looks on, near a masked woman who adds to the carnival atmosphere. Kline piles figures so close to the picture plane that they seem ready to tumble out onto the tabletops. Intensifying the agitation are the strong diagonal composition and the broad movements of Kline's brush.

Voluptuous females and loud music—flamenco

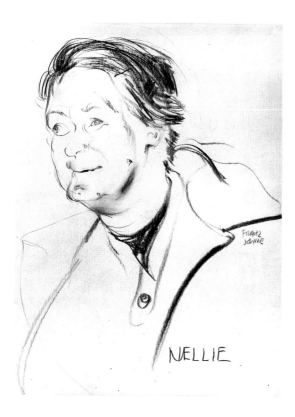

26. **NELLIE**, c. 1940–42
Pencil on paper, 11½ × 8½ in.
Allan Stone Gallery, New York

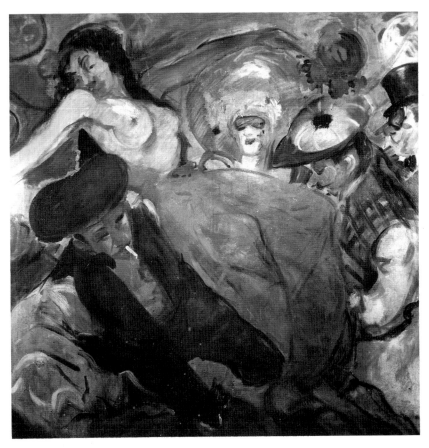

27. **DANCER IN A RED SKIRT**
(BLEECKER STREET TAVERN MURAL), 1940
Oil on canvas mounted on panel
46 × 46½ in.
Private collection

Below:
28. **DANCING COUPLE**
(BLEECKER STREET TAVERN MURAL), 1940
Oil on canvas mounted on panel
36 × 31 in.
Private collection

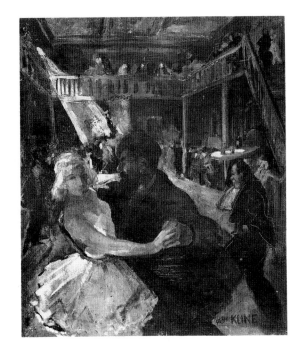

and jazz—dominate the series. The commission may have stipulated that Kline include a number of nudes or seminudes, as stand-ins for those who could no longer appear on New York stages. The previous year, 1939, Minsky's had been denied a license, which proved the *coup de grâce* for burlesque in New York; this was the culmination of a campaign led by La Guardia since 1932. Certainly one reason that Kline focused on female performers was his familiarity with singers and dancers in Village taverns and the movies. His preference in these panels for an extroverted woman who flaunts her physicality corresponded to a growing taste for this female type in films. The popular woman of the 1940s was healthy, broad-shouldered, sometimes tough, and often outspoken. This hardy image, embodied by Rosalind Russell and Rita Hayworth, ripened during World War II with pin-ups Betty Grable, Lana Turner, and Jane Russell. Re-fashioned with an abundance of sweetness and light, she emerged in the 1950s as Marilyn Monroe, strangely anticipated by Kline's sexy, tightly gowned singer (plate 25). Kline's appreciation of a wide range

29. **CIRCUS RIDER**
(BLEECKER STREET TAVERN MURAL), 1940
Oil on canvas mounted on panel
45 × 45 in.
Private collection

Below:
30. **APACHE DANCERS**
(BLEECKER STREET TAVERN MURAL), 1940
Oil on canvas mounted on panel
46 × 46 in.
Private collection

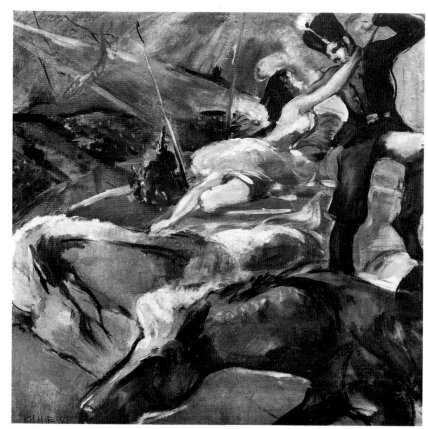

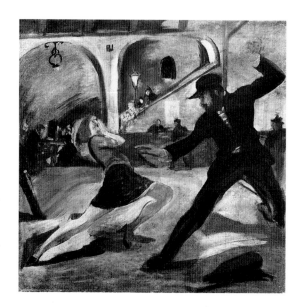

of female types as subjects for public art is pointed up by an additional tavern panel (plate 28). A man wearing a beret and pea jacket dances with a tutu-attired blonde, in what may be a thematic self-portrait: Kline's wife had been a ballet dancer several years before they met.

Kline's murals provided a kind of scenery, something to look at and talk about—before the intrusion of television. By this date Kline had firsthand knowledge of stage sets: in 1939 he had worked with Cleon Throckmorton, the stage designer; they also collaborated on tavern decorations in Hoboken. Kline worked at the World's Fair for about a week in late summer 1940 painting airplanes on a cyclorama. He also had a portrait-drawing concession at the Fair for the '39 and '40 seasons.[8]

The Bleecker Street Tavern murals were Kline's first major public commission, as well as the largest and most complex pictures he had yet undertaken. They are his intrepid attempt to adapt illustrative drawing to large pictorial painting. Unlike his previous work, which had been heavily dependent on line, the murals are dominated by brush drawing; compo-

sitions are integrated in painterly ways that Kline had never before attempted on an easel-painting scale. He brushed in colors and values after the skeletal composition was drawn, reinforcing and pulling the figures forward through insistent contour.

Ten years later Kline would have his first one-man show, of black and white abstractions. Yet installation of these murals qualified, in effect, as his first one-man show in New York and one that found a more enthusiastic audience. On both occasions his art had recently changed—not overnight, by any means—but in a fairly short time, several months at most. In the murals Kline freed his drawing from the pen and pencil and turned it into painting. In 1950 he publicly declared his independence from figurative art and affirmed his belief in the viability of abstraction—again, by fusing drawing with painting.

Kline painted another series of murals in 1945 for El Chico's, a Spanish restaurant and nightclub on Sheridan Square (plate 31). They were commissioned by the owner, Benito Collada, who had been introduced to Kline's work by Milo Lemus, operator of a Greenwich Avenue art gallery.[9] Arrangement of the murals is clear from a small sketch: they were to be read from one wall to the next, moving left to right. The most ambitious section depicted an arena during a bullfight; the leading lady, in mantilla, stood in the foreground. On the rear wall, she and her hero rode horseback across the plains toward a mountaintop castle. The movies offered Kline an always available repertoire of characterizations and poses, costumes and settings. In the case of El Chico's, musicals like *Rio Rita* (1929), *Rose of the Rancho* (1936), and various singing-cowboy films could have been his general sources.[10] He went to the movies regularly and was particularly fond of romantic and period pictures. "He went to *Rembrandt* twice to see Charles Laughton. He called me his 'Saskia' for a while —and his 'Juliet' after seeing John Barrymore and Norma Shearer in a Hollywood production of Shakespeare's play. He sort of 'lived' in the movies and sometimes temporarily identified with the protagonists."[11] The El Chico and Bleecker Street murals

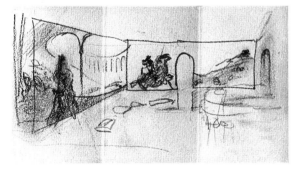

31. **EL CHICO'S INTERIOR WITH MURALS**, 1945
Pencil on matte board
5½ × 10 in.
Collection of
Mr. and Mrs. I. David Orr

have a cinematic quality. One reads them episodically, as if each painting were the condensation of a ten-minute movie scene. Everyone performs.

While artistically undistinguished, the El Chico murals are of interest because they attest to Kline's eclecticism. He cultivated diversity, as Elaine de Kooning noted when describing him as "the most inclusive of artists in his attitudes, methods and long development."[12] The bullfight arena affords intriguing possibilities for prototypes, from a New York ball park to London's Royal Albert Hall. Kline had gone to Albert Hall in 1937 for a Sunday matinee performance by tenor Beniamino Gigli; he drew in his sketchbook throughout the recital and, in the early 1950s, was still impressed with the building.[13] His mural also brings to mind Canaletto's *Interior of the Rotunda at Ranelagh*, which Kline could have seen in the National Gallery in London.[14] These sources, as well as others from Village life, might have contributed to Kline's idea for an arena.

Kline was fairly pleased with the murals. The day after they went on view, he wrote to his friend and patron David Orr: "Last evening was the opening of the El Chico and I spent the evening among newspaper men and in the atmosphere of as much of Spain as could possibly be rendered in a nightclub.... The work seems to be successful—it's in a light tone—very unoffensive and after all newspaper men hardly know the difference if the meals are good and the drawing lively...."[15] El Chico's clientele, however, did know the difference, and they did not like Kline's murals, which were compared unfavorably with paintings hanging downstairs by Usabal. Within a year, Kline's scenes were covered with new ones by Spanish artist Julio Martin.[16]

Kline delighted in the Village with its odd personalities, its human as well as architectural landmarks. These were frequent subjects of his art from 1939 until his growing concern with abstraction in 1947. One Village character was Frederick Blumenstein III, who drew childlike pictures with brightly colored crayons. Kline collected these drawings and painted at least three portraits of Blumenstein.

32. **"THE MAJOR**," 1942
Oil on canvas, 16 × 12 in.
Collection of
Mr. and Mrs. I. David Orr

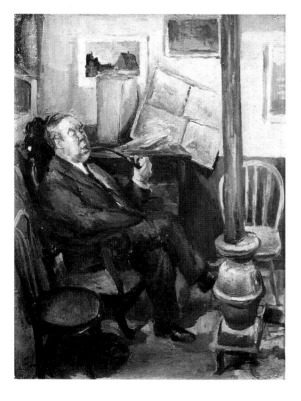

Kline is the only Abstract Expressionist whose early work contains a considerable number of interiors: his own studios and public or semipublic places like the shop of "Major" von Brandenburg. A Village sage, "The Major" sold paintings, drawings, and objects of historic interest, although skeptics might have challenged their authenticity.[17] His studio-shop was just west of 148 and 150 West Fourth Street, where Kline lived and, intermittently, had a studio from 1942 to 1947. In a 1942 portrait Kline surrounded Brandenburg with antiquarian clutter, giving him a meerschaum pipe and turning him into a Charles Laughton look-alike—an overstuffed personage in a room packed with collectibles (plate 32).

Shortly after settling in New York, Kline decided to buy an etching press and set up a small print shop.[18] The business never materialized but he used the press to turn out a few prints. In one etching, which he used for his 1940 Christmas card, Franz, Elizabeth, and their black and white cat, Kitska (acquired as a kitten from "The Major") are seen inside the West Third Street studio (plate 33).[19] They had moved there in January 1940 after being evicted from 146 Macdougal Street for not paying the rent.[20]

More prominent in the etching than anything else is the rocking chair, one of Kline's favorite pieces of furniture and one that appears frequently in his work.

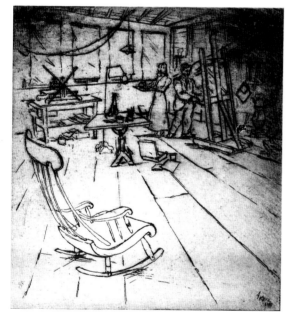

33. **STUDIO INTERIOR**, 1940
Etching with drypoint
5¼ × 4⅞ in. (image)
Private collection

Right:
34. Franz Kline with Kitska
in the studio at
430 Hudson Street, 1941

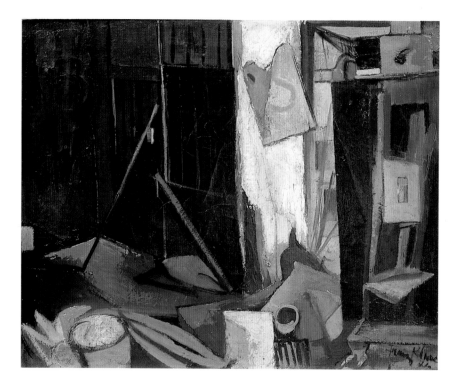

35. **STUDIO INTERIOR—FOURTH STREET**, 1945
Oil on canvas, 20 × 25 in.
Collection of
Mr. and Mrs. I. David Orr

Below:
36. **STUDIO INTERIOR**, 1946
Oil on canvas, 17 × 14 in.
Collection of
Mr. and Mrs. I. David Orr

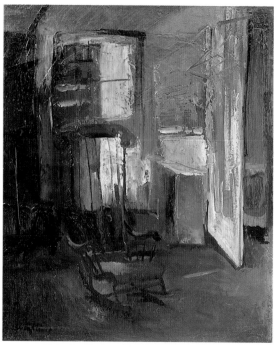

He had picked up the rocker in 1940 outside a Bowery junk shop and walked home with it.[21] Kline repeatedly painted and drew his wife and the chair; they were inextricable from his life as an artist. "On Hudson Street [in 1941–42] he drew, mostly in pen and ink, many nudes of me doing things . . . like washing dishes or ironing a shirt, etc. so that he would know what all the muscles were doing and how people *moved*. He said he learned so much more that way than from static poses."[22]

A few years later the rocker was the subject of a moody interior of the Fourth Street studio (plate 36). The poignancy of this painting with its empty chair derives from Kline's feelings about Elizabeth. Suffering from repeated attacks of depression and schizophrenia, she entered Central Islip State Hospital in May 1946 for six months.[23] Quivering as if she had just gotten up and walked out the door, the rocker may imply Elizabeth's return. The well-worn chair creates a paradoxical sensation; although empty, the room is inhabited.

In small drawings of 1946–48 Kline sometimes combined loosely brushed contour with colored planes (plate 37). Dramatic configurations appear as summarily rendered shapes impinging on the figure. In a 1946 example the head is remade as a

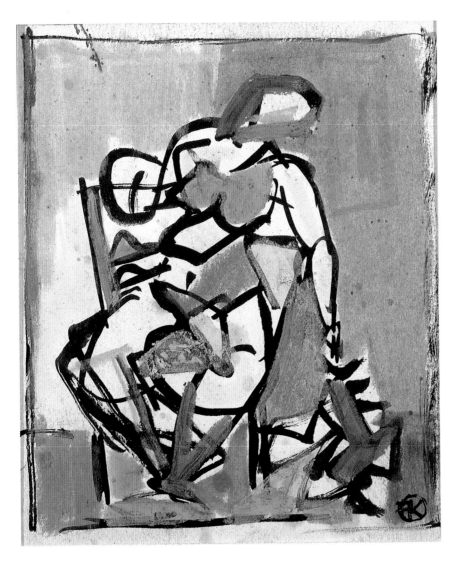

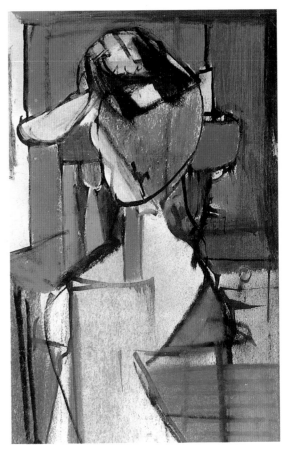

37. **SMALL SEATED FIGURE**, c. 1947
Ink and pastel on paper
5 × 4½ in.
Collection of
Mr. and Mrs. I. David Orr

Below:
38. **SEATED FIGURE (ELIZABETH)**, 1948
Ink and pastel on paper
8½ × 5½ in.
Collection of
Mr. and Mrs. I. David Orr

rough-edged open rectangle (plate 39). Once asked by David Orr why he omitted features from Elizabeth's face at this time, Kline replied: "She isn't there anymore."[24] Additional black strokes cut across the body, not as descriptive details but as carriers of intense feeling. Regarding these drawings from a strictly formalistic viewpoint blocks their meaning in the context of Kline's dedicated but frustrated attempts to cope with Elizabeth's recurring illness. They plot his struggle to retain Elizabeth as subject and wife while her disintegrating personality pulled her farther and farther from him. By 1948 the rocking chair was transformed by slashing strokes into a famous abstracted sketch that Elaine de Kooning has cited as triggering Kline's "instantaneous conversion" to a big black and white style after he saw it projected by a Bell-Opticon.[25]

That Elizabeth's mental deterioration affected

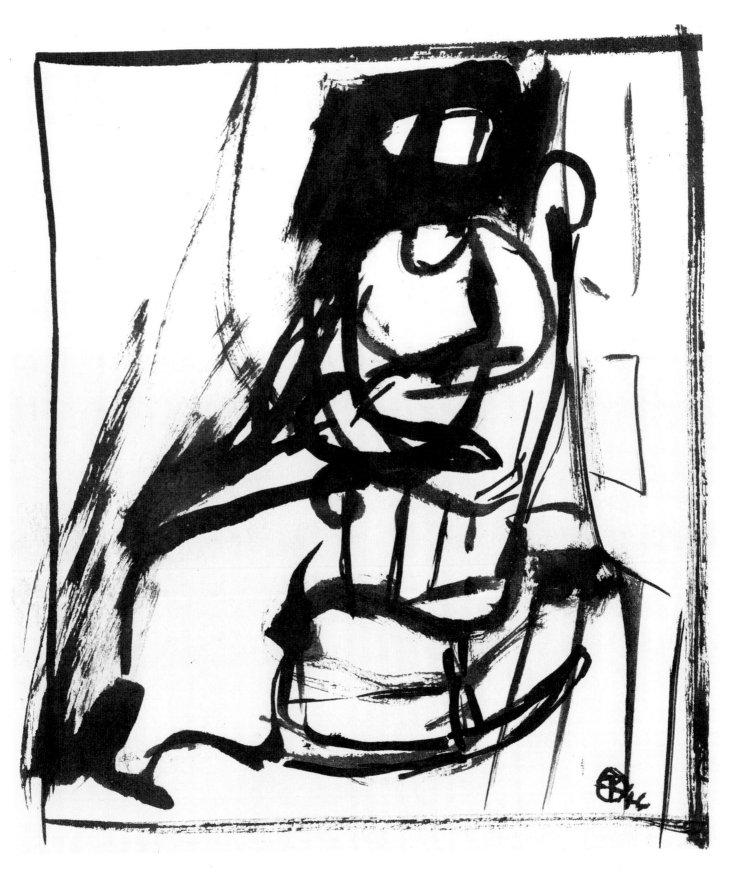

39. **WOMAN IN ROCKING CHAIR**, 1946
Ink on paper, 8¼ × 7 in.
Richard E. and Jane M. Lang Collection, Medina, Washington

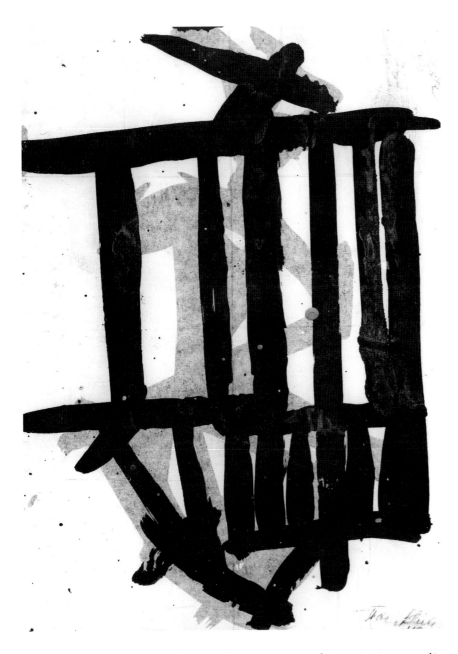

40. **DANCER AT ISLIP**, 1949
Casein on paper, 10½ × 7¼ in.
Mr. and Mrs. Harry W.
Anderson Collection

Below:
41. **PORTRAIT OF STEVE**, 1946
Oil on corrugated paper
10 × 8¾ in.
Dr. Theodore J. Edlich, Jr.

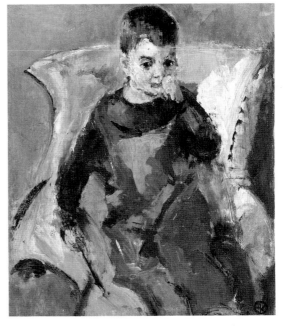

Kline's drawing style and image making is immediately clear in *Dancer at Islip* of 1949 (plate 40). The front of the drawing is a cagelike barrier of heavy black strokes; showing through from the verso is a schematized human body. The image relates both to Kline's fascination with Nijinsky (see chapter 4) and to the animate personages in some of his mature abstractions. Yet in the context of his personal life, *Dancer at Islip* is a diagrammatic record of loss and loneliness. In February 1948 Elizabeth again entered Central Islip State Hospital, where she would remain for twelve years.[26] Kline visited her from time to time, although she did not see him from February 1955 until October 1959. Released as cured in 1960 and

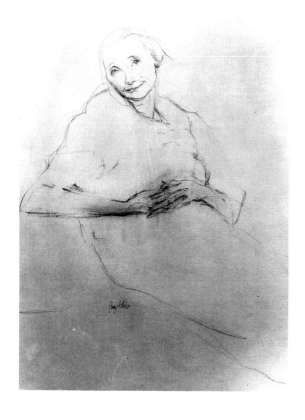

42. **PORTRAIT OF DAVID ORR'S MOTHER**, 1951
Pencil on paper, 13⅝ × 9⅜ in.
Collection of
Mr. and Mrs. I David Orr

Right:
43. **PORTRAIT OF I. DAVID ORR**, 1941
Oil on canvas, 14 × 12 in.
Collection of
Mr. and Mrs. I. David Orr

Far right:
44. **PORTRAIT OF I. DAVID ORR**, 1941
Pencil on paper, 8⅜ × 10⅞ in.
Collection of
Mr. and Mrs. I. David Orr

still married to Kline, Elizabeth lived by herself in a small Long Island apartment and, later, in a nursing home. She died on December 15, 1984.

Because of Elizabeth's illness and his nearly always desperate need for cash, the 1940s had their grim side for Kline. Occasional commercial commissions kept him going, along with other odd jobs such as sign painting, frame making, and carpentry. More important to his survival were two reliable patrons, Dr. Theodore J. Edlich, Jr., and I. David Orr, a Long Island businessman. Edlich, who was Kline's physician, commissioned portraits of his wife and three sons, including three- or four-year-old Stephen, now an accomplished artist himself (plate 41). Edlich also asked for a Gandhi portrait based on a newspaper photograph. In 1940 Kline made a painting of Washington Square on a folding screen that the physician placed in front of an examining table. On the back are small scenes of Village characters painted in a style reminiscent of Phil May. Originally, Kline had pasted prints of these subjects on the screen but they fell off as he carried it to Edlich's office.[27] Washington Square was the subject of at least one more "New York monument" picture, but apparently Kline soon dropped this overworked landmark from his art.

Orr commissioned a total of thirteen portraits of his mother (plate 42), sister, wife, and daughter Sue from 1941 to 1951. Kline also drew and painted six portraits of Orr himself (plates 43, 44). He often

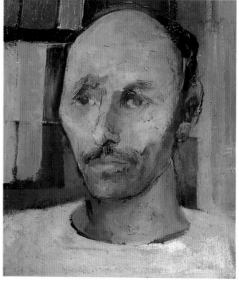

worked at the Orrs' home; sometimes intending only to retouch a painting, he would repaint the entire work. One of Kline's few historical paintings, *The Synagogue* (plate 45), was a major commission. The left side was based on a photograph Orr provided of Jewish pilgrims studying scriptures during the 1920s inside a wooden shelter in Palestine. Kline followed the photograph in a general way, but rearranged details—the man at the reading stand, for example, was moved from left foreground to right middle ground. In a similar way, two years earlier in *Vanished World*, Kline had incorporated likenesses of Orr's relatives from eight separate photographs into another dark interior illuminated by the epiphanic presence of a Jewish bride.[28]

Obviously reflecting Kline's admiration of Rem-

45. **THE SYNAGOGUE**, 1945
Oil on canvas, 22 × 29 in.
Collection of
Mr. and Mrs. I. David Orr

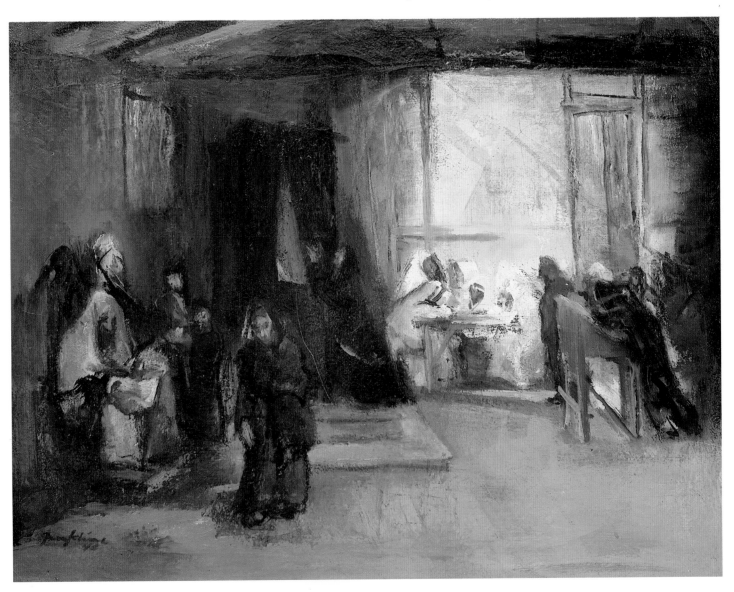

brandt, *The Synagogue* creates its own meditative ambience that pulls a viewer into the scene. The painting's contrast of light and dark as well as its geometric armature of horizontals and verticals was to be extended in his later black and white abstractions. Allowing for differences in scale, such a relationship is particularly evident when comparing *The Synagogue* to *Requiem* (1958, plate 114), possibly Kline's memorial to Jackson Pollock.[29]

Kline's overriding interest was in putting a scene together, not in making a social statement. His figurative city paintings refrain from any comment on the condition of urban man, displaying none of the loud satire of such sociopolitical artists as Jack Levine or the more amiable Reginald Marsh. At a time when the artist had extreme difficulties providing for his wife and himself—Mrs. Kline described their situation as "grinding poverty"[30]—Kline's city paintings verify his acceptance of his environment. His fatalism about the city is reflected in a comment he is reported to have made in the Waldorf Cafeteria on Seventh Avenue: "If you've been here more than a year it's beyond your liking it or not."[31]

A 1940 pen and ink sketch of West Fourth Street is one example of Kline's "commercial art."[32] The drawing was printed on a brochure for the Greenwich Village Artists' Gallery and Museum (plate 46) and documents the kind of easy, casual life that Kline might have enjoyed had he sold more pictures.[33] Another small drawing of apartment buildings and a church tower shows how his style had changed by 1945 (plate 47). The church is identifiable as Our Lady of Pompeii at the corner of Bleecker and Carmine streets,[34] yet Kline did not draw it or the surrounding structures with the verisimilitude that had governed his earlier sketches of Washington Square and Fourth Street. The 1945 drawing is a composite of pictorial elements—buildings, windows, the tower, a suspended sign—which were freely positioned by the artist with no attempt to duplicate likeness. (Naturally, he was making the little drawing for himself, as it would have been impossible to sell.) Kline was not just loosening up his drawing style, for

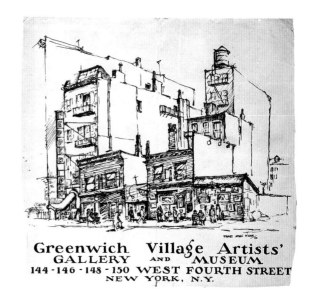

46. **GREENWICH VILLAGE STREET SCENE**, 1940
Printed brochure, 5¾ × 5⅞ in.
Private collection

in fact most of the lines are not as flexible as those in earlier sketches. His concern was with reducing buildings to planes that fit together not primarily as architectural structures nor as totally abstract forms, but as heavily outlined two-dimensional shapes.

Knowing that the 1945 sketch falls chronologically between the 1940 Fourth Street drawing and Kline's urban abstractions such as *New York* (1953), *Crosstown*, and *Wanamaker Block* (both 1955) gives significance to his reorganization of stock ingredients from a cityscape. It is noteworthy that figures are excluded from the sketch and that an abstract clump of strokes in the left foreground links buildings to the lower edge. A self-consciousness implicit in the sketch is perhaps most keenly sensed in the

47. **CHURCH**, 1945
Brush and ink on paper
5½ × 4⅛ in.
Private collection

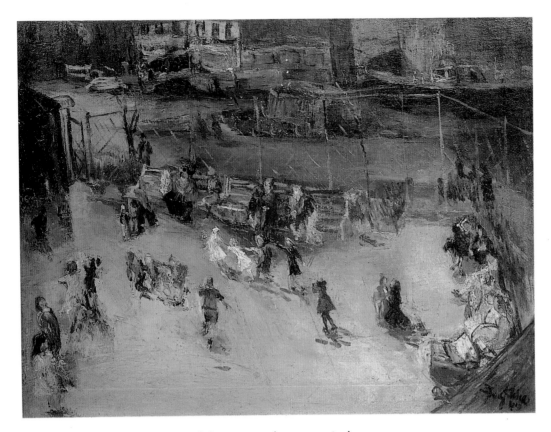

series of eight vertical lines at lower right.

Kline undoubtedly related shapes to the overall rectangular field, for he outlined it with a black "frame," a feature of some of his interior drawings as well. This clearly defined "frame" relates the 1945 sketch to earlier paintings of scenes viewed from a window in Kline's studio-loft. For one 1943 picture he looked out on rooftops, empty balconies, and silent windows. The compositional problem they presented is underscored by the fact that the painting was originally about four inches wider on the right; at the suggestion of David Orr, Kline cut it down to its present dimensions.[35]

Another picture made from a window in the Fourth Street studio is *The Playground* (plate 48), completed during a single painting session.[36] Prudent application of paint and restrained composition have given way to sporadic impasto and a scattering of energetic forms not always clearly defined. The work appears closer to Chaim Soutine than to Kline of the year before.[37] This is partially due to the active subject —children scampering across a playground—but also to Kline's lessening dependence on drawing to structure a picture. In the 1940 barroom murals he

48. **THE PLAYGROUND**, 1944
Oil on canvas, 18¼ × 24¼ in.
Collection of
Mr. and Mrs. I David Orr

Opposite:
49. **CHATHAM SQUARE**, 1948
Oil on canvas, 40 × 30 in.
Collection of
Mr. and Mrs. I. David Orr

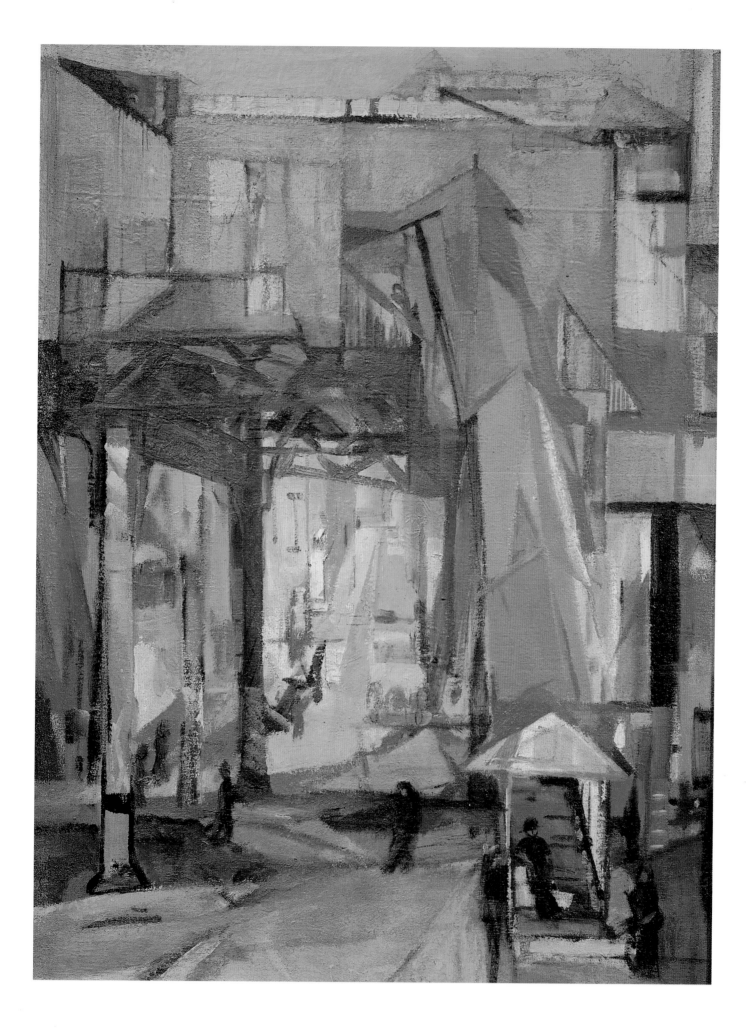

50. Franz Kline, mid-1940s

had begun to integrate painting and drawing, yet this did not generate a one-track evolution, and Kline continued to move back and forth between an essentially drawn and an essentially painted style. This dichotomy persisted throughout his abstract period. To draw *or* to paint, and how to fuse the two regardless of medium, were perpetual questions.

In *The Playground*, Kline did not accent all areas equally, yet nearly all the buildings and figures are painted with a similar concentration of heavily worked pigment. A textural density overlays all details and gives the picture surface unity. As a result, the work is held together as much by paint application as by composition. Yet the surface does not meld but remains a composite of strokes and scrapings of varying widths and directions.

New York's several elevated trains repeatedly appear in Kline's art from his arrival in the city until 1948, when abstraction was imminent in his painting.

In 1938, the year he moved to New York, the Sixth Avenue El was torn down; newspapers featured stories of its once romantic youth as well as its ignominious old age. An 1878 sketch of the El showing the first southbound train passing Jefferson Market Police Court was reproduced twice in the *New York Times*. Using this drawing, Kline included the image in one of his first etchings.[38]

Represented in the etching was an X-pattern of braces reinforcing the railbed. Kline inserted a similar band of Xs into a 1940 painting, *Ninth Avenue Elevated Station, Christopher Street,* and *Chatham Square* (1948, plate 49), a consequential work in the light of his later abstraction. The degree to which Kline associated these Xs with the Els may be discerned from the fact that they never appear as such in his abstractions. One of his largest black and white canvases, *Painting No. 2* (1954), does have an X-pattern scratched across its wide white midsection, but unless one gets eyeball to eyeball with the surface the pattern is barely visible. In *Chatham Square*, where the Xs function as part of the El's structural logic, Kline had broadened the pattern. Here form is articulated in a quasi-Cubistic way, with one shape reflecting or encroaching on another: the X-pattern refers to the triangular gable above the entrance to the stairs and to the high peaked roof above them.

Kline was introduced to the El when it was on the way out, and nothing really happens in his paintings of it. A sense of idleness fills the early scenes as if the elevated were just waiting to be torn down and trucked away. Yet this decrepit monument to urban speed and decay helped open his eyes to new possibilities of structure and form. To be sure, the El alone did not carry him to a semiabstract mode, but, as evident in *Chatham Square*, its exposed skeletal system quickened his invention of nonliteral forms. Having reached the end of its usefulness to the city, the El afforded an alternative to ingratiating naturalism for an artist whose stereotyped concepts of subject matter and range of figurative styles were also running down. More than any other urban structure, the El helped Kline find the track to abstraction.

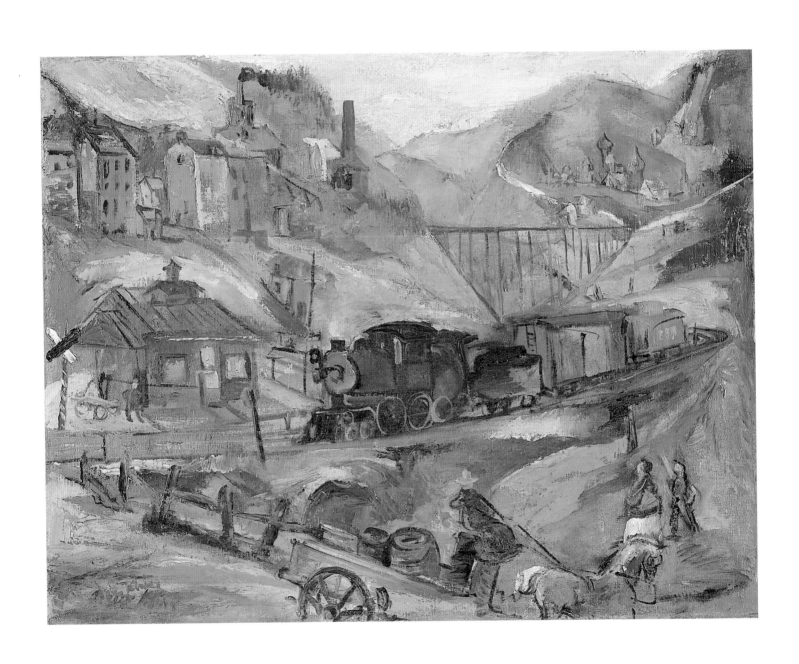

3.

PENNSYLVANIA LANDSCAPE

Although he became a major artist of the New York School, Kline never forgot his roots in the coal country of eastern Pennsylvania. Lehighton and its environs provided him with subject matter for figurative pictures during the 1940s and with names for black and white abstractions during the 1950s and '60s.

Kline's affection for small-town life is most sentimentally revealed in *Palmerton, Pa.* (plate 51), a painting of great importance to the artist because it won the 1943 S. J. Wallace Truman Prize at the National Academy of Design and brought him his first "big" public recognition.[1] The railroad was a powerful force in the lives of many people in eastern Pennsylvania, including Kline's stepfather; but in *Palmerton, Pa.* the train looks like a toy in a model landscape.[2] Kline was not concerned with the economic consequences of the railroad nor with any contrast between coal- and horsepower in his pictures of trains. His fascination was with the shape and size of the locomotive, its many moving parts, and its ability to work up and maintain high speed—a fascination that would be manifested in his interest in automobiles in the 1950s and '60s when, affluent at last, he bought a black Thunderbird and a silver gray Ferrari.[3]

Kline's ebullience over winning the National Academy prize in 1943 filled the letter he sent home:

51. **PALMERTON, PA.**, 1941
Oil on canvas, 21 × 27⅛ in.
National Museum of American Art,
Smithsonian Institution,
Washington, D.C.

Now for some real news that came to me as a complete surprise. First, I entered two canvases for the annual National Academy art show which you know I exhibited in last spring. Well, they usually take only one picture; that's the rule. This year to my surprise they accepted and are exhibiting the two. And for one of them I have received a $300.00 prize.

I am sending you under separate cover the catalogue explaining the whole thing, pages 3, 5, 7, and 9. The winning picture was a large painting from memory of Palmerton, Pa., the Lehigh Valley—yard train, station, and the hills leading home to Lehighton. The composition is slightly abstract and the mood of the painting seems to receive many compliments. Again it was selected from exhibitors from all over the country including work by members of the National Academy. So among hundreds or several thousands mine received the second highest prize award.

I tell you I was never so surprised in my life for I would have been pleased enough just to have gotten in the show.

I know this will make you all very happy. I'll try to get you the New York Times write-up with mention of me on Monday, Feb. 15th and perhaps they will review the show in this Sunday's papers—Art Section.

The money won't be paid probably 'till after the show. Anyhow I'll try and get home after it comes.[4]

On February 16 the *Times* mentioned Kline's winning the prize.[5] And in the Sunday edition, Edward Alden Jewell listed Kline among the prizewinners, adding: "Of the several landscapes thus honored, those by Henry Gasser and Franz Kline are perhaps most pleasurable."[6]

Palmerton, Pa. is a composite of images, not of yesterday or the day before and not sketched on the last trip home, but aged in memories. The painting's mood is naive reverie, a daydream not of the problematic future but the generous past. Perhaps this was why Kline described the composition as "slightly abstract," thereby preparing his family for a picture that did not exactly match the town. Taking into account that he was writing to relatives, not conversing with artists, Kline's use of *abstract* nevertheless indicates his restrictive definition of the term. He uses it in reference to composition rather than conception of form, although it may also have connoted a sum-

mary treatment of detail. In 1943, Kline did not share the advanced definition of *abstract* applicable, for example, to the work of Kandinsky, Mondrian, or even Arthur G. Dove.

Kline's love of trains is again reflected in *Lehigh River, Winter* (plate 53), which brought him a second Truman Prize.[7] This painting has an English air, as if Kline had rediscovered the buildings in one of his London sketchbooks. Yet the painting captures the stoicism of the coal country anticipating or recovering from winter's crush. Kline knew the power of cold. In his letter home, along with the "real news" of his first National Academy prize, he wrote: "The weather down here for the past few days has been terrible; 8 below zero was the coldest. I presume Lehighton felt it very much also. I hope you've managed enough coal and fuel. Down here the supply is very scarce —however we manage."[8] This was during World War II when supplies were rationed, but Franz and Elizabeth's living conditions were made harsher by their chronic lack of money.[9]

Kline painted at least two ingenuous pictures of chugging coal locomotives in the early 1940s, but he was just as attracted to a streamlined diesel, the Lehigh Valley Railroad's Black Diamond. He sketched it by referring to a postcard of the train (plate 52).[10] Even though it was a "daylight train," Kline saw it in his mind's eye at night, when the headlight streaking in front became as positive a feature as the shape and size of the engine or the words along its side. His sense of the train's blackness extended beyond its name (which he printed on the rear of the locomotive as well as at the bottom of the drawing), beyond its shiny coat of paint, and beyond any association with coal. The train signified night for Kline. Perhaps his long romance with trains deepened through identification with them as fellow travelers in the night, always on the "owl run" deadheading home.

In 1960 Kline painted two abstract paintings entitled *Palmerton* and *Diamond* (plate 54). *Palmerton* bears no explicit similarity to its predecessor except for a black zigzag, which in the 1941 picture is shorthand for a hillside structure, possibly a conveyor next

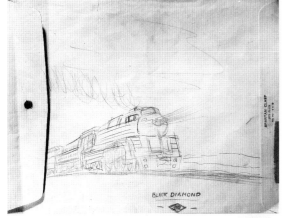

52. Top:
BLACK DIAMOND, c. 1949–50
Pencil on manila envelope, 8 × 11 in.
Bottom:
Postcard of the Black Diamond
Private collection

to a factory or mine. Enlarged in proportion to the whole canvas, the 1960 zigzag is an irregular vertical no longer predictable in rate or direction of ascent. It is doubtful that Kline derived this painting's title from a conscious recollection of this form; more likely, he chose to reuse the name because of more general associations with the earlier picture and the town.

Diamond suggests that Kline perceived a link between the Lehigh Valley train and the painting's dark mass pushing against the white as if moving across the painting on the "track" or "platform" below. He did not name the painting *Black Diamond*, for such a one-to-one relationship between image and source would have been too restrictive. This is not an abstraction *of* the train. Moreover, *Diamond* is one of the most colorful black and white paintings, tempered by blues, blue greens, and pinks. A different kind of relationship exists between form and title in *Caboose* (1961), an unfortunately inert abstraction that as image goes nowhere.[11]

In the late fall of 1946 Lehighton's American Legion commissioned Kline to paint a fourteen-foot mural of the town for its large assembly room (plate 55).[12] He worked on the picture that December, basing it on sketches and an earlier painting. Considering the bird's-eye view and the airplane at lower right, Kline may also have seen the town from a plane or

53. **LEHIGH RIVER, WINTER**, 1944
Oil on canvas, 20 × 25½ in.
Collection of
Mr. and Mr. I David Orr

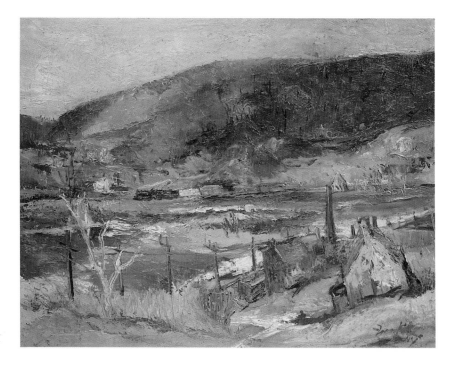

at least referred to an aerial photograph of it. The general composition of the landscape, however, was dictated by no sudden revelations. He chose a vantage point known to him for years: looking east toward the center of town from the Carbon County fairgrounds and airport. The family home on the southwest corner of Ninth and Alum faced the same direction and afforded a view appropriate for the commission and related to his experience as a youth who lived there for six years.

In the mural a house quite similar to the family home stands in its proper place in front of the fairgrounds. But Kline has altered the rest of the topography to such an extent that one part of town can-

54. **DIAMOND**, 1960
Oil on canvas, 64½ × 79¼ in.
Mr. and Mrs. Gilbert H. Kinney,
Washington, D.C.

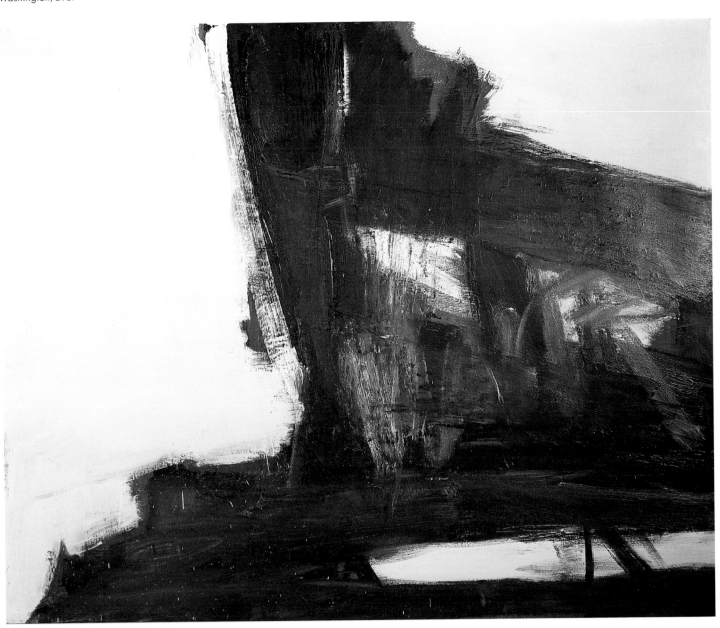

not be logically connected with another. The corner of Ninth and Alum does not appear in the painting; in fact, Alum Street has not been included at all. Other features have also been changed in a way that might trouble Lehighton natives trying to get their bearings. The Central Railroad Bridge at upper left has been enlarged so that it is not only visible above the main line of buildings on First Street but looms over its part of town.[13] The First Street buildings curve like cars on a roller coaster. While the left two-thirds of the mural appears elongated horizontally, the right one-third seems compressed. And, although in actuality the ground slopes down toward the center of Lehighton, because of his elevated viewpoint Kline

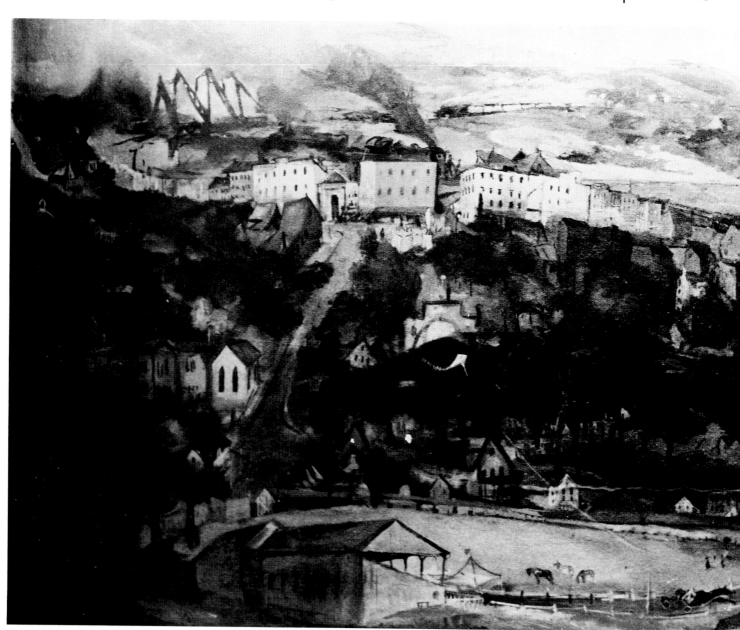

made it slope up. If Kline's topography is a turnabout of naturalistic appearances, so is his choice of season. Painting the mural in early winter, he created a spring day when trees are full, trotters try out the track, and a child flies a kite. This, then, is as much a memory landscape as *Palmerton, Pa.* And as in that pleasurable painting, a sense of good humor animates the mural.

This was the largest single picture that Kline had yet painted.[14] Working on this scale and with these proportions forced him to compose by grouping details in long strips: the fairgrounds and airport in front, the buildings on First Street, to a lesser degree the cemetery, and, vertically, the houses along Iron Street

55. **LEHIGHTON**, 1946
Oil on canvas mounted on plaster
73 × 166 in.
American Legion Post 314,
Lehighton, Pennsylvania

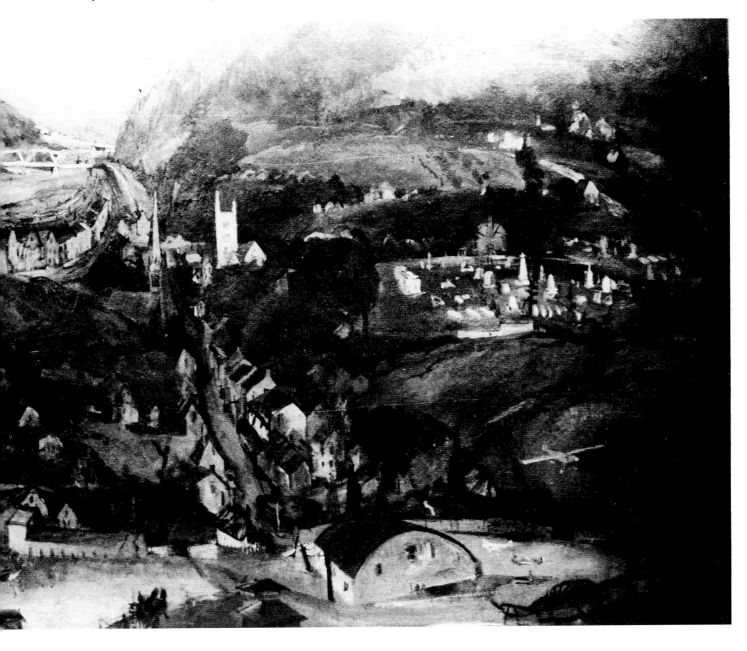

culminating in the two churches. After the sometimes desolate New York anonymity that Kline had known for more than eight years, he may have been excited by the chance to paint something he knew so well on this grand scale, to be on top of the world again in his hometown, where he had been one of the most popular students at Lehighton High School.

The mural is discursive, moving from specific to general. No structural armature compacts the scene into an immediately graspable unit. Pieces retaining their separate character make up the whole; one specific leads to another, creating the general impression that Lehighton and the mural are the sum of their parts—no more, no less. Looking at the mural, a

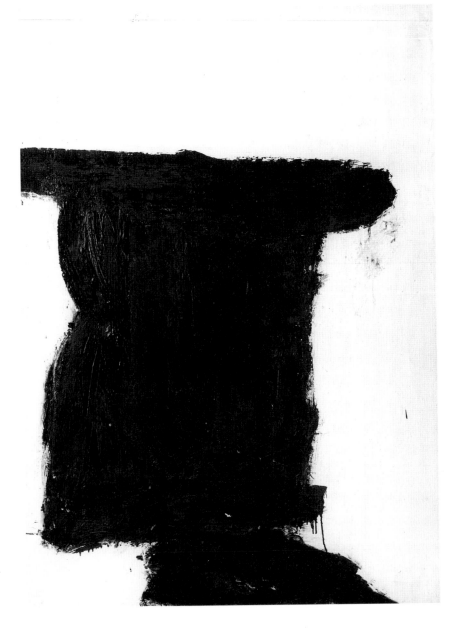

56. **THORPE**, 1954
Oil on canvas, 62 × 44 in.
Museum of Contemporary Art,
Los Angeles

comparable phenomenon occurs: one moves from a specific place, the Legion bar, toward Kline's comprehensive overview of the town.

Later, as an abstract artist, Kline made references to his hometown and to eastern Pennsylvania in general by naming paintings *Wyoming* and *Luzerne* (both counties), *Bethlehem, Scranton, Nesquehoning, Mahoning, Shenandoah, Pittston*, and *Hazelton* (plate 57).[15] His identification with these places—and the fact that he liked the sound of their names—is affirmed by this declaration of personal geography. Philip Guston recalled that in the early 1950s Kline talked so much about Mauch Chunk (once the name of Lehighton's neighboring towns) that Guston thought he had been born there.[16] Fellow artist Nicholas Marsicano remembers Kline's talking for hours in the Cedar Bar about the area around Lehighton, sprinkling his conversation with names cryptic to outsiders.[17]

In 1954 Kline entitled an abstraction *Thorpe* (plate 56), the same year in which Mauch Chunk—two communities until then—merged under the name Jim Thorpe.[18] The painting contains one of Kline's bluntest, most matter-of-fact images, a surly presence seemingly painted with black tar embedded in a heavily opaque ground. The image is immobile, ominous in staying power. Like a massive, balanced rock, sta-

57. **HAZELTON**, 1957
Oil on canvas, 40¾ × 77½ in.
Museum of Contemporary Art,
Los Angeles

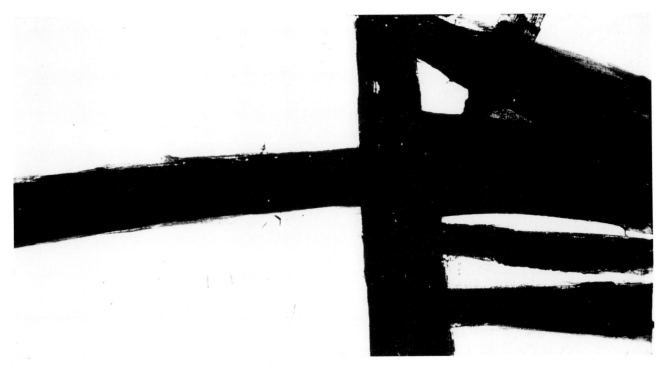

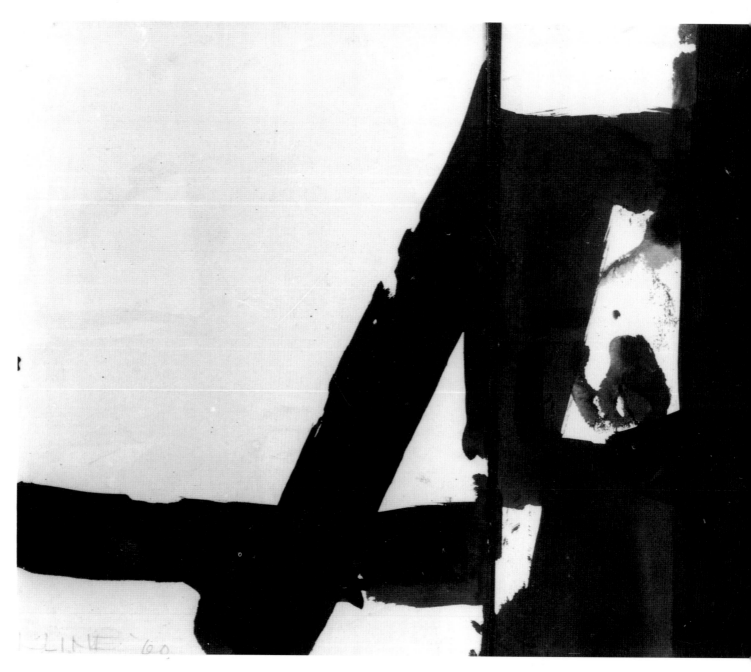

58. STUDY FOR "SHENANDOAH WALL," 1960
Ink and collage on paper
10½ × 25 in.
Sheldon Memorial Art Gallery,
University of Nebraska, Lincoln;
Gift of Mrs. Olga N. Sheldon

ble because of weight, it blocks us as surely as Jim Thorpe or Mauch Chunk Mountain. In a general way, the configuration suggests a *T*, a further reason for relating the name Thorpe to the painting.[19]

While Kline identified with these abstractions through imagery and title, they may not be so readily accessible to viewers as, say, the Lehighton mural. One can articulate feelings about the mural with ease. Bar talk is as much part of it as its many trees and houses. As a focal point of camaraderie, it depends on well-worn storytelling. Anecdotes, however, play no part in *Shenandoah Wall* (1961), which is an abstraction nearly identical in size to the mural; their

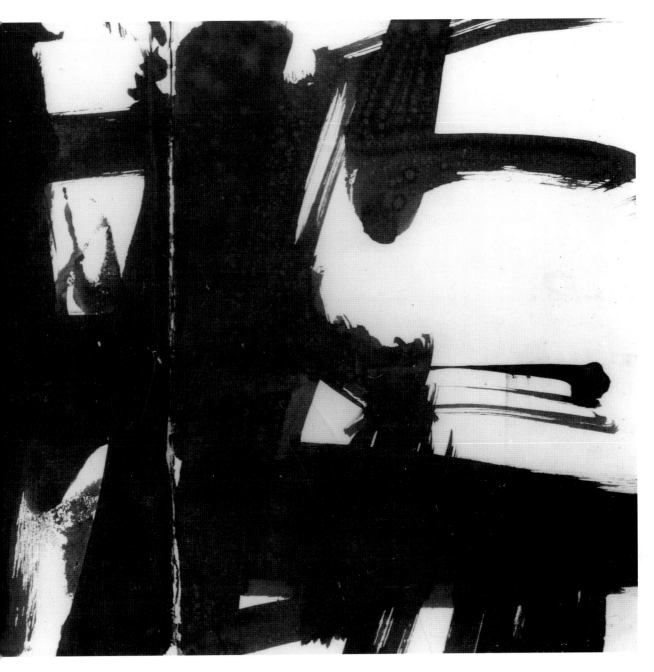

function as carriers of communal meaning has been superseded by the artist's singular experience alone in the studio, carrying on a silent dialogue with the painting. Still, the mural and abstraction have in common the power to produce physical effect. In both cases the paintings' scale and imagery dominate the viewer and adjacent space. Of course, Kline is not unique among Abstract Expressionists in this regard; Pollock, de Kooning, and Rothko also produced works with strong physical impact. Yet unlike his contemporaries, Kline referred repeatedly in his mature abstractions through intimations of site and title to the harsh landscape of his youth.

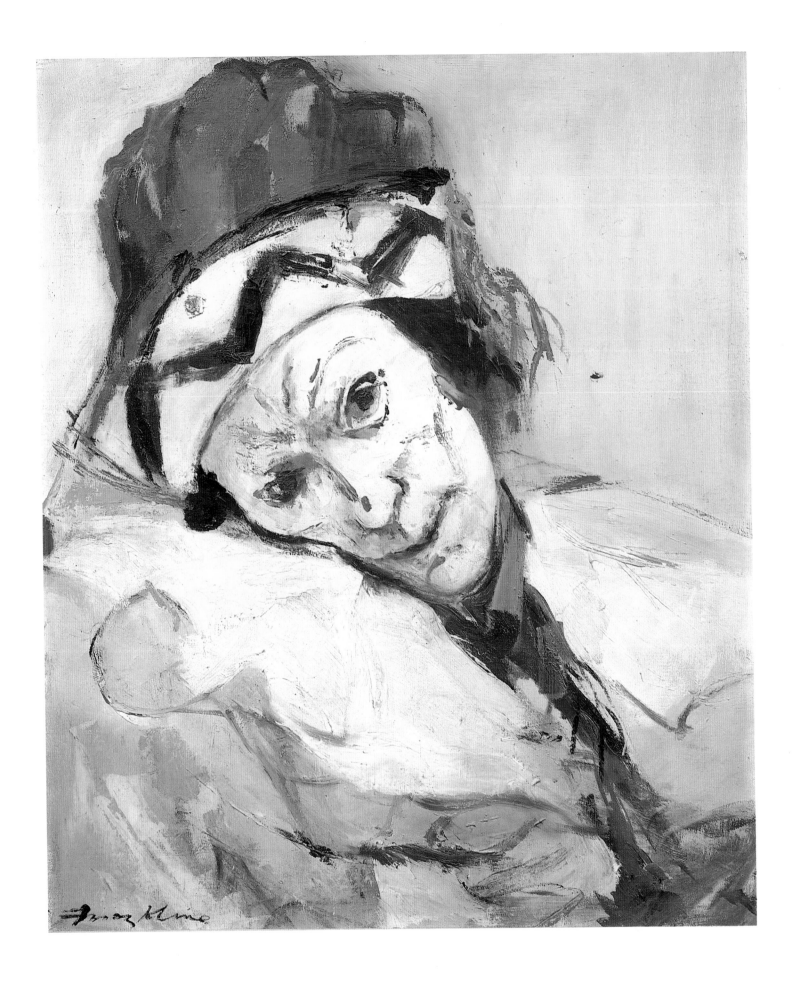

4.

NIJINSKY, SELF-PORTRAITS, CLOWNS

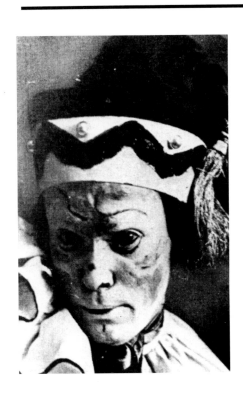

Opposite:
59. **NIJINSKY AS PETROUCHKA**, c. 1948
Oil on canvas, 33 × 28 in.
Collection of Mr. and Mrs. I. David Orr

60. Nijinsky as Petrouchka, 1911

Nijinsky as Petrouchka—the puppet-mortal in Igor Stravinsky's ballet—is the most poignant and persistent face in Kline's art. Between 1936 and 1949 he sketched and painted the head of the great dancer in this role at least six times, basing the image on a 1911 photograph by Elliott and Fry (plate 60). Kline was first attracted to the photo in London in 1936.[1] Later, Elizabeth introduced him to Romola Nijinsky's 1934 account of her husband's life, a book containing the Petrouchka photograph; she also shared a copy of Nijinsky's *Diary* with Kline.[2]

In his paintings Kline carefully preserved such details as Nijinsky's oversized collar and tie, his floppy, tasseled hat with zigzag band, and splotchy makeup accenting Petrouchka's nature as a hybrid of human and doll. But their appeal as visual elements does not explain Kline's recurring interest in the Nijinsky-Petrouchka theme. It became for him an alternative self-portrait. "He [Kline] was overcome by the photo of Nijinsky as Petrouchka. It was apropos of this that he went on about Lon Chaney. He said he *knew* what Petrouchka felt and Lon Chaney in *his* circus clown tragedy."[3]

Kline's identification with the subject is evident in a 1940 photograph, in which he sits in front of a Nijinsky canvas on his easel (plate 61).[4] Kline had told Elizabeth in England: "I have always felt that I'm like a clown and that my life might work out like a tragedy, a clown's tragedy."[5] This could be regarded as a momentary bit of romanticism, but the number of Petrouchka heads and melancholic self-portraits that Kline painted makes it more credible as a succinct statement of self-perception. It is an intimation of the "other side" of Kline, the lonely, loser, artist side.

Although he identified with Petrouchka, by way of Nijinsky, more than with any other, Kline loved all clowns. *Punchinello*, his earliest clown drawing, depicts two puppets in a Punch-and-Judy show and was one frame of a 1930–31 cartoon calendar for the high school yearbook. Kline's interest in clowns originated in Lehighton, where the circus would set up on open ground behind his home. In the 1940s he reminisced about looking out at the circus from his window and going with friends to peek in the tent.[6] In 1940 Kline also made paintings of puppets, one wearing a Ted Lewis top hat (plate 62). Seated on the edge of the artist's painting table, the puppet is propped up against a can used to soak brushes. His head falls to one side, similar to Nijinsky's pose as Petrouchka.

Kline's formal dependence on the 1911 photograph was nearly total, and his problems regarding the edges of his painting (an area excluded from the small photo) are repeatedly evident in the somewhat muddled arrangement of ruff and the vacant corner at lower left. Not until about 1948, in the final version (plate 59), was Kline able to free himself from the photograph and deal with these areas imaginatively: he simply abandoned the ruff's photographic configuration, summarized the folds in two layers, and filled the vacuum in the left corner by signing his name in black along the lower edge. One detail not in the photo but appearing in both the first version, of 1937, and the last indicates how Kline exaggerated Nijinsky's mood: he reddened his eyes. The impression in the earlier painting is that the subject

61. Franz Kline with **NIJINSKY** on easel, 1940

weeps silently and tearlessly, while the eyes of the later Nijinsky are ignited by the red paint. Although cosmetic, these red marks refer to Petrouchka's genuine feeling and point up all the more sharply the human pain of unrequited love and isolation suffered by the supposedly happy clown.

Kline based at least three other paintings of Nijinsky on the Elliott and Fry photograph: two from the early 1940s nearly identical in size to the first and a much smaller canvas dated 1942. The early paintings are matter-of-fact images; Nijinsky's personality is held in check. His eyes were refocused to look out either the upper right or lower left. Compositionally, the small 1942 version is the same as that of 1937, loosened up and diminutive, but the treatment of the face with many strokes of varied colors, densities, and directions creates a countenance that pulls Nijinsky away from the viewer. Kline is on the way to turning Nijinsky's face into a mask, an evolution culminating in the 1948 version. The small Nijin-

has a pendant: Kline painted a clown in a pointed hat who looks toward Nijinsky and grins.

Between this pair of 1942 paintings and the 1948 *Nijinsky*, Kline did a semiabstract drawing–painting in ink and pastel also entitled *Nijinsky* (plate 64). Although not based directly on the photograph, this work is still dependent on the artist's knowledge of it and perhaps others. The drawing–painting ranges from near abstraction in some details to clearly figurative form when considered as a whole. As Kline tried out a combination of media—this was not the first time he used ink with pastel, but neither was it habitual—his concentration shifted from the form's bulk to its edges. Masses are flattened not only because modeling is excluded but also because they are "colored in" by parallel pastel strokes. Pastel is rubbed over ink, and ink is brushed on top of pastel. Kline works with both at the same time, yet ink defines and pastel supplements. Color is secondary to structure, as in some of his early "color abstractions" of the 1950s. If Kline had conceived the possibility of a mask for Nijinsky in the small 1942 painting, here he makes the irregular configuration of strokes more

62. **PUPPET**, c. 1940
Oil on canvas, 16 × 14¼ in.
Dr. Theodore J. Edlich, Jr.

obviously masklike in that it does not allude to flesh and seems incapable of changing expression.

Stylistic changes in Kline's Nijinskys did not develop in an unbroken line. Without knowing the final figurative painting, one could easily be misled by the 1947 example into anticipating a much more abstract version than Kline was capable of in 1948. (The ultimate *Nijinsky*, the abstraction in his first one-man show, was painted in 1950.) At least two factors account for the nonabstract nature of the 1948 *Nijinsky*. First, it was a commission. Kline painted it for David Orr, who remembers that "it took him longer than usual to do it."[7] Second, in painting a subject he had known for years—and Nijinsky was the image he had worked with more often over more years than

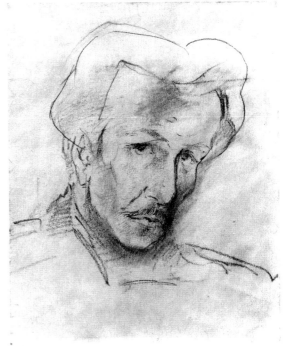

63. **SELF-PORTRAIT**, 1941–42
Pencil on paper, 6 × 5 in.
Collection of
Mr. and Mrs. I. David Orr

Left:
64. **NIJINSKY**, 1947
Pastel and ink on paper
11 × 8½ in.
Collection of
Mr. and Mrs. I. David Orr

any other—Kline was not about to abstract it beyond recognizability.

In the 1948 *Nijinsky* the dancer has mellowed considerably, coming closer to a knowing smile than ever before. The face has also evolved into a bona fide mask—a synopsis of Nijinsky. Kline's distillation of the face is as deeply psychological as he ever became in his figurative art, yet the painting's importance is limited neither to its value as a memorable "portrait" of Nijinsky, nor to its special place as the final declaration of Kline's empathy with that image. It is in this major painting that Kline looks back thematically and yet achieves a new breadth and flexibility of style through succinct articulation of detail. To be sure, this *Nijinsky* does not forecast the abstract style of 1950, for it was not crucial by itself to the maturation of Kline's abstraction—one doubts that any painting could have such singular impact—but it is a pivotal work that helped to open new stylistic directions. In this respect, it is comparable to another 1948 painting, *Chatham Square*, in which likeness to a familiar subject was retained but structurally abbreviated by the brushstrokes defining it.

The extent to which Nijinsky had permeated Kline's mind is reflected in an incident in early 1949: while visiting Orr, Kline claimed that he could paint Nijinsky blindfolded. "To prove his point he proceeded to draw the head on a corrugated carton which was there at the moment. It must have taken him less than thirty seconds."[8] Fragmentary though it is, the sketch indicates how Kline drew first the overall form and then located details within it. Nijinsky's most indelible feature for Kline was the tilted head. In each *Nijinsky* he emphasized the head's strong diagonal, exaggerating the angle in the photograph. Kline's liking for the tilted head may be traced to a small sketch of his stepniece from about 1935. Even before seeing the Nijinsky photo he had recognized that melancholy could be expressed by turning a head down to one side. This feature is repeated in one of his most sensitive self-portraits (plate 63), where he tilts his head to the right. While this drawing was not directly influenced by the 1911 photo, it does have a

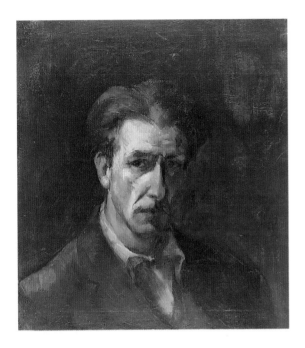

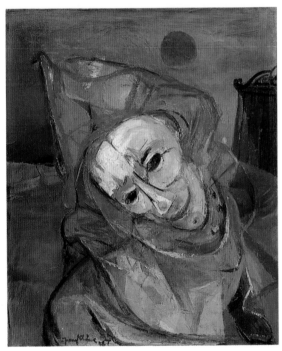

Top:
65. **SELF-PORTRAIT**, c. 1945–47
Oil on canvas, 20 × 18 in.
Suzanne Vanderwoude,
New York

66. **RED CLOWN**, 1947
Oil on canvas, 23½ × 20 in.
Collection of
Mr. and Mrs. I. David Orr

serious, tremulous mood close to that of Nijinsky.

Kline recognized the irreconcilable sides of Nijinsky—the supremely disciplined dancer incapable of controlling his private fantasies—and he may have felt a similar though less severe duality in himself. Certainly this is not evident in every self-portrait, but it can be seen in at least six from 1942 to 1947, one of which is exceedingly romantic (plate 65). So stark is this painting's chiaroscuro that half the face, neck, and collar are nearly isolated from the rest of the figure and background, as if a spotlight shone directly on the subject. Obviously, Kline's taste for acute value contrasts did not originate with his abstractions. Kline sometimes studied his face in a mirror, observing how his expression would change with different muscular movements and different lighting.[9] Not infrequently, as in the c. 1945–47 self-portrait, he emphasized the structure of his face and by doing so heightened its psychological drama.

In a strange self-portrait of 1940 Kline distorted his face into the sad expression of a stomped-on clown. His imagination had been fired by a recent incident. He had painted a sign for an Italian nightclub, but the owners refused to pay. Kline got tough and got himself beaten up.[10] The real subject of the picture is a poor artist's bad luck in New York. Kline turned even this into grist for his art, pumping up his head like a balloon, livid on one side with dislocated eye and cheek. It is unpleasant to look at, but the artist's inflation of his predicament cannot be taken too seriously.

A different kind of mask appears in Kline's *Red Clown* of 1947 (plate 66), a harlequin variation on the Nijinsky theme. Although the clown has a smile, its Cheshire-cat fixity, along with its gray white face, blank eyes, and the extreme angle of the head pushed painfully to one side stir macabre associations: is this a clown's death mask? A circus background originally occupied the picture's left side, but Kline eliminated it, except for part of a circus wagon, to concentrate on the clown.[11]

With its many angular planes, nearly prismatic in places, *Red Clown* is related to paintings by the New

67. Earl Kerkam
HEAD, n.d.
Watercolor on paper
13 × 14½ in.
Zabriskie Gallery,
New York

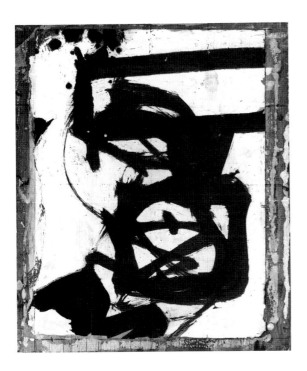

68. **STUDY FOR "NIJINSKY,"** c. 1950
Ink and gouache on telephone-book page
11 × 9 in.
Richard E. and Jane M. Lang Collection,
Medina, Washington

York artist Earl Kerkam (plate 67). "People like Earl Kerkam have affected me; I've talked a lot about drawing with him. I think the reason his work hasn't caught on more is because he's always been so out-and-out honest about the artists he's been influenced by. He hasn't hidden them. If he liked Cézanne, he used Cézanne. He definitely believes in influences, but naturally he's not an imitator."[12] Kline met Kerkam in 1940 at the Washington Square Art Show, and they shared Kline's Ninth Street apartment for about six months during 1948.[13] One of Kerkam's watercolors, seen beside *Red Clown*, illustrates the way that drawing connected the two artists. Each has mastered an expressionistic style in which the face is flattened, segmented, with the features formed and apportioned not only according to likeness or pattern but also to a concentrated rhythm that keeps the image intact. While Kline and Kerkam exchanged ideas about drawing, as painters they went independent ways; both, however, often painted and drew self-portraits.

Kline's concern with clowns exceeded an interest in them as eccentric entertainers. He identified with them as characters burdened by society's demand that their masks be always in place. His empathy with Nijinsky was particularly deep: he was Kline's antihero. On April 8, 1950, Nijinsky, then sixty years old, died in London, the city where Kline had been introduced to him through a photograph.[14] On October 16 of that year Kline opened his first one-man show in New York. One painting exhibited, that with the most contorted and high-strung configuration, was named *Nijinsky*. The image of the clown crowned by his fool's hat is gone. A diagonal movement remains, but has been rearticulated in several directions. All that really survives is Kline's deep feeling for Nijinsky, which he acknowledges by the title. Indicating that Petrouchka had been her husband's favorite role, Romola Nijinsky observed: "It grew on him as he became more and more used to it; and the longer he danced it the more monumental was his conception."[15] The same is true of Kline's affinity for Nijinsky as he portrayed the ironic clown in painting after painting.

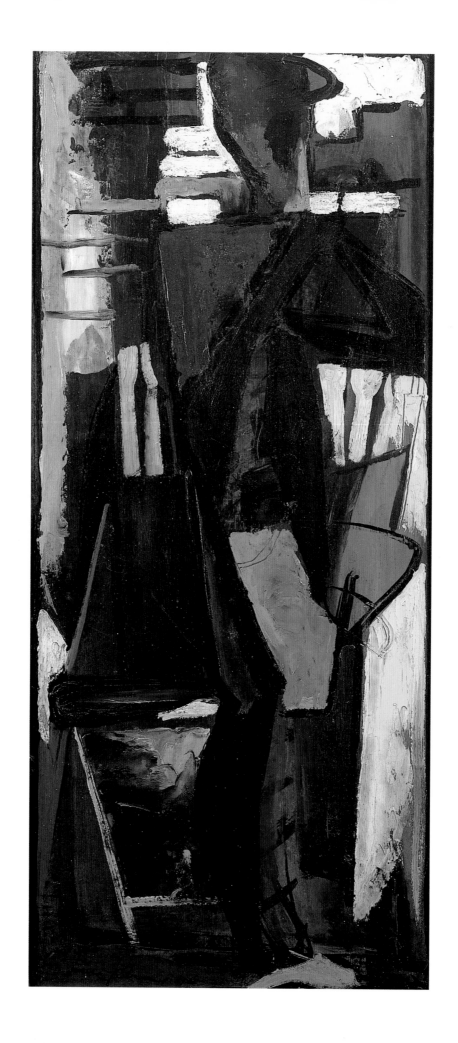

5.

ABSTRACTION

Kline's black and white paintings may burn themselves into our visual memory the moment we see them, but they were not created with that immediacy nor did they result from any spontaneous decision to produce an abstract style. His shift from an amiable, yet retardataire figurative style to a vigorous abstract one was gradual, with the artist carefully but urgently feeling his way. While de Kooning recalls that Kline went to abstraction "all of a sudden, he plunged into it," he also explains that this took a year or so. "Franz had a vision of something and sometimes it takes quite a while to work it out. Then, later on, one has to make a break again. It's very hard to explain. You have to be a painter."[1]

As early as 1945 Kline began to broaden his drawing technique and become more selective of illustrative details. In 1946—47 his taste for the anecdotal in noncommissioned paintings turned toward the anonymous. A belief that all things in a painting merit equal emphasis contributed to this changing attitude about subject matter. An example is *Elizabeth* of 1946 (plate 70), showing Kline's wife seated by a table in the studio. She sits and waits, as much an element in a still life as a table, chair, or teapot. Recognizable only as a woman, not as Elizabeth, the subject is secondary to Kline's composition of fluctuating lines and nondescriptive painted zones. Unlike de Kooning, Kline moved toward abstraction by generalizing his subjects' appearance. Compared to de Kooning's

69. **THE DANCER**, 1946
Oil on Masonite, 22¾ × 10¼ in.
Donald C. Aberfeld

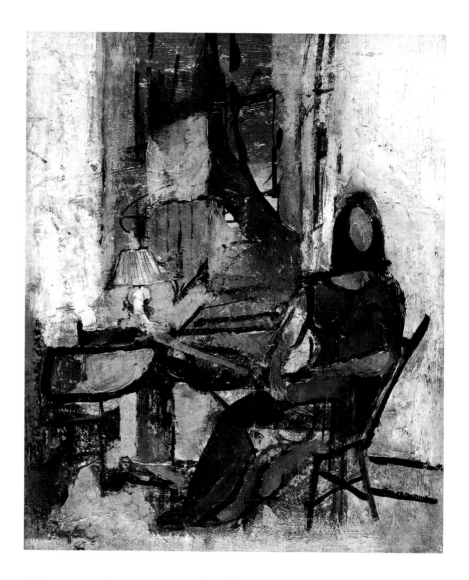

70. **ELIZABETH**, 1946
Oil on canvas, 20½ × 16⅞ in.
Private collection

Women of 1942–44, the figure in *Elizabeth* is a de-
personalized mannequin.

 Stylistic changes did not take place in Kline's paint-
ing and drawing simultaneously. In part, this may have
been due to his limited financial means. To experi-
ment in paint would have cost more than Kline could
afford. He kept oil paint, academy board, and can-
vas for commissioned pictures or for others that he
thought might sell. The difficulty he had in buying
materials is clear from his having painted *Elizabeth*
on the canvas cover of an accounting ledger. Investi-
gating new stylistic possibilities in small drawings
rather than paintings was cheap and satisfied his con-
stant interest in fast sketching.

 A photograph of *Elizabeth* made while Kline
worked on it clarifies how he sought to articulate
mass and space at the same time (plate 71). Forms
are broken into flat planes that are no longer outlined,

as they had been in the preliminary sketch for the painting. Kline extends his attention across the surface of most of the forms. This kind of painting, built on a planar and tonal skeleton, is indebted to Charles Hawthorne's direct-painting principles, to which Kline had been introduced by Henry Hensche in Boston.[2] Discussing composition with Elizabeth in England, Kline had said: "I put something here and here, and here and here, and then I pull it all together." In fact, "pulling it all together" was an expression he used repeatedly in talking about his work.[3] Having approached figurative compositions in this way, he adapted his somewhat casual dispersal and consolidation of shapes to his early abstractions.

Kline's location of a specific field for a sketch —analogous to a surveyor marking off a plot of ground—is emphatically expressed in a sheet of four sketches, each about three inches square (plate 72). Mrs. Kline recalled such drawings from 1947, the year in which she said he began to experiment with abstraction: "I remember series of little sketches of *anything*, figures, cat, furniture, etc. in detail at first and gradually shedding all detail and then representing the subject with a few basic significant lines which retained the idea more than the image."[4] The energy of these drawings is highly concentrated because the agitated forms are enclosed by quickly drawn borders.

Two additional characteristics of these small drawings recur in Kline's mature abstractions of the early 1950s: singleness of image and overpainting. The big form in Kline's art, one mass dominating its space, germinates here. Singularity of image is, however, sometimes accompanied by a contorted rhythm; the form is bound together yet changes direction abruptly. *Figure Eight* is a prime example (plate 73). Its central form pushes to the right at the bottom, turns sharply through the middle of the painting, and at the top seems ready to zoom off to the left. Making small sketches—Kline must have turned out hundre only a few inches across—enabled him to redirect instantly the momentum of his brush in response to impulse. The physical energy needed to produce a drawing

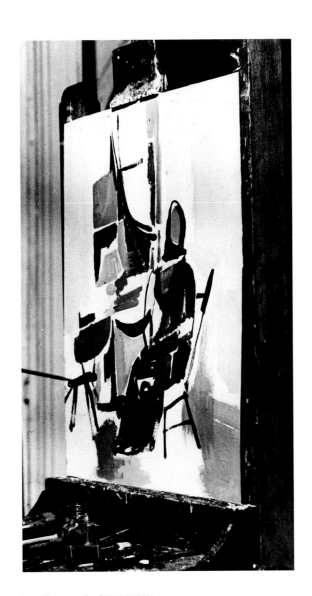

71. Photograph of **ELIZABETH** (unfinished), 1945–46

72. **FOUR STUDIES**, 1945–47
Ink and oil on paper
7¼ × 7¼ in.
Mrs. E. Ross Zogbaum

Below:
73. **FIGURE EIGHT**, 1952
Oil on canvas, 81 × 63¾ in.
Mr. and Mrs. Harry W.
Anderson Collection

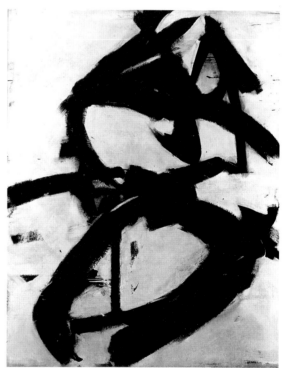

was thus concentrated on a small area, and its potential as an element in a larger painting could be evaluated. Overpainting, present in the sheet of four sketches, appears repeatedly in the 1950s. Many of the whites in *Figure Eight* lie on top of the blacks, some of which Kline let show through intentionally while others have worked to the surface as the painting has aged.

In 1947–48 Kline produced what can best be described as "white drawings" because of their open compositions permitting relatively large areas of paper to show, in addition to extensive white overpainting (plate 76). Several drawings related to this group are dated '48 and bear traces of collage and color. In these Kline has recognized that white and black are coefficients, each with a positive and negative side. Reciprocity of white and black had not been a major interest until now. Before the "white drawings," black had done nearly all the work.

Like Arshile Gorky's long route to a personally valid abstraction, Kline's transition was a slow, multifarious process. Turning out paintings influenced by

artists as different stylistically as Gorky, de Kooning, Seong Moy, and Bradley Walker Tomlin, Kline floundered in incipient abstraction. Ironically, this indeterminate phase had an impact on Jack Tworkov in the early 1950s. Tworkov's *The Bridge* (plate 74) partakes of the piecemeal geometry, black calligraphy, and free brushwork—albeit with fewer color accents—of Kline's untitled collage of c. 1948 (plate 75).

From 1946 to 1949 Kline was jack-of-all-artistic-trades, but master of only one style. Figurative, affable, outmoded, but occasionally vibrant, that style culminated in the 1948 *Nijinsky*. Kline then began gradually phasing out his figurative concerns as abstraction became, for him, the most honest and original way to develop as a postwar artist painting in New York.[5]

According to Kline, *The Dancer* of 1946 was his

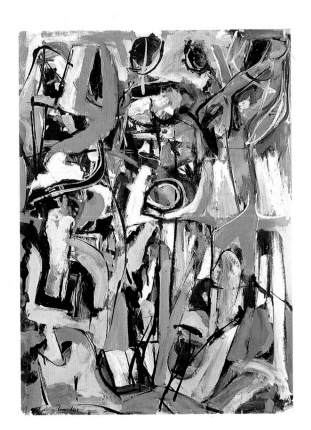

74. Jack Tworkov
THE BRIDGE, 1951
Oil on paper, 25 × 20 in.
Hirshhorn Museum and Sculpture Garden,
Smithsonian Institution, Washington, D.C.

Right:
75. **UNTITLED**, c. 1948
Oil and collage on paperboard
mounted on wood, 28½ × 22¼ in.
Hirshhorn Museum and Sculpture Garden,
Smithsonian Institution, Washington, D.C.

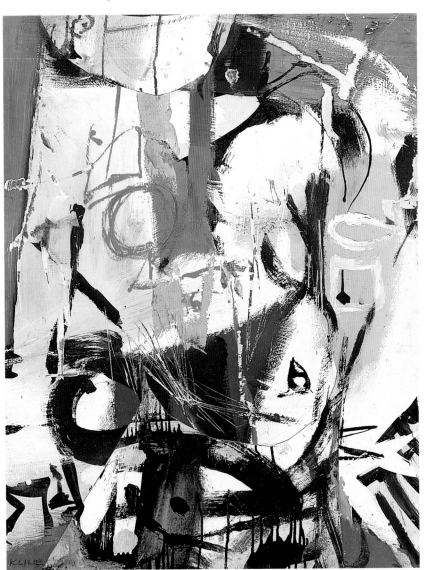

first abstract painting (plate 69).[6] Although more abstract than *Elizabeth* (also 1946), *The Dancer* still has a hold on figurative imagery. A leg, knee to foot, can easily be identified. One senses that something is happening that ought suddenly to ring true in the articulation of planes, in the relationships of value contrasts, and in the interplay of mass and space. However, these various elements do not coalesce as wholly convincing abstraction. When *The Dancer* is seen in the context of Kline's multiple styles of 1946–49, two observations are unavoidable. First, and not surprisingly, it is a planar composition. Pieces overlap in some places and fit together in others, like a self-conscious remake of Synthetic Cubism. Second, some pieces are accented by color, green and yellow above all. These two characteristics —which would not be important to Kline's major abstract works—are of primary interest during this trial and error period of abstraction.

A 1948 photograph of Kline in the Ninth Street studio (plate 79) shows him standing beside his easel looking at an unfinished painting, an assortment of flat shapes—by and large geometrical—in bright orange, yellow, and green with smaller segments in white, brown, and blue. A fantasia worthy of Walt Disney, this work, entitled *Rocker*, reveals how far Kline veered toward a kind of brash Synchromism in

Opposite:
76. **UNTITLED**, 1948
Ink on paper, 30½ × 23½ in.
Brice Marden

77. **UNTITLED**, 1947
Oil on paper mounted on Masonite
23⅛ × 30 in.
Hirshhorn Museum and Sculpture Garden,
Smithsonian Institution, Washington, D.C.

78. **STUDY FOR "THE DANCER,"** 1946
Ink, pastel, and oil on paper, 7 × 3 in.
Collection of
Mr. and Mrs. I. David Orr

Opposite:
79. Franz Kline in his studio at
52 East Ninth Street, 1948

a dauntless attempt to find a viable abstract style.[7] By intensifying hue and enlarging scale, Kline cut this painting adrift from two long-lived aspects of his figurative art: subdued color and easily portable size. *Rocker* (36 by 20½ inches) is not comparable to the big abstractions of the 1950s, but it does indicate that Kline began to enlarge paintings before arriving at a black and white style. His figurative work tended to increase in size at the same time. *Chatham Square* is larger than usual, and the last *Nijinsky* of 1948 is the biggest *Nijinsky*—that is, until the abstract version of 1950.

By 1948 Kline had begun to break through to a new concept of size, as well as of form and color. His dedication to achieving a significant abstract style appears even greater when one recalls the added cost of materials this must have meant. Between 1947 and 1948 Kline decided that abstraction was not just another way to paint. It became the sole chance worth taking. This did not demand an immediate end to his figurative pictures, as long as the possibility existed that they would sell. Neither a romantic about-face nor an intellectual whim, the turn to abstraction was for Kline and his peers a matter of professional integrity.

The Ninth Street photo documents two additional aspects of Kline's art in 1948. He painted on Masonite as well as canvas—*Rocker* is oil on Masonite. This provided a firm surface, a property of the much larger "painting walls" he used in the 1950s. *Rocker* also rests on its side on the easel, pointing out that Kline would turn a painting to consider it from more than one viewpoint.[8] This, too, is characteristic of some later abstractions. *Torches Mauve* (1960), for instance, began as a horizontal painting and only later became a vertical one after proving difficult to finish.[9]

The chief catalyst in Kline's recognition of abstract art was Willem de Kooning, who had met Kline in 1943 at Conrad Marca-Relli's studio near the Pepper Pot on West Fourth Street. Kline had not begun to work abstractly, but de Kooning liked and took seriously his figurative art.[10] Kline, on the other hand, was greatly impressed by de Kooning's "black

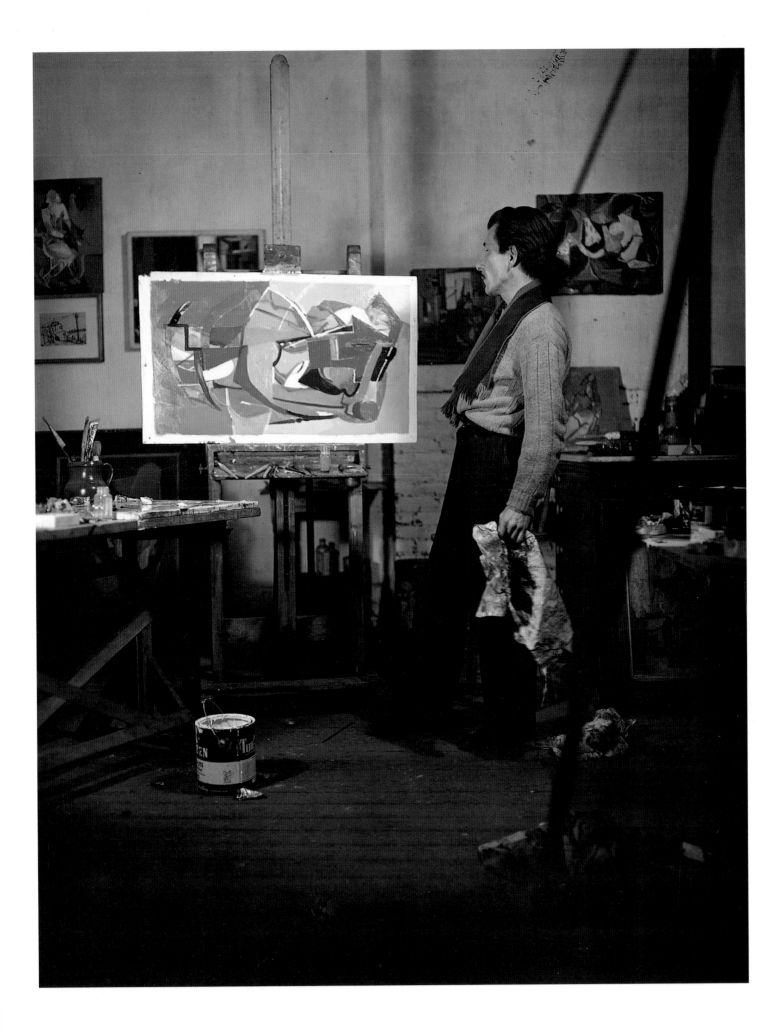

paintings" of 1946–49; their impact on Kline's early abstraction was profound.

One of the first abstract paintings in which Kline tapped his potential for freewheeling expressionism is *Untitled* (*Blue Abstraction*) of 1949 (plate 80). Looping brushstrokes, planar overlays, and paint runs recall de Kooning's *Light in August* (c. 1946) and *Black Friday* (1948). The assemblage of forms, some mashed on top of others, is also comparable to de Kooning's airless packing of black and white shapes. Yet Kline's individual elements are not so tightly compressed, nor is his painting so vertically oriented by the streaking that sets up an erratic rain-on-the-window rhythm in the de Kooning works. Considering Kline's previous quasi-abstract work, *Untitled* (*Blue Abstraction*) is a most ambitious painting. Not only did he play down references to likeness while retaining traces of female anatomy, he also worked in color, using a variety of techniques, from applying paint thickly with a brush or allowing it to run to scraping into the wet surface. At the same time he located forms in a very shallow space while quickening their disparate movements. Kline tackled these problems, moreover, on a piece of Masonite 40 by 30 inches; this provided a firm and ample field, in keeping with his 1948–49 tendency to increase scale.

In an often-cited account, Elaine de Kooning reported Kline's "total and instantaneous conversion" to abstraction and how his "style of painting changed completely" after he saw some of his drawings enlarged by "a friend" using a Bell-Opticon.[11] The friend was Willem de Kooning and the drawings were projected on the wall of his studio at 85 Fourth Avenue in 1948 or 1949.[12] (De Kooning had borrowed the Bell-Opticon for a few days to enlarge some of his own sketches.) While important to Kline, this event must be seen in the context of his previous moves toward a totally abstract mode and a larger size in both his figurative and abstract paintings. It can only have affirmed, not initiated, his ideas. The projection of his black and white drawings would have been more significant for helping him recognize that black and white could stand alone at the scale of a

80. **UNTITLED (BLUE ABSTRACTION)**, 1949
Oil on Masonite, 40 × 30 in.
Worcester Art Museum;
Gift of William H. and Saundra B. Lane

painting rather than a drawing. Again, this simply corroborated Kline's perennial interest in black and white, already stimulated in a different way by de Kooning's abstractions.[13]

If the Bell-Opticon made Kline aware of the potential for enlargement, he did not develop it fully until painting the 1949–50 canvases that made up his first one-man show. Painting freehand and without a projected image, he would enlarge on canvas a configuration first drawn in a sketch. He used this technique throughout his career as an abstract artist. Richard Diebenkorn, who visited Kline in 1953, recalls: "I was impressed that the several current large paintings in his studio were exact blow-ups of very small sketches (telephone-book pages), accidents and all. I was surprised, having assumed that his ideas evolved in terms of the scale and size of his canvases."[14] One of Kline's last and largest paintings, *Riverbed* (1961), was originally a few strokes of the brush on a piece of paper roughly 10 by 11 inches.

Another influence on Kline's transition to abstraction was Bradley Walker Tomlin, whom Kline had met by late 1949. In November or December, Kline built a partition of two-by-fours and plasterboard for Tomlin and Philip Guston in their studio-loft on University Place. (Guston had met Kline months before at the Cedar Bar and heard that he had tools and did carpentry.)[15]

81. **BLACK AND BLUE**, 1949
Oil on canvas, 19 × 37½ in.
William H. Lane Foundation

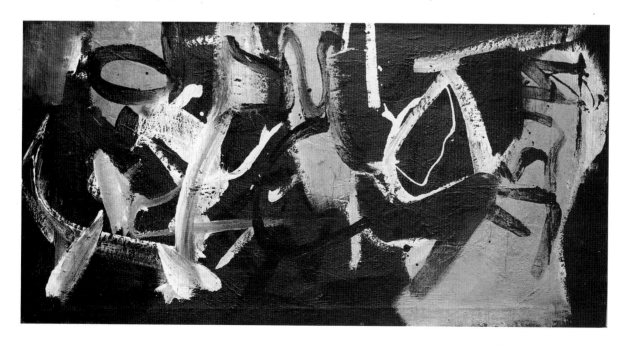

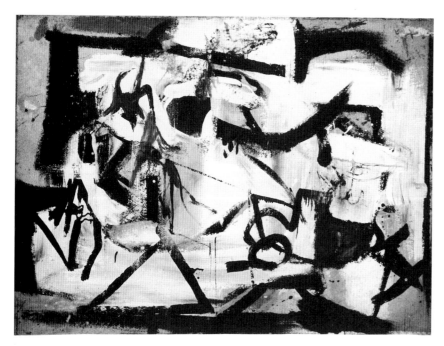

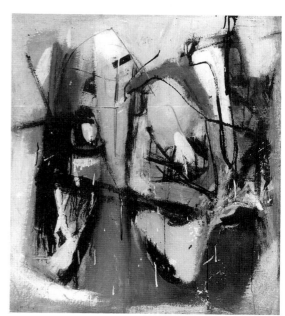

82. **GRAY ABSTRACTION**, c. 1949
Oil on beaverboard, 31¼ × 41 in.
William H. Lane Foundation

Below:
83. **PAINTING**, 1950
Oil on canvas, 37¾ × 34½ in.
Private collection

Black and Blue (plate 81) indicates Kline's familiarity with Tomlin's energetic calligraphic abstraction —for example, *Small Wind Disturbing a Bonfire* (1949)—which lacks the claustrophobic pressure of de Kooning's black and white works from the same period. Kline's *Black and Blue* is lighter in color, forms, and mood than paintings by either Tomlin or de Kooning. As for the disposition of forms, which seem to be levitating rapidly to the top of *Black and Blue*, this was a decision Kline made after "completing" the painting. He cut the painted canvas along what is now the upper edge and stapled it to a stretcher, thereby pulling the forms closer to the top. Tomlin's forms, in contrast, are distributed fairly evenly across the surface. While Kline may have adopted Tomlin's resiliency of strokes painted with a one- or two-inch brush, he did not take over Tomlin's spreading, yet balanced composition. It was Tomlin's virtuoso handling of the brush in letting strokes stand unreworked, expressive largely because of their succinct declaration of unexpected changes in direction, velocity, and texture, that was crucial to Kline's resolution of tendencies in his own developing style.

Kline had used color to work his way toward abstraction on a generous easel-painting scale. In 1949, however, color became something to paint against. With a few patches of blue, *Gray Abstraction* (plate

82) remains primarily a black and white painting; the light brown beaverboard showing through the paint actually supersedes as color the dark blue tending toward black. (Kline may have originally used the beaverboard as a table top for holding paint cans. Marks and smudges appear to have preceded the abstract brushwork.) The next step was to extinguish color completely.

Kline's first one-man show took place October 16–November 4, 1950, at the Egan Gallery, 63 East 57th Street.[16] Color rarely surfaced in the eleven abstractions: brown underpainting near the bottom of *Nijinsky* and traces of green in *Leda*. The paintings displayed a variety of images and moods: the geometric austerity of *Wotan* (plate 89), the tentative, weblike balance of *Giselle*, the taut sharpness of *Cardinal*. In spite of this range, the canvases shared one feature that they proclaimed openly, if not in all cases loudly: they were black and white. Other details might slip away from the viewer's memory but not the indelible afterimage that these were made of black and white paint.

Kline's dynamic welding together of opposites so that black and white depend on each other in equal

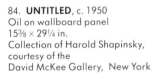

84. **UNTITLED**, c. 1950
Oil on wallboard panel
15⅜ × 29¼ in.
Collection of Harold Shapinsky,
courtesy of the
David McKee Gallery, New York

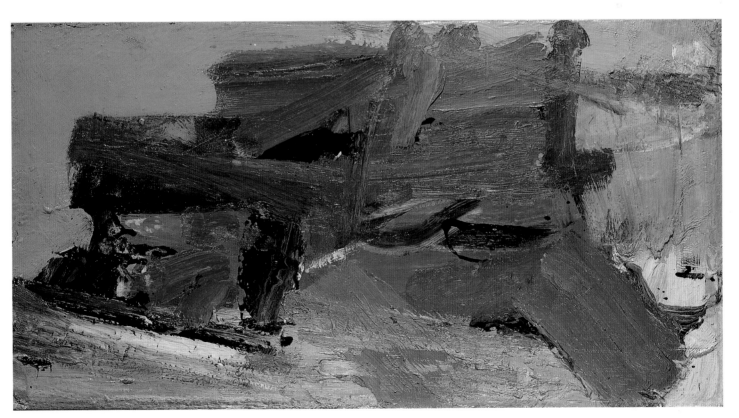

measure created such an emphatic impression that it persisted the rest of his life. Thirteen years earlier in London, he had called himself a "black and white man," but not until his first one-man show did the aptness of that phrase become obvious to others. Because of his paintings' impact, Kline was immediately dubbed "the black and white artist." The label stuck, and in later years he would at times feel restricted by it. At a party when Sidney Janis was his dealer, Kline referred to the necessity to produce always black and white paintings and remarked: "They won't let me leave the harbor."[17] His first one-man show marked the nearly simultaneous beginning and end of his major invention as an abstract artist. At the age of forty, he secured a unique, personal style. He also mastered it at once, based upon years of drawing. Its viability was almost completely limited to extending and rearticulating the essential tensions between black and white. Moving on meant, ultimately, going back into color, the direction Kline was headed at the time of his death.

Egan had known Kline's work for some time but felt that as an artist he didn't "boil" until 1950.[18] While Kline was upstate for a couple of weeks in August, Egan visited the Ninth Street studio, looked at some black and white paintings and decided to give him a show that fall.[19] Kline's long-time patron, David Orr, helped back the show with a $300 grant to the artist.[20]

This was not the first time that abstractions by Kline had been exhibited at an uptown gallery. In May he had been one of twenty-three artists showing one example each in *Talent 1950* at the Kootz Gallery. Clement Greenberg and Meyer Schapiro chose the work. "We rescued Kline," Greenberg recalls. "His paintings were bad, but he did good drawings."[21] At the time, Kline expressed surprise to the artist John Ferren, who lived in the same building, that Greenberg had liked his black and white work.[22]

Evaluating *Talent 1950*, Tom Hess wrote: "It all adds up to one of the most successful and provocative exhibitions of younger artists I have ever seen. And not the least part of the excitement comes from the fact that almost all the works have never been

85. **STUDY FOR "CARDINAL,"** c. 1950
Ink on paper, 7¾ × 6 in.
Mr. and Mrs. Lee V. Eastman

Overleaf:
86. **UNTITLED**, c. 1950–52
Oil on telephone-book page
9¼ × 11 in.
Mr. and Mrs. Lee V. Eastman

shown before and are by unrecognized talents. . . ."[23] Mentioning paintings by Robert Goodnough, Larry Rivers, Esteban Vicente, he added: "Other pictures I admired equally are by Friedbald Dzubas, Harry Jackson, Franz Kline and Elaine de Kooning."

Kline's 1950 abstract paintings were based on drawings made on pages of telephone books (plate 86). He used these, rather than drawing paper, because they could be picked up for nothing. (Robert Goldwater pointed out that the print pattern on these pages "prevents any mistaken perspective recession," perhaps another reason Kline liked them.[24]) From time to time Kline looked through these telephone-book drawings, which were stacked by the hundreds in a corner. Selecting one that he felt would work as a painting, he pasted it to a piece of cardboard. Then, either tacking the drawing beside a canvas or holding it, he followed it closely, painting directly.[25] An image was usually not transferred with any grid system. One painting in his 1950 show, *High St.*, may have passed through a grid stage, as indicated by a drawing on graph paper, but it began as a telephone-book sketch and remains closer to it than to the slightly attenuated and more refined graph paper example.

In 1950, as during most of his life, Kline liked to paint at night, after the distractions and noise of the day and evening. Ferren remembered that he always kept late hours, sleeping in the daytime.[26] Emmanuel Navaretta, who shared Kline's loft for about eleven months in 1950, would sometimes wake up at 7 a.m. and find him still painting.[27] A 1950 photograph of Kline's studio taken before his October show illustrates that he worked under a strong ceiling light aimed at his painting wall, made of Masonite or homosote supported by two-by-fours (plate 87).[28] Painting under artificial light at night intensified contrasts between black and white, reflecting the glossy texture of the black and giving the white a sheen. The even distribution of light on the painting wall was commensurate with Kline's allover focus directed across an entire canvas. Beginning a new work, he would envision a small sketch amplified many times;

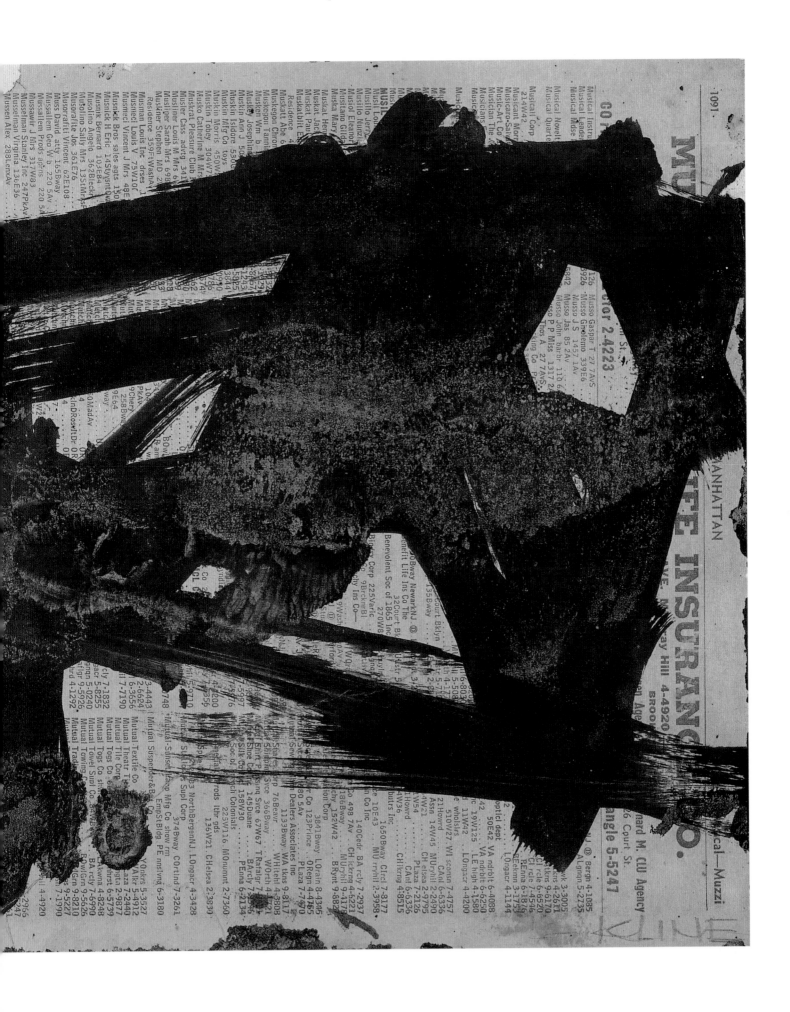

realizing that visual conception required an evenness of attention across the canvas in front of him. A legacy of the Bell-Opticon is suggested in that the strong light helped bring big images into being, burning away the gray rows of type from a telephone-book page.

Cardinal, tacked on its side on the painting wall, is partially visible in the photo; it would not be stretched until completed and dry, a method Kline continued throughout the 1950s.[29] Also visible in the studio are two unfinished paintings, which undoubtedly contained color. While working on *Cardinal*, one of his most tightly wound black and white compositions, Kline kept the color option open; he also painted a few figurative color pictures in 1950. A major example, *Wild Horses*, indicates that he was far more interested at this point in expressionistic configurations that emphasized the flatness of the canvas than in preserving easily recognizable naturalism. Forms do not register as horses until after one senses the exigencies of paint.

A newspaper sheet covered with black paint runs and pinned to the studio wall (plate 88) may have

87. Franz Kline's studio at
52 East Ninth Street, fall 1950

been the source for images carried over, perhaps through drawings on telephone-book pages, to early black and white paintings. Hess suggested that this may have been an *objet trouvé*, first used by Kline for wiping a brush and setting down a wet paint can or lid.[30] The open circle and solid triangle are primary forms in *Hoboken*, another painting in the 1950 show. On the newspaper it is interesting to note the extent of "white" or unprinted space and how the greatest concentration of paint covers the largest printed area. The grayest surface has been canceled by the biggest black shape, which functions as both the most positive and negative element on the page.

Balancing his repertoire of circles, triangles, and wedges, Kline occasionally resembles a juggler, an acrobat in paint, especially when cantilevering shapes from only one or two sides of a painting without weakening their structural groundings. From his first one-man show on, paintings with two or more shapes are not dominated by a single overbearing form. Reciprocity, not autocracy, is the principle governing the community of shapes in a Kline abstraction. Naturally, this is not true when a painting has but one shape, with *Wotan* the supreme example.

Kline prepared for his one-man show earnestly, designing the four-page brochure and working hours on lettering his name. Struggling with it again and again, he said to Navaretta: "I haven't got a signature."[31] He also framed his paintings, covering the stretchers' edges with thin metal strips. Thinking up painting titles, he had help from the de Koonings, Charles Egan, and Navaretta, who named *Hoboken*. They sometimes went to Hoboken to eat fish and Kline liked the name.[32] The word also had earlier associations for Kline: the murals he had painted in Hoboken in 1939–42. Kline had an eight-hour naming session with the de Koonings and Egan. It was "in a spirit of levity with a bottle of Scotch on the table."[33] Veto power was agreed on. If one person didn't like a title, even though the others did, it couldn't be used.

Elaine de Kooning has noted that *Chief* and *Cardinal* were names of trains that Kline remembered.[34] *Clockface* came from a reference to the clock

88. Oil sketch on the
July 16, 1950, *New York Times*

Overleaf:
89. **WOTAN**, 1950
Oil on canvas mounted on Masonite
55⅛ × 79⅜ in.
Museum of Fine Arts, Houston;
Museum purchase by exchange

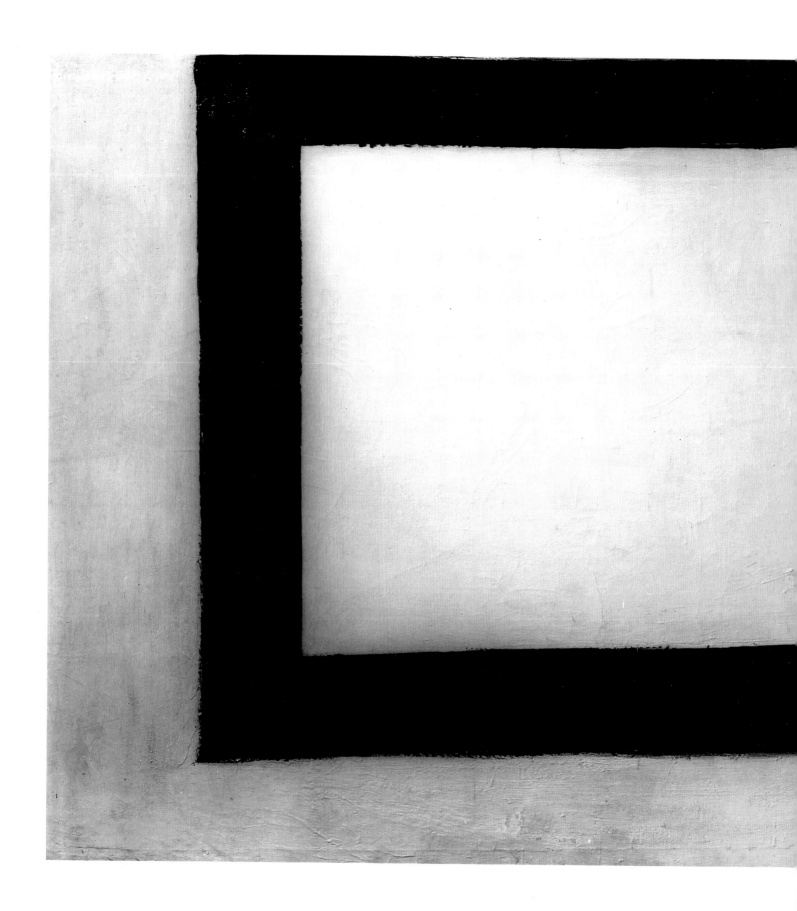

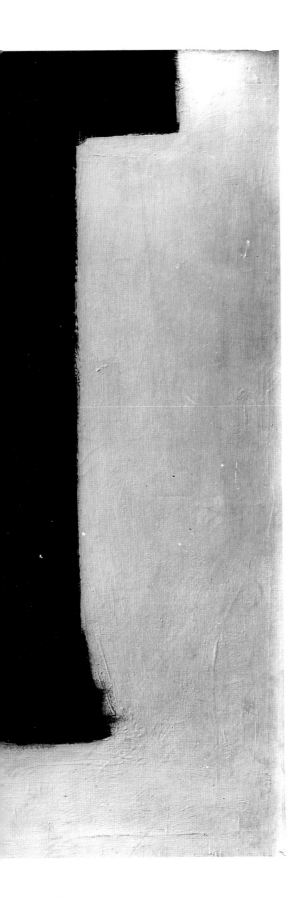

on Wanamaker's Department Store.[35] *High St.* is a subway stop in Brooklyn and may derive from the fact that Franz and Elizabeth lived there in 1945. *Wyoming*, a county in eastern Pennsylvania, was also the name of a 1940 film with Wallace Beery and Leo Carillo, which Kline could easily have seen.[36] *Nijinsky* was homage to the great dancer and Kline's long fascination with Petrouchka. *Giselle* also grew out of his familiarity with ballet. Moreover, Sadler's Wells Ballet, on its first U.S. visit, performed *Giselle* with Margot Fonteyn and Moira Shearer alternating in the title role at the Metropolitan Opera House, two weeks or so before Kline's show opened.[37] A form in the painting suggests the moss-covered cross traditionally on stage during *Giselle*'s second act. A similar association of title and image is possible with *Leda*, in light of the bird- or winglike form at the bottom. The relationship between *The Drum* and its title is also made obvious by the image.[38] *Wotan* originated in Kline's love of Wagner and his recognition of the one-eyed head of the gods. Kline frequently listened to Wagner while working, sometimes playing *Götterdämmerung* on the phonograph at five in the morning.[39]

Included in the show were a number of small studies and untitled drawings priced $50 to $100, which Egan kept in a portfolio. The paintings were priced around $700, the amount paid for *Chief* by art collector David M. Solinger who, along with Alfred H. Barr, had been impressed with Kline's work. Wishing to acquire a painting for the Museum of Modern Art, they narrowed their choice to *Cardinal* or *Chief*, finally deciding on the latter.[40] In spite of this "official recognition," *Chief* and *Leda*, bought by G. David Thompson, were the only paintings sold.[41]

Criticism of the show was not as hostile as might have been expected. Certainly this was due in part to Kline's late arrival as an abstract painter—after Gorky, Pollock, and de Kooning. Several critics cautioned that Kline's paintings didn't survive their initial impact. His imagery, likewise, was read as blown-up Far Eastern calligraphy or indecipherable symbols. Each critic, however, recognized at least

one positive element in Kline's art. Writing in the *Nation*, Manny Farber exemplified most critics' pro-con appraisal: "[Kline] achieves a malignant shock that is over almost before it starts. The first impression...is refreshing. A heroic artist achieves a Wagnerian effect with an almost childish technique. It is the blunt, awkward, ugly shape that counts, not finicky detailing or complication. But these yawning white backgrounds and hulking black images hide a nimble rather than a primitive craftsmanship, clever at making facetious emotion appear morbidly violent and suave brushing seem untrained."[42]

By 1950 Kline was a mature abstract artist involved with the elemental: black and white *and* geometric shape. These would persist, moreover, throughout his career. Circles or ovals appear in *Clockface*, *Chief*, *The Drum*, and *Hoboken*, where a circle is played against a triangle. *Clockface* also contains a circle, lozenge, and modified rectangle. During the early 1950s, Kline was drawn most often to the open rectangle or square. As well as bracing the bottom half of *Clockface*, it appears in *Nijinsky, Leda, Giselle*; sets up a resilient armature at the center of *Cardinal*; and prevails as a solitary eminence in *Wotan*.

Kline was more concerned with the square as a vector of human emotion than any other Abstract Expressionist. Through proportion, flexibility of brushstroke, and density of paint, he pushed the square beyond singular geometry to a variety of direct emotional statements.[43] His embracing the open

90. **UNTITLED**, c. 1950–52
Oil on rag drawing paper
10 × 8½ in.
Collection of Robert Motherwell

Right:
91. **UNTITLED**, 1951
Oil on canvas, 25¼ × 42 in.
Montana Historical Society,
Helena; Poindexter Collection

96

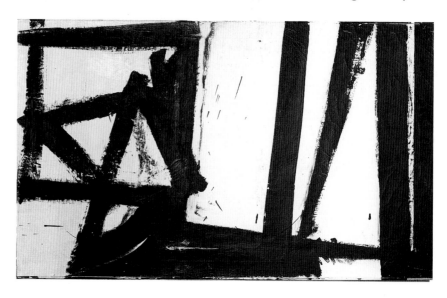

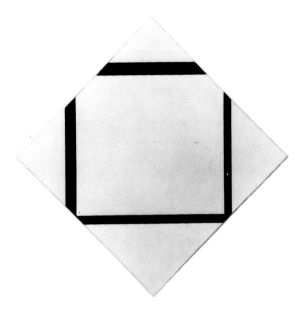

square as a visual fact of life, rather than a philosophical construct, had an impact on younger artists in the late 1950s and '60s. Although insisting on aesthetic distance from the square or rectangle, Frank Stella and Eva Hesse, among others, retained the framelike, open-centered nature of Kline's basic form.[44] Compared tellingly with *Wotan* are Stella's *Tomlinson Court Park (Second Version)*, of 1959, and Hesse's bandaged wall-sculpture *Hang-Up*, of 1965–66.

Precedents for the open rectangle were available to Kline in Picasso's paintings of the late 1920s, such as *The Studio* (1927–28), which hung in the Museum of Modern Art. He may also have known Paul Klee's *The Cupboard* and *Kettledrummer* of 1940, although the claim that MoMA's 1949–50 Klee exhibition had an "immediate and decisive" impact on Kline must be viewed with as much skepticism as the Bell-Opticon "instantaneous conversion" theory.[45] Mondrian's *Composition 1A* (plate 92) is a more likely catalyst for his recognition of the open square's rich visual potential. This black and white work, in Hilla Rebay's collection, was shown in late 1949 at the Janis Gallery.[46]

A more contemporary influence came from Adolph Gottlieb's *Romanesque Façade*, a 1949 "pictograph" with an open black square (plate 93).[47] (Although not identical, a Kline telephone-book sketch closely resembles this detail.) Already aware of the open square in Mondrian, would Kline have excised it as a detail from Gottlieb's canvas and, by varying format and enlarging scale, transformed it into such self-sufficient works as *Leda* and *Wotan*? An affirmative answer is suggested by an untitled 1950 painting that was created through a parallel process (plate 94). Resonating with a sculptural presence far exceeding its size, the image of lozenge and black bar derives from an unlikely and diminutive source: insignia for the Black Diamond drawn under the train's name on the back of a manila envelope (plate 52).

Josef Albers offered another source for Kline's adoption of the square as a major leitmotif. In February 1949 two Albers shows ran simultaneously at the

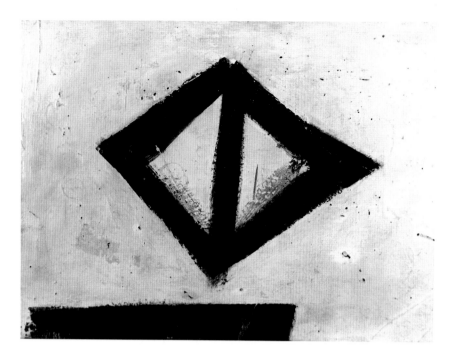

94. **UNTITLED**, 1950
Oil on canvas, 17⅞ × 23¾ in.
Mr. and Mrs. Burton Tremaine,
Meriden, Connecticut

Egan and Janis galleries, with early black and white works in the Egan section.[48] Speaking of Albers, well known for his *Homage to the Square* series, Kline remarked: "It's a wonderful thing to be in love with The Square."[49] While Albers dedicated himself to the square as an austere if ubiquitous form, Kline turned it into an active shape that elbows its way into space. Since high school he had drawn figures and objects to make them unequivocal in shape and location. This ability was now adapted to his abstractions. The open squares have as much substance as did the objects in his figurative drawings. They also have as much —and sometimes more—personality. Kline once said, "Two squares can be two of the saddest eyes in the world."[50]

As Nijinsky had persisted in Kline's representational art, so the square became the form permeating his abstraction. Throughout his eleven years as a major abstract painter, it was, variously, confronted, skirted, stretched, and pushed off stage. Up-front in *Suspended* (1953) and *Palladio* (plate 15), it roars through *Heaume* (1958), or waits around the corner in *Bethlehem* (1959). It was even colored, c. 1952, and turned sour yellow, an unsuccessful experiment that weakened the square's physicality and flattened its poetic reverberation.

When asked in 1961 what had happened to the

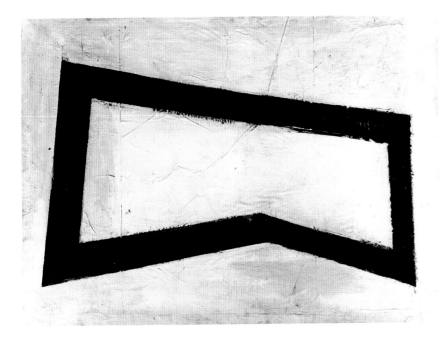

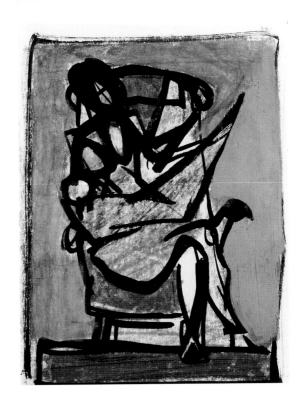

95. **UNTITLED**, c. 1951–52
Oil on paper mounted on
honeycomb panel, 32 × 44 in.
Solomon R. Guggenheim Museum,
New York;
Gift of The American Art Foundation, 1980

Below:
96. **SEATED FIGURE**, c. 1947
Ink and crayon on paper
8¼ × 6½ in.
Collection of
Mr. and Mrs. I. David Orr

"enclosed rectangle" from his early paintings, Kline replied: "The rectangular areas are still there if you look closely. It's just that my paintings have become looser, freer, I suppose, in recent years, so the edges are not always as clearly defined."[51] His last painting, the deeply moving blue *Scudera* (plate 2) incorporates a variation on the square.[52] Astonishing is the transcendent spirituality of a work whose central form is a ragged-edged square, essentially the same shape that had appeared years before in Kline's first one-man show.

Along with *Wotan*, Kline's bent black trapezoid in *Untitled* of c. 1951–52 is his most "minimal" image (plate 95). A flatly painted, well-aged surface undercuts the form's intimation of perspective. Kline may have pared the form down from his own quasi-abstract work. For example, a bent black outline reads as an open newspaper in *Seated Figure* (c. 1947, plate 96) while a similar shape appears in another wholly abstract drawing from the same period. Not to be overlooked are visual parallels between Kline's open black "frame" and the logotypes of popular products such as Champion Spark Plugs and neon signs for name-brand beers.

Adding to the complexity of *Untitled* (c. 1951–52) is the fact that it hung vertically in the Fourteenth Street studio.[53] The painting still belonged to Kline at the time of his death, and he may not have determined

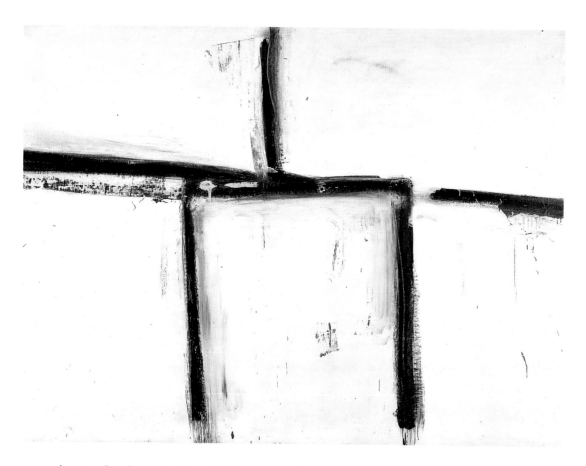

conclusively that it should hang only one way. If so, this would not be the sole instance of his ambivalence about a painting's orientation. *Untitled* (1954, plate 98) and *Four Square* (1956, plate 100) could hang horizontally or vertically, although for both Kline preferred vertical orientation.[54] The back of *Le Gros* (1961, plate 141) is signed and dated one way, but arrows, the word *top*, and the title printed beside the artist's name on the stretcher indicate the opposite. One concludes that in this case Kline changed his mind, deciding finally that the work should hang one way. Such ambivalence stemmed from turning paintings while at work on them, a common practice among artists including de Kooning and Rothko.[55]

Continuing to articulate geometric shapes in paintings for his second one-man show, in 1951, Kline began to push black and white imagery in several directions. Works totally different in appearance, such as the lean *Painting No. 11* (plate 97) and the dense *Ninth Street* (both 1951), project sculptural qualities. Black forms with clearly defined edges seem cut from an otherwise constricting space, but heavy paint application and scraping binds them to

97. **PAINTING NO. 11**, 1951
Oil on canvas, 61½ × 82¼ in.
Richard E. and Jane M.
Lang Collection,
Medina, Washington

Opposite:
98. **UNTITLED**, 1954
Oil and house paint on canvas
83⅛ × 66¾ in.
Donald B. Marron Collection

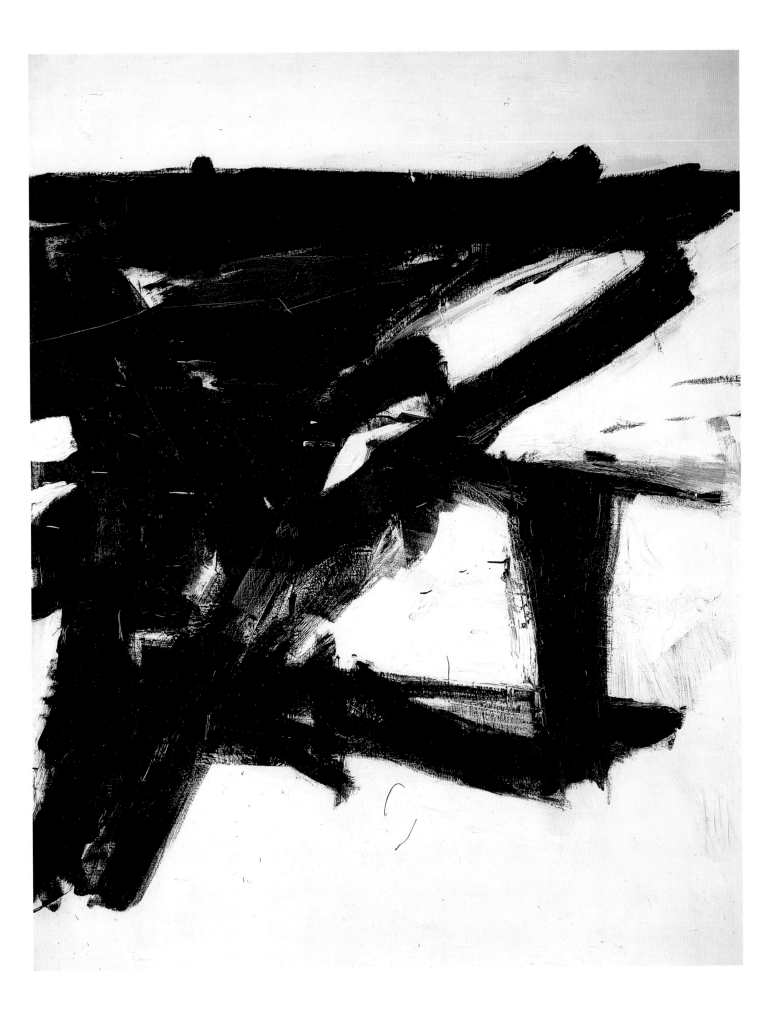

the surface. Herein lies a major tension in Kline's art. Sculpturally solid shape, apparently capable of existing in the three-dimensional world, is held in check by paint layering that negates any illusion of actual space. Well-built and tough-minded contemporary sculpture, particularly that by Mark di Suvero, obviously relates to Kline's stark images. "A rough wooden beam became, in di Suvero's art, the near perfect analogue of the wide brushstroke in the painting of Kline and de Kooning."[56] On the other hand, Kline's sculptural proclivity was limited to painting. Except for a modeled head and small soap carving of a man (plate 164), both from the mid-1940s, he made no sculpture.[57] Even so, having been taught as a student in London to draw like a sculptor, he painted like a sculptor from 1950 to 1957—and even later —hacking structures and figural surrogates into being through the impacted spaces of his canvases. Visible in Kline's blunt, yet enigmatic images, this sculptural process is also reflected in titles of such paintings as *Tower* (1953), *Buttress*, and *Hewn Forms* (both 1956).

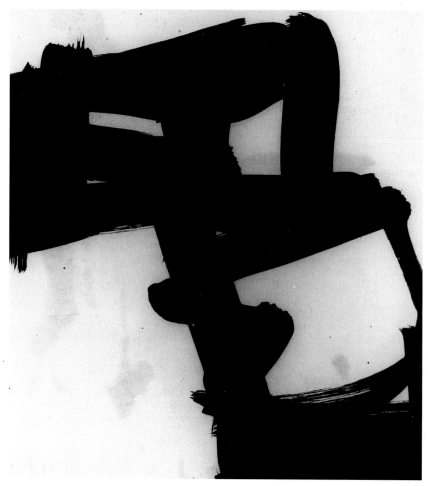

99. **UNTITLED**, 1953
Oil on paper, 8 × 8¾ in.
Betty and Stanley K. Sheinbaum

Opposite:
100. **FOUR SQUARE**, 1956
Oil on canvas, 78¾ × 50¾ in.
National Gallery of Art,
Washington, D.C.;
Gift of Mr. and Mrs. Burton Tremaine

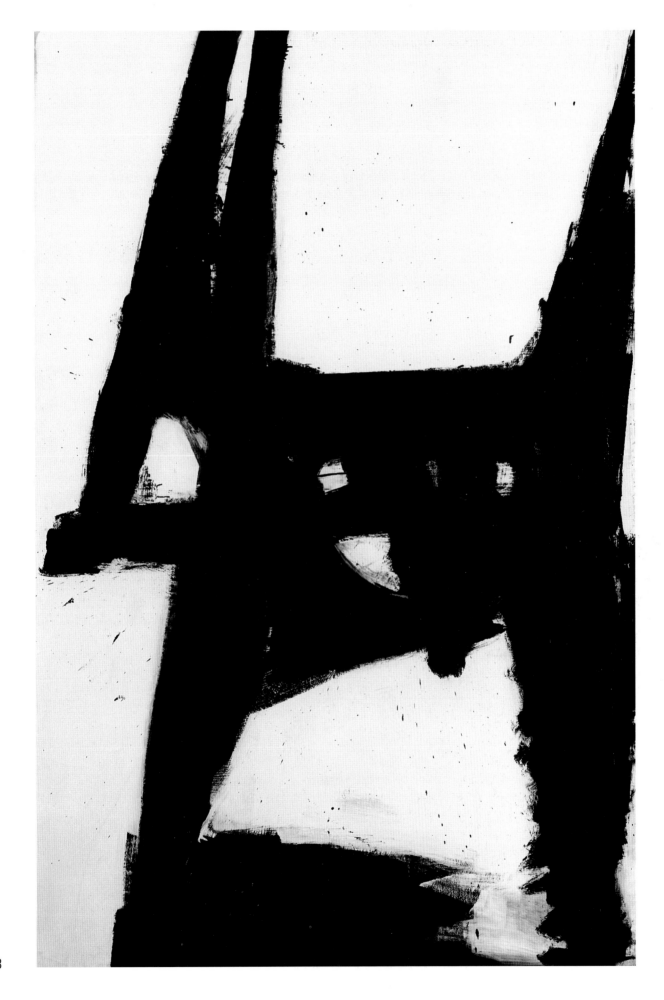

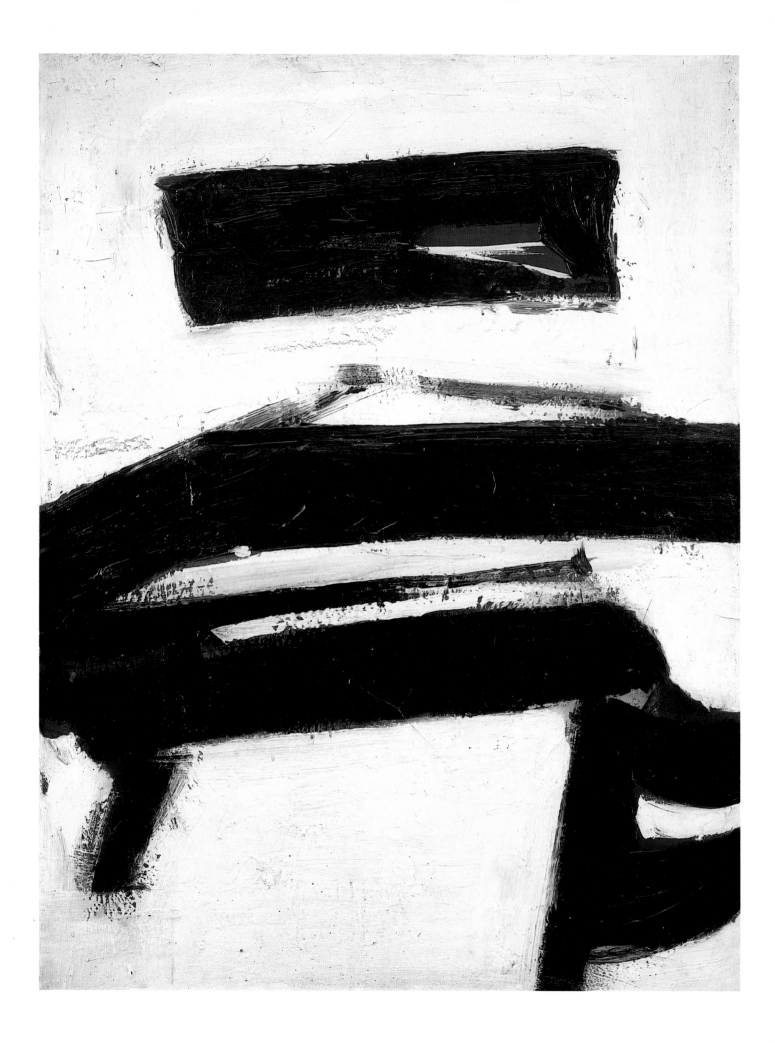

6.

BEYOND ABSTRACTION

Kline's seemingly abstract imagery often contains figural presences, as Frank O'Hara observed in 1958: "These personages which are at the same time noble structures (*Cardinal, Elizabeth, Siegfried*), these structures which are at once tragic personages (*Wanamaker Block, Bridge, C & O*), seem both to express and to live by virtue of the American dream of power, that power which shuns domination and subjection and exists purely to inspire love."[1] Of course, personages do not inhabit all of Kline's paintings, and one could easily take issue with some of O'Hara's examples as well as with his syrupy interpretation. Yet even *Painting No. 11* (plate 97), a rigorously abstract canvas, brings to mind a schematic figure and a desolate landscape. Indeed, a similar black image occupies the upper-left corner of a 1948 painting, *Lehigh River Bed*. Kline simply extracted, enlarged, and streamlined the form three years later. Another 1951 work, *Black and White* (plate 101), at first appears totally abstract, its hardy substructure topped by a floating black-brown rectangle. In fact, the painting was originally a study of Nijinsky; Kline suggested that it be titled *Black and White over Brown—Torso.*[2]

Like other Abstract Expressionists, Kline felt no need to explain or defend his work, although he did offer a key to the meaning of his images in a 1955

101. **BLACK AND WHITE**, 1951
Oil on canvas, 44 × 34 in.
Courtesy Sidney Janis Gallery,
New York

statement for the Whitney Museum's exhibition, *The New Decade*:

> Since 1949...I've been working mainly in black and white paint or ink on paper. Previous to this I planned painting compositions with brush and ink using figurative forms and actual objects with color. The first work in only black and white seemed related to figures, and I titled them as such. Later the results seemed to signify something —but difficult to give subject or name to, and at present I find it impossible to make a direct, verbal statement about the paintings in black and white.[3]

Kline's reference to figures in the early black and whites implies human presences, a phenomenon veri-

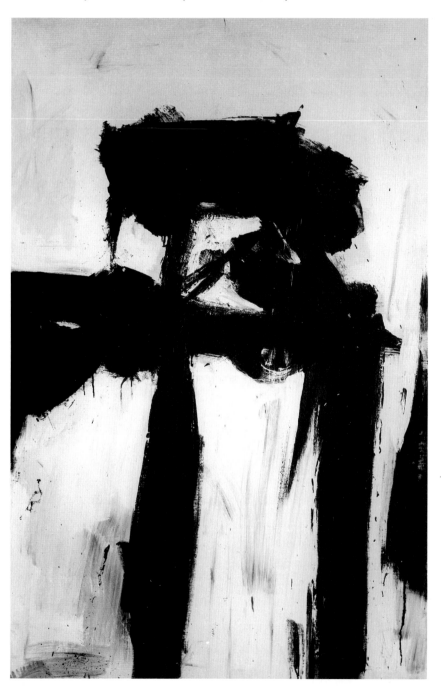

102. **FIGURE**, 1956
Oil on canvas, 71 × 44½ in.
DeCordova Museum,
Lincoln, Massachusetts

Below:
103. **STUDY FOR "FIGURE,"**
c. 1956
Oil on paper, 10 × 7½ in.
Norman P. Joondeph

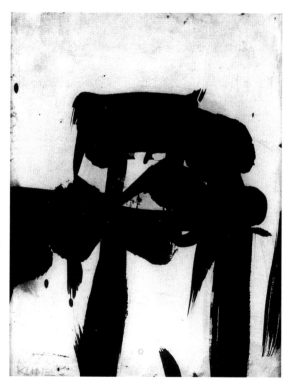

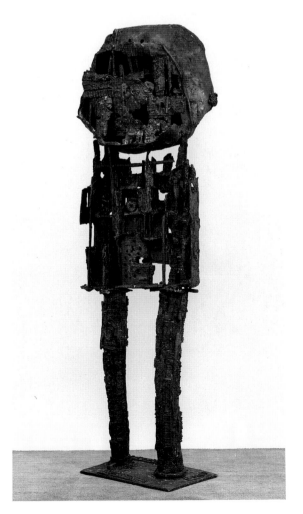

104. Eduardo Paolozzi
ST. SEBASTIAN, NO. 2, 1957
Bronze, height: 84¾ in.
Solomon R. Guggenheim Museum,
New York

fied by the viewer's confrontation or empathy with certain images. Not all paintings in his three Egan shows evinced figural abstraction, but a great many did. Just as important is the persistence of figure-laden imagery in Kline's late work, 1960–61. Indicative of the artist's own perception of figural forms in his abstract work is his description of a pair of black rectangular shapes side-by-side in *Untitled* (plate 105) as "two wounded lovers."[4]

In the early 1940s Pollock had created such figural abstractions as *Male and Female, Pasiphaë,* and *Gothic,* problematic descendants of Surrealism. De Kooning's figural abstraction was also a response to Surrealism by way of Gorky and Picasso, as in *Pink Angels* (c. 1945) and *Attic* (1949). However, Kline's figural presences differ from Pollock's and de Kooning's in both appearance and process. They also derive directly from Kline's background in drawing, rather than from any response to Surrealism —Kline was less influenced by Surrealism than any other major artist of the New York School. Indeed, one can conceive of his abstraction without Surrealism as a precedent, impossible for work by his contemporaries.

Figural abstraction constitutes one of the largest categories of Kline's imagery, equaled only by architectonic abstractions with urban or landscape overtones. His figural compositions range in scale, mood, and degree of abstraction. *Crow Dancer* (1958), for example, began as a horizontal painting with limited figural associations. Turned upright, however, the matte black image assumes a clodhopper identity, more abstract yet akin to those dumb but fiendish stumblebums in Guston's late pictures. Most recognizably intact, *Figure* (1956, plate 102) conjures up totems attending some primordial rite. Battered and hardbitten, *Figure* also displays strong sculptural qualities comparable to Eduardo Paolozzi's tottering iconic robot, *St. Sebastian, No. 2* (1957, plate 104). Yet while Paolozzi's fusing of the frightening and the mechanical generates a serviceable mutant, Kline's creature is more provocateur than icon—a stand-in for Ulysses in Nighttown. Seeing the *Study for "Figure"*

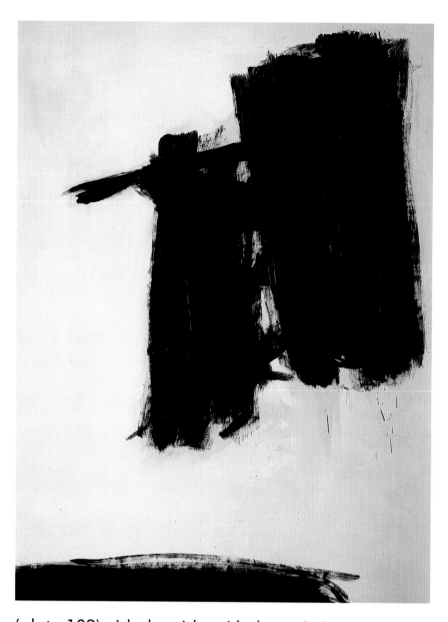

105. **UNTITLED**, 1960
Oil on canvas, 79 × 60 in.
Mr. and Mrs. Lee V. Eastman

Opposite:
106. **STUDY FOR "FLANDERS,"** 1961
Ink and oil on paper, 9 × 7⅛ in.
The Metropolitan Museum of Art,
New York;
Gift of Renee and David McKee, 1984

(plate 103) side-by-side with the painting points up how closely Kline followed the small sketch, but also altered crucial details. Stretching the image and elongating overall proportions literally heightens its humanoid presence. On one level—the comic, which is not as remote from Kline's figural abstractions as a cursory viewing might suggest—the distinction between the study and final painting suggests a *Star Wars* encounter between C-3PO and R2 D2.

Year after year Kline's figural surrogates formed a nearly continuous parade of intense personalities, staggeringly varied in character. One of the most accessible and memorable fills *Study for "Flanders"* (1961, plate 106), an ensnared form that inevitably recalls crucifixion. Remarkably, the study transcends in emotional impact the larger, stirring, but sleeker

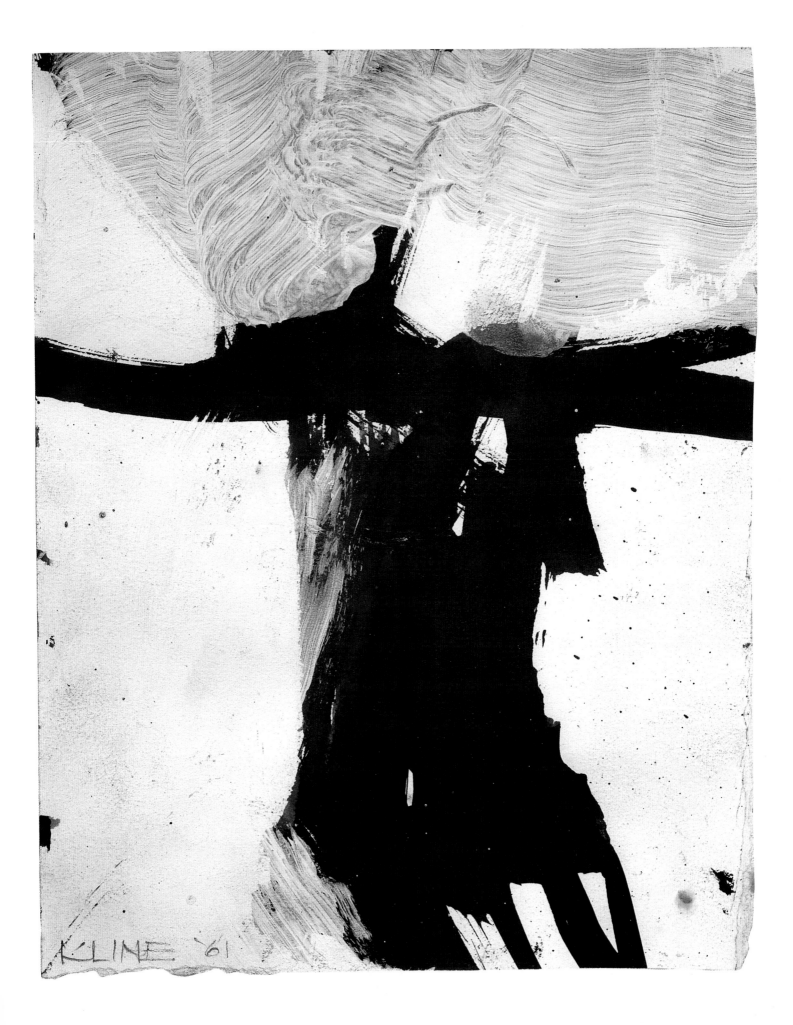

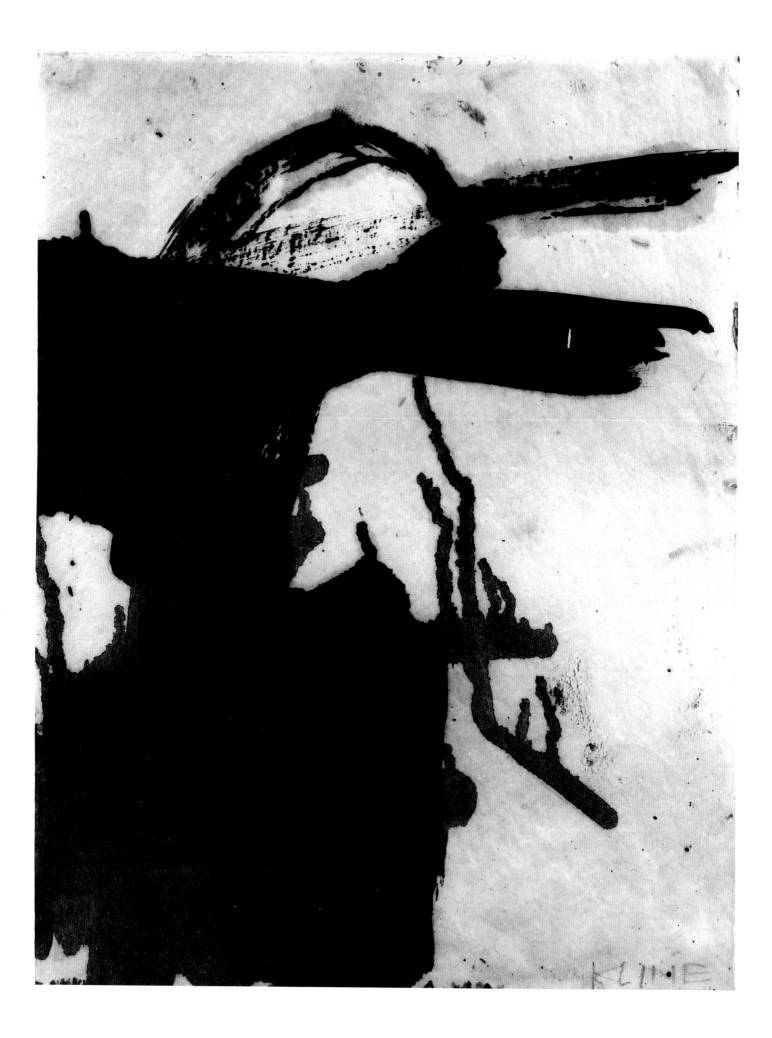

painting. Likewise, the obstreperous energy in *Study for "Crow Dancer"* (1958, plate 107), with dashing strokes and irregular rivulets, has been steamrollered into acquiescence for the bigger but much more self-contained painting. Some presences live only in small drawings. The precarious act of their creation, whereby Kline sought pictorial and emotional viability, could not always be carried over to a large, finished painting.

Usually not so readily apparent as in *Figure, Crow Dancer,* or *Flanders,* Kline's figural presences may reveal themselves after prolonged viewing or in a sudden shock of recognition. The vertiginous *Figure Eight* (plate 73) embodies as an abstraction the volatility of urban life, yet its imagery also coalesces into a figural construct. Noteworthy for its highly efficient juxtaposition of black and white, *Untitled* (1959, plate 108) exposes nearly hidden traces of pink and green before disclosing a potential animism. Pinioned by white, the black counterthrusts; torsion tears it free. Figural in upright position, the black form masks any specific identity, thereby opening itself to animal as well as human associations.

One of Nijinsky's consummate features had been the pronounced tilt of his head, retained in the semi-abstract drawing of 1947. In the several versions of Nijinsky as Petrouchka (1936–48) this telltale diagonal suggests a pulling back from the hostile world outside the paintings. In Kline's figural abstractions the diagonal acquires more generalized significance, yet a connotation of physical and psychological restlessness persists. In small paintings such as *Night Figure I* (1959) and in larger-than-life works of 1961—*Bigard, Merce C, Sabro IV*—the activated diagonal amplifies figural implications. No longer bound by pose to the angle of Nijinsky's head, it generates a bodily presence by extending across an entire canvas.

Kline may have equated sharp diagonal movement with artistic personality—an abstract counterpart, for instance, to the "sign on the brow" in Thomas Mann's *Tonio Kröger.* Titles of paintings dominated by diagonal configurations afford links to artists that Kline admired: jazz clarinetist Barney Bigard, dancer

107. **STUDY FOR "CROW DANCER,"** 1958
Oil and ink on paper, 11 × 8¼ in.
Private collection, New York

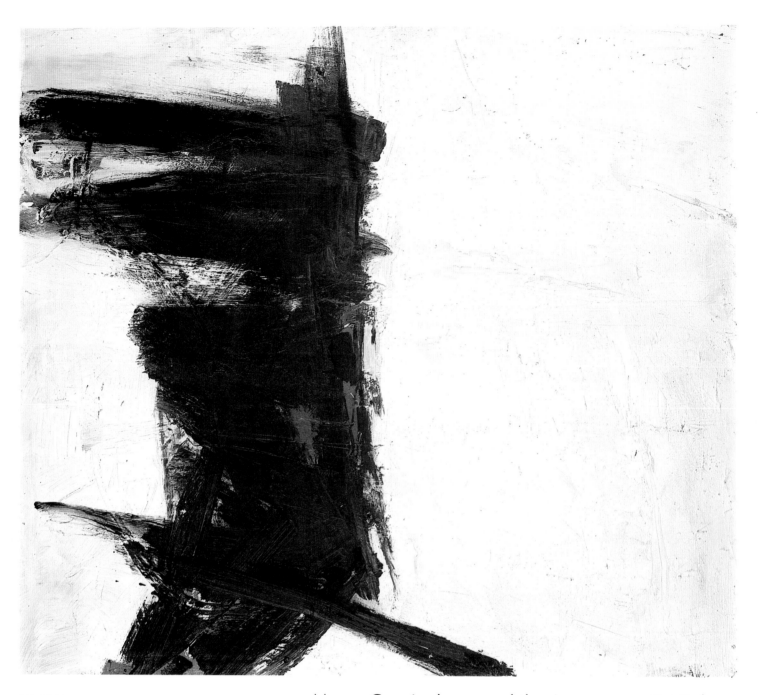

108. **UNTITLED**, 1959
Oil on canvas, 31½ × 35½ in.
Private collection, London

Merce Cunningham, and the Japanese artist Sabro Hasegawa, who deeply appreciated Kline's art and introduced it to Japan.[5] The 1958 *Elizabeth* (plate 110), whose suspended black triangle speeds diagonally across white-lighted space, takes on a personal meaning when one recalls Elizabeth's brief career as a ballet dancer in England. An abstraction with suggestions of the stage or even landscape, the painting also becomes Kline's tribute to his wife as *artiste manquée*.

Other diagonal configurations unrelated to specific persons nevertheless bear figural associations. Ten-foot-high *Mahoning I* (c. 1961) recalls on a grand

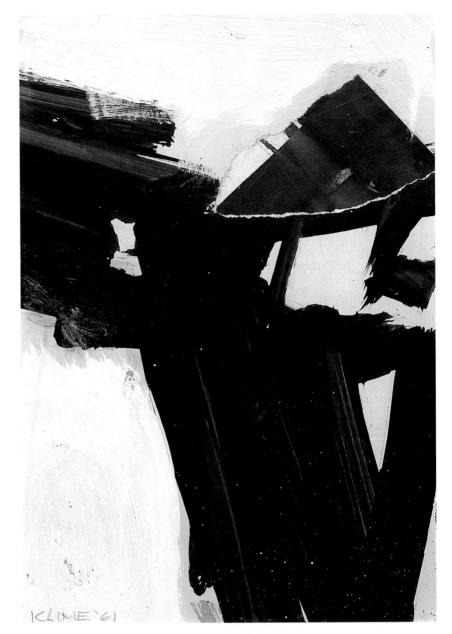

109. **UNTITLED (STUDY FOR "SABRO IV")**, 1961
Oil on paper collage
mounted on canvas, 14 × 9¾ in.
Marcia S. Weisman/Weisman
Family Collection

Below:
110. **ELIZABETH**, 1958
Oil on canvas, 68 × 72 in.
Collection of A. Alfred Taubman

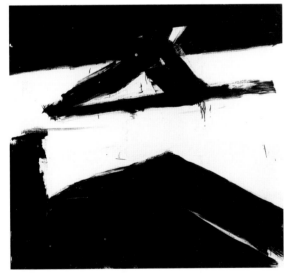

scale the marionettelike form confined behind a se-
ries of black strokes in the 1949 *Dancer at Islip.* Any
one-to-one interpretation, however, unnecessarily re-
stricts the meaning of the work. These figural ab-
stractions are not pictorial reiterations drawn from
Kline's world of friends and fellow artists. They are,
instead, embodiments of his own moods and ges-
tures, which he considered visual correspondences
for certain individuals or more equivocal presences.
And, to be sure, a diagonal thrust does not always
relate to figural identity. It may energize a structural
abstraction such as *Turin* or *Horizontal Rust* (plates
122, 1).

The massive *King Oliver* (1958), a cacophony of

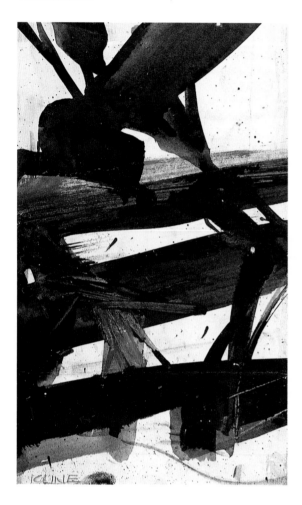

slatted and buckling color, stands as a joyous monument to the great jazz musician, affirming at the same time the range of Kline's figural implications. Important as one of his most accomplished color works, it is also his only mature color painting to declare openly a figural identity. Other canvases with significant color only allude to figures, and these are relatively few. Both *Green Vertical* (1958) and *Untitled* (1959) provoke animal as well as human associations. *Harley Red*'s figural referent is more up-front, yet distant from human anatomy (plate 112); its fiery presence sets off mythological reverberations.[6] Zooming through colored space like a maroon black laser, *Dahlia* (1959–60) combines urban site with animate identity, a fusion of architectonics and kinetics.[7]

Kline noted the emotional reach and solitary character of his paintings in a 1960 interview:

> As a matter of fact it is nice to paint a happy picture after a sad one. I think that there is a kind of loneliness in a lot of them which I don't think about as the fact that I'm lonely and therefore I paint lonely pictures, but I like kind of lonely things anyhow; so if the forms express that to me, there is a certain excitement that I have about that. Any composition—you know, the overall reality of that does have something to do with it; the impending forms of something, do maybe have a brooding quality, whereas in other forms, they would be called or considered happier.[8]

Nearly all Kline's figural abstractions contain singular presences. Pairing in individual paintings is rare and may suggest landscape as well as figures. Although undercut by a black trapezoid, the ascending form in *Theodosia* (1960–61) may indeed stand as a solitary presence: the lower shape implies a site and shadow more persuasively than a companion. *Ilza* (1955), a heavily brushed and toughened canvas, affords a similar dichotomy of form and meaning. Two abstract entities simultaneously attract and repel, perhaps Kline's vernacular for the cosmic Yin-Yang.

In general Kline celebrated the isolated presence, pushing it toward ultimate abstraction by merging identity and ambience. *Siegfried* (1958, plate 113) embodies both Wagner's naive protagonist and his fateful, mythic locale. (On another level, it is the in-

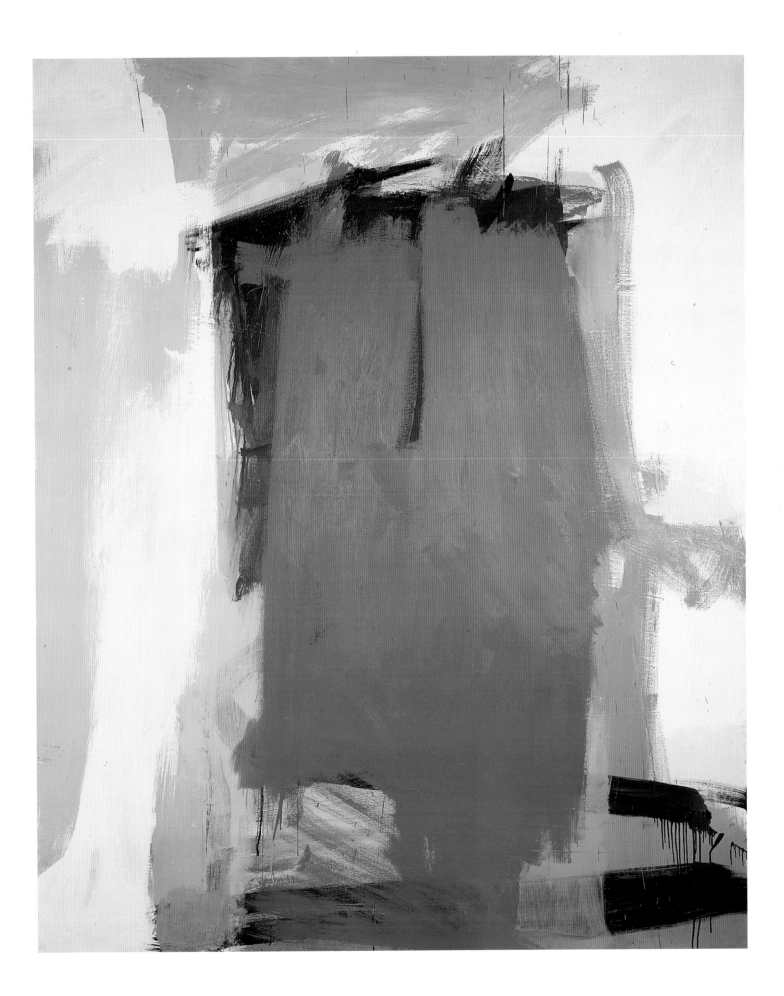

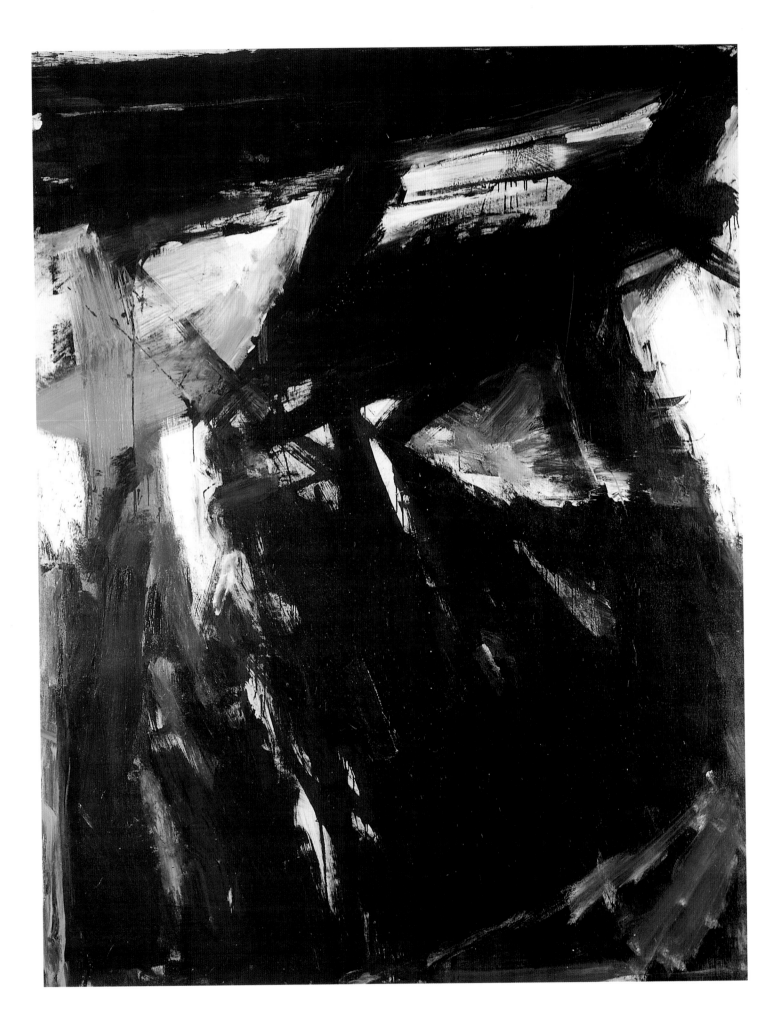

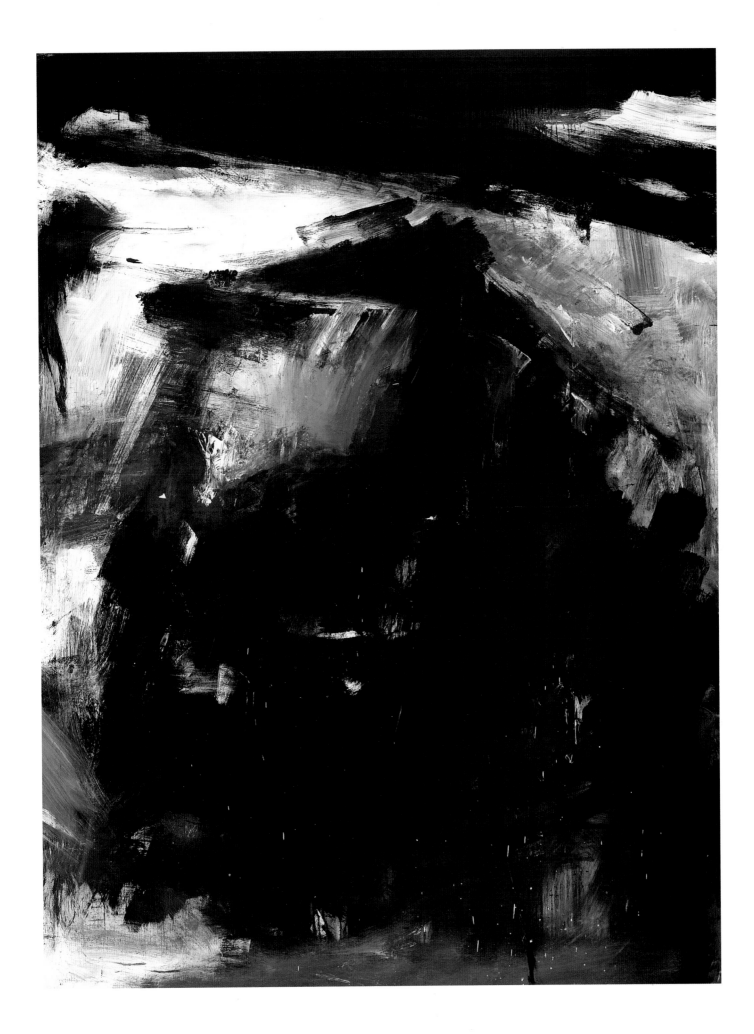

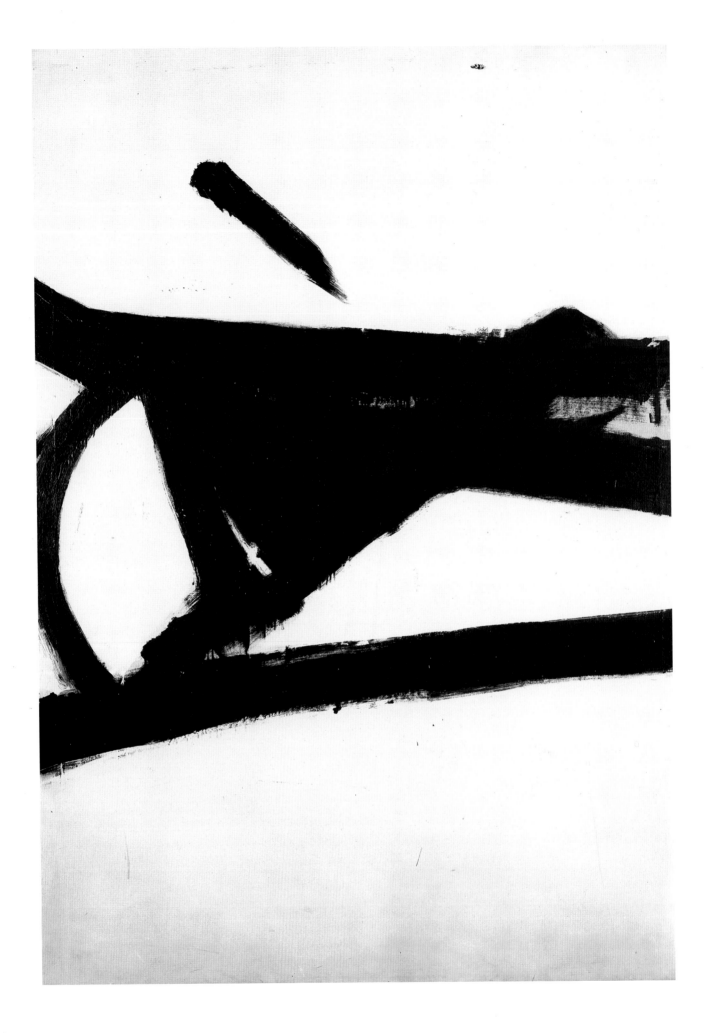

carnation of Siegfried's funeral music from Act III of *Götterdämmerung*.) *Siegfried* has a pendant in *Requiem* (plate 114), another 1958 painting nearly identical in size and comparable in mood. If, as suggested previously, *Requiem* is Kline's memorial to Jackson Pollock, an even closer correspondence may be sensed between the two works, namely a convergence of heroes. In 1954, two years before Pollock's death, Kline had entitled a small oil on paper *Jackson*. More than homage to his friend, this was Kline's way of commemorating a specific event. (To be sure, through title, not image.) In September 1954 Kline was driving a Lincoln roadster in East Hampton and struck another car head on. No one was seriously hurt, but Pollock, riding with Kline, suffered a cut lip.[9]

It is, of course, impossible to establish an exact, painting-by-painting chronology of Kline's work. Certain elements characterize his eleven years as a mature abstract artist, but in most instances they coexisted, rather than evolving from one to the next. Paintings separated by several years may be closer in style to each other than those painted in the same year. In 1955 Kline began the practice of painting pairs of canvases that relate through imagery, scale, and proportion.[10] The earliest pair, *Accent Grave* and *White Forms* (plates 115, 116), are moderate in size and two of his most open compositions. Tightly stretched blacks encroach on clear-cut whites. Descendant of the open square and Mondrian, *White Forms* is Kline's ultimate tectonic statement. (Not surprisingly, it was for years in Philip Johnson's collection.) Encountering it in the Janis Gallery's 1956 one-man show, Leo Steinberg was caught up in an architecturally exalted experience: "I declare that it treated me to a sensation the like of which I have known only under gothic vaults, when, upon entering Chartres, the flight of space about me seemed to suck the breath from my lungs. In Kline's painting, not the framing blacks but the keen, purposive white is the champion, and even though, at top, dark rafters hold it down, it made a splendid flight; and it gave me a key to Kline's other works and to the drama of their sequence."[11]

Just as Kline moved pictorial ideas from small sketches to larger canvases, so one painting might generate its counterpart. Yet unlike Pollock in the Black Paintings or de Kooning with the Women, Kline did not work in series. Only occasionally would a pictorial idea extend beyond one or two works.[12] One long-lived image in Kline's art first coalesced in an untitled 1958 painting, then the elongated black figural abstraction was reworked the following year as an array of colored planes, *Yellow, Orange and Purple*. Kline returned to the overall configuration a year or two later and sketched it again in black, opening figural possibilities. After these three incarnations, the configuration finally emerged as the listing skeletal colossus of *Mahoning I* (c. 1961). Oddly enough, the 1956 *Mahoning* (plate 117), a quintessential Kline packed with landscape references, lacks a figural presence, unless viewed irreverently on its side.

While some Kline paintings are possessed by figural surrogates that gesticulate in space or equivocate in mood, yet never leave any doubt as to their human origins, others are affirmations of place. This bonding of canvas and site became for Kline a major alternative to figural abstraction. His earlier representational work had been filled with people and places. It was only logical that his abstractions would manifest these subjects in less recognizable but paradoxically more emphatic ways.

Mahoning, for example, pulls a viewer forcefully into its clutch of black struts and beams. The painting's attraction as place supersedes its identity as thing. One recalls in this context Pollock's well-known statement about being "in" the painting. The total physical and psychic act of making the painting may be partially experienced after the fact by an attentive viewer. Unlike Pollock's lyrical landscape evocations such as *Autumn Rhythm* (1950), *Mahoning* does not pleasantly embody locale and season but carves out rigorous territory all its own. Kline's "site abstractions" find natural counterparts in eastern Pennsylvania, particularly the coal country, with its seasonal and geologic severity, but they reach beyond landscape into unmapped places of tumult and catharsis.

Mahoning comes as close to ancient Thebes as to Mauch Chunk Mountain in the dead of winter.

Formalist analysis has recently been challenged as being much too limited an approach to Abstract Expressionism.[13] In Kline's art, meaning must be grasped by looking at the work in the dual context of the artist's life and the New York School. Yet meaning need not stop there. Whether informed about historical context or not, a viewer may find in a Kline painting—as in any effective work of art—a personal meaning not necessarily shared by either artist or contemporaries. As a reader of the *Daily News* rather than Sophocles, Kline may never have imagined a "Greek connection" in his art. But for someone familiar with Oedipus' dilemma at the crossroads, *Mahoning* communicates on that level of inevitable tragedy. Kline himself did not intend his work to have a narrow, programmed meaning. "Some years ago, Franz Kline was being questioned—not with hostility but with intensity, by another friend—and finally he said, 'Well, look, if I paint what *you* know, then that will simply bore you, the repetition from me to you. If I paint what *I* know, it will be boring to myself. Therefore I paint what I don't know.'"[14] For Kline, painting what he didn't know required no disavowal of the past but, rather, ongoing discovery. He hoped that a viewer experiencing his art would be as actively engaged.

The site abstractions frequently required an oversize horizontal canvas. With this format, landscape associations are unavoidable; cinematic implications are also possible. Kline's Wall Paintings (1959–61) are a major example. To be really felt by the viewer, they must be scanned, a visual and kinesthetic process. The physical impact of such works is instantaneous, but they reveal themselves only over time,

118. **STUDY FOR "WASHINGTON WALL PAINTING,"** 1959
Oil and collage on paper
5⅛ × 25¾ in.
Mr. and Mrs. Harry
Anderson Collection

Opposite, top:
119. **LEHIGH V SPAN,** 1959–60
Oil on canvas, 60¼ × 80 in.
San Francisco Museum of Modern Art;
Gift of the Hamilton-Wells Collection

Opposite, bottom:
120. **PENNSYLVANIA LANDSCAPE,** 1948–49
Oil on canvas, 27½ × 34 in.
Collection of
Mr. and Mrs. I. David Orr

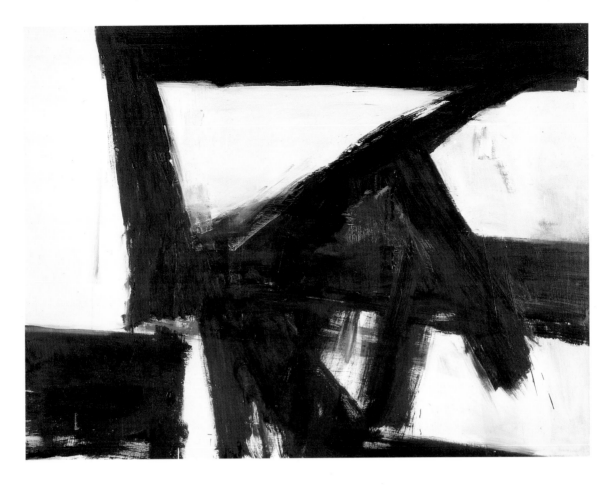

123

as formal and emotional relationships are perceived.

Most of Pollock's big horizontal paintings—which require time to discern all details but are not cinematic—preceded the expansion of motion picture screens in the 1950s. In contrast, Kline's largest canvases were painted in 1959–61, after theater screens had reached cycloramic scale in CinemaScope, VistaVision, and Todd A-O. It should be noted that although first-generation Abstract Expressionists such as Gottlieb, Motherwell, Newman, and Kline did make big paintings, truly mammoth works came later in the 1960s and '70s, painted by Al Held, Norman Bluhm, and Gene Davis, among others.[15]

Places in Kline's abstractions reveal specific geographic references through configuration and title. With hulking black shapes, *Delaware Gap* (1958) suggests geologic strata, a massive cleft under pressure strong enough to split rock. Its title refers to Delaware Water Gap on the Delaware River between Pennsylvania and New Jersey, a place known by Kline since youth and visited by him with friends in 1934.[16] A 1954 painting, *Pennsylvania*, recalls in a general way the oblong outline of the state itself. An even more explicit reference is made to Lehighton and its Central Railroad Bridge in *Lehigh V Span* (1959–60, plate 119).[17] Triangular forms reiterate through mass and interlocking stress the bridge's trestlelike structure, featured years before in the Lehighton mural and in *Pennsylvania Landscape* (1948–49, plate 120). Traces of blue and, particularly, green under black and white in *Lehigh V Span* also link it to the earlier work, a garish green picture that passed through several stages. After being "completed," it was touched up by Kline on a visit to the Orr household. However, he could not resolve the painting and took it back to his studio; it passed through a Hudson River School phase before emerging two months later as an Oz-green landscape with streamlined bridge and chugging train.[18] Although miles apart topographically, both the representational painting and the abstraction indicate Kline's overriding concern with place. And in light of its structural lineage as well as its sturdy abutting forms, *Lehigh V Span* provides an

121. **RAVENNA**, 1961
Oil on canvas, 37½ × 51½ in.
Yale University Art Gallery,
New Haven, Connecticut;
Gift of the Woodward Foundation

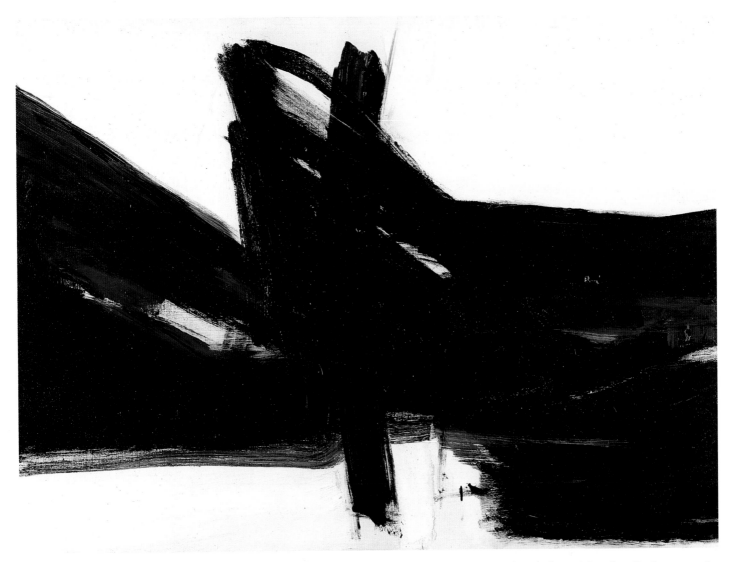

extraordinarily apt precedent for Mark di Suvero's steel *X Delta*.

Kline traveled to Chicago in 1957 to serve as juror for the *Momentum* exhibition. While there, he, Philip Guston, and Aaron Siskind went to Calumet City for an all-night spree. Guston later described the place where they ate and drank as a scroungy dive worthy of Jack Levine; a nude dancer did bumps-and-grinds while her audience stuffed themselves with lobster.[19] In Siskind's words, "What a night that was in Cal City!"[20] Three paintings in Kline's 1960 one-man show at the Janis Gallery were named in recollection of that adventure: *Chicago*, *Calumet City*, and *Orleans*, all 1959.[21]

After his 1960 trip to Italy, Kline began giving his abstractions Italian names, most of which refer, sometimes obliquely, to places he visited. *Spagna* (1961) is an easygoing distillation of Rome's Piazza di

Spagna. Bisected horizontally, with a more spacious zone below, the work is capped by a compact block of fluent strokes. Much impressed by Ravenna, Kline took the city's name as title for another 1961 painting (plate 121). Having visited the fifth-century Tomb of Galla Placidia, daughter of Emperor Theodosius, Kline named still another work *Placidia*. Its canvas-spanning black rectangle recalls in shape the massive sarcophagus of Galla Placidia inside the mausoleum. Renowned for its mosaics, Ravenna is also visually echoed in the latter two paintings with bits of green and blue gleaming through blacks of fluctuating densities.

In Siena, Kline attended the world-famous horse race in the Piazza del Campo and backed a *contrada* ("district") named Bruco. The artist later entitled a heavily impastoed black and brown painting *Bruho*, perhaps having heard someone with a strong lower-class Florentine accent turn *Bruco* into *Bruho*.[22] Moreover, a banner-flaunting personage bestrides *Contrada* (1960), clearly a reference to charged-up participation in Siena's race and procession.

In the interview with Katharine Kuh, Kline said: "Often titles refer to places I've been at about the time a picture was painted, like the composition I called Palladio [plate 15]. It was done after I'd been to the Villa Malcontenta near Venice, but it didn't have a thing to do with Palladian architecture."[23] One could take issue with the artist, for the painting's open square, which provides a solid yet flexible core for the composition, also refers to quadrilaterally symmetrical Palladian plans. Yet Kline's linking Palladio with the painting was intuitive, neither predetermined nor scholarly.

Another highly structured painting, *Turin* (plate 122), contains its own variation on the square—as well as on other open-ended geometrics—but is much more unsettling. *Turin*'s thrusting, splintering dynamism was supplanted the following year by *Palladio*'s baroque stasis. Caution must be taken, however, when superimposing a pattern of development on Kline's art; any such order is usually overturned by the paintings themselves. A specific instance is afforded by

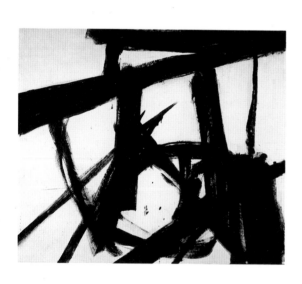

122. **TURIN**, 1960
Oil on canvas, 80 × 95 in.
The Nelson-Atkins Museum of Art,
Kansas City, Missouri;
Gift of Mrs. Alfred B. Clark
through the Friends of Art

comparing *Turin* and *Palladio*. Did Kline's painting evolve from agitated to relatively static compositions between 1960 and 1961? The answer is found not only by considering other works from these years but by looking back to Kline's first one-man show. Like *Palladio*, *Wotan* in 1950 was dominated by a potentially dynamic but momentarily arrested open square—or rectangle, to be specific. Yet *Cardinal*, also 1950, was activated, like *Turin*, by pronglike cuts through space. To complicate this tidy but inconclusive comparison, *Cardinal* also has an open square at *its* center. Viewing paintings individually and in groups across time, one notes an absence of consistent stylistic evolution in Kline's art. With the exception of his increased use of color beginning in 1955–56 and his texturing of black paint during 1960–61, he did not bring new elements into his art. As a mature abstract painter he varied more than he changed. Yet his prescribed mode afforded a constant source of emotional veracity and pictorial excitement.

Why was identification with place a recurring phenomenon in Kline's art? Mere speculation is inconclusive, but a partial answer may derive from two crucial factors in Kline's life. First, when Franz was seven years old, his father committed suicide. Years later Kline remarked that he had not had a happy childhood. "You know, I was in an orphanage

Below, left:
123. James A. McNeill Whistler
ARRANGEMENT IN GREY AND BLACK NO. 1,
1871–72
Oil on canvas, 57¼ × 64¾ in.
Musée du Louvre, Paris

Below, right:
124. **PAINTING NO. 7**, 1952
Oil on canvas, 57½ × 81¾ in.
Solomon R. Guggenheim Museum,
New York

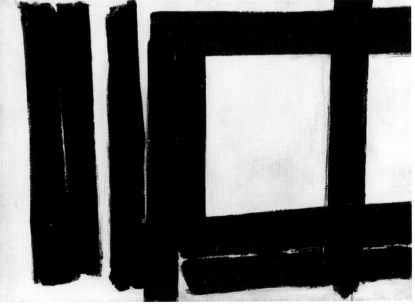

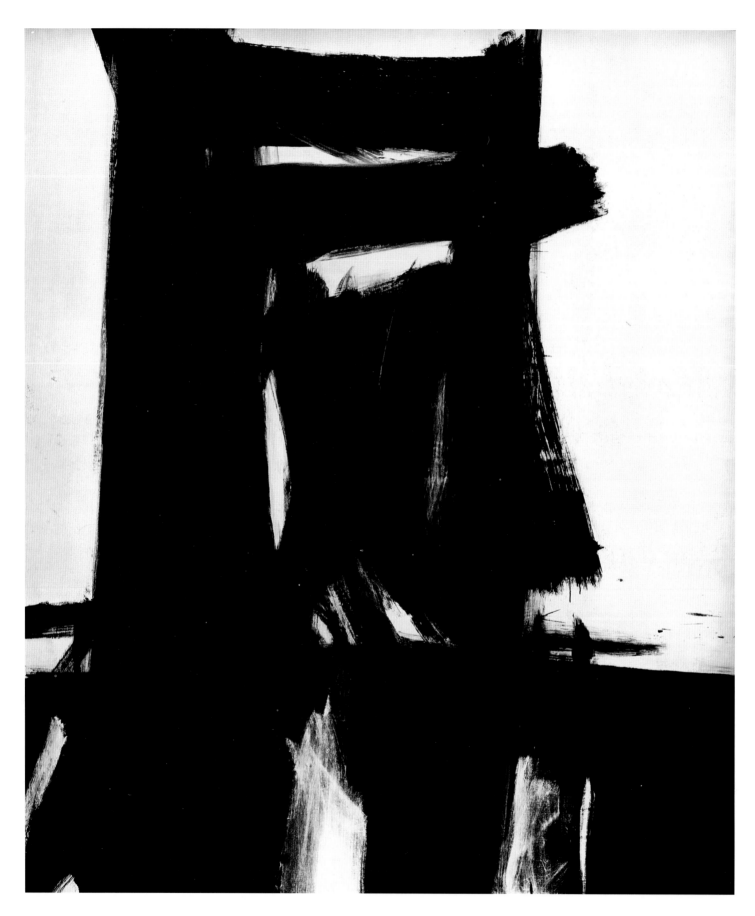

126. **MERYON**, 1960 (first stage)

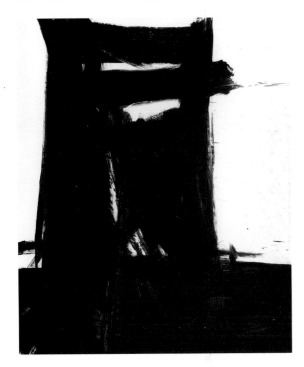

127. Charles Meryon
THE CLOCK TOWER, PARIS, 1852
Etching, 9½ × 7³⁄₁₆ in.
National Gallery of Art, Washington, D.C.;
Gift of R. Horace Gallatin, 1949

for eleven years." He added: "I was my father's favorite son."[24] Undoubtedly, the young Franz knew a certain rootlessness. Second, between his arrival in New York in 1938 and 1957, he moved fourteen times —including at least three evictions. From time to time he also had a separate studio and spent summers outside the city. Memories of an unsettled childhood extended through this transient New York existence. It would have been natural to regard his art as affording the only place he could always depend on to be there, to affirm his place as an artist in an ephemeral world.

Kline's admiration for traditional art, active since his student days, is not readily apparent from his abstractions. At first, his art seems to turn its back on the past rather than embrace it. This is, of course, a short-sighted response, for Kline's work is permeated by his recognition of such masters as Velázquez, Manet, Whistler, Albert Pinkham Ryder, and Albert Blakelock—not to mention various English draftsmen and Mondrian. Specific influence is another matter.

> You could say Manet and Velasquez—you see the coral world of Velasquez, his organization of the past —but their paintings don't "influence" mine. It would take a top kind of egotist to say, "Velasquez is related to what I'm doing." So it's not a matter of rejecting the past, but if you fall more in love with it, your own painting escapes you. And of course if you want to paint you have to look at everything; you can't help seeing the past.[25]

Kline once remarked that he hadn't continued to make prints because Rembrandt and Whistler had done it all.[26]

A direct link between an older work and a Kline can occasionally be made. *Painting No. 7* (1952, plate 124) replicates the composition of Whistler's *Arrangement in Grey and Black No. 1* (1871–72, plate 123), better known as "Whistler's Mother."[27] The painting is one of Kline's most monumental variations on the open square. The ubiquitous form pushes in dramatically from the right but is held in suspended animation by flanking verticals. Even in moderately sized paintings such as this, a cinematic succession of images may engage the spectator.

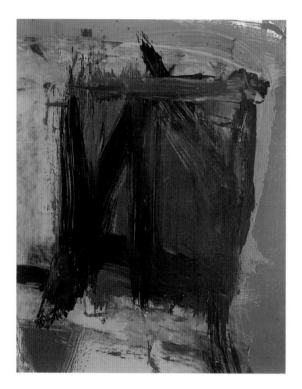

128. **HEAD FOR SATURN**, 1961
Oil on paper, 13½ × 10¾ in.
John H. Pinto, New York

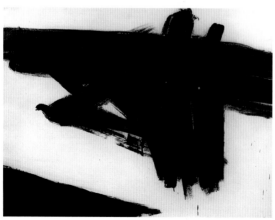

129. **WAX WING**, 1961
Oil on canvas, 38 × 52 in.
Private collection

Meryon, an architectonic canvas from 1960–61 (plate 125), reflects another nineteenth-century work, Charles Meryon's prescient etching *The Clock Tower, Paris* (plate 127). In fact, *Meryon*'s upright image stands as a bold amplification—sans peaked roof—of the tower's top story. A photograph taken while Kline worked on the painting shows it to have been much blacker at first (plate 126). In completing it, Kline introduced white apertures across the bottom that correspond in general position, albeit not shape, to the etching's foreground bridge. Whites and contours were reworked in the upper form as well. Retaining the generalized orientation of the Parisian scene, *Meryon* takes on a structural yet animate ferocity, like that experienced at times in works by Goya, another artist Kline admired. Confronting *Meryon*, whose overweening vicelike construct grips a smaller form, one recalls Goya's *Saturn Devouring His Child* (1819–23), one of the Black Paintings. The same year as *Meryon*, Kline painted an incendiary red, orange, and black work called *Head for Saturn* (plate 128). These discomforting paintings introduce a new interest in mythology during the last year of Kline's life. Another is *Wax Wing* (plate 129), suggestive of the bird family, but also calling to mind the fatal flight of Icarus. Kline certainly did not share the deep concern for mythology characteristic of Rothko, Gottlieb, or even Pollock. Yet these plangent paintings bear witness to Kline's growing interest in myth during 1961, an interest that could easily have been stimulated on his trip to Italy the previous year.

The black and white abstractions have often been compared with Oriental calligraphy. Such careless observation began with Kline's first one-man show and persisted in spite of his repeated attempts to point out how his work differed from Chinese and Japanese writing. "Critics also describe Pollock and de Kooning as calligraphic artists, but calligraphy has nothing to do with us. It's interesting that the Oriental critics never say this. The Oriental idea of space is an infinite space; it is not painted space, and ours is. In the first place, calligraphy is writing, and I'm not writing."[28]

Still, in one instance, Kline was surely influenced by a specific master, Ogata Kōrin (1658–1716), although the influence was pictorial, not calligraphic. The 1956 bare-bones abstraction *Luzerne* (plate 131) derives from the *yatsu-hashi* or "eight-part bridge" motif that often occurs in Kōrin's work, including a stoneware tray in the Freer Gallery of Art in Washington, D. C. (plate 130).[29] Kline's five black strokes, diminishing in width by halves while also shrinking in length, add up to a transmutation of Kōrin's well-known subject. It is difficult, if not impossible, to imagine that Kline's recapitulation of Kōrin's theme occurred on an unconscious level. In *Meryon*, however, his adoption of pictorial ideas from the etching seems more likely to have been a spontaneous process, only during or after which he recognized their origin.

Kline's move to the Sidney Janis Gallery in 1956 brought more than financial success. Urged by his dealer to use tube paint and good quality canvas for which he could bill the gallery,[30] Kline began to turn more and more toward possibilities of color and texture. (He had, of course, used tube paint before, but, like de Kooning and Pollock in the late 1940s and early '50s, had often used commercial paints.) Not by chance, Kline's painting lost some of its sur-

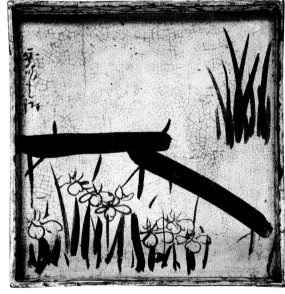

130. Ogata Kenzan and Ogata Kōrin
"YATSU-HASHI" STONEWARE TRAY, 17th century
Ceramic, 8⁹/₁₆ × 8⁹/₁₆ × 1⅛ in.
Freer Gallery of Art,
Smithsonian Institution,
Washington, D.C.

Right:
131. **LUZERNE**, 1956
Oil on canvas, 78 × 100 in.
Private collection

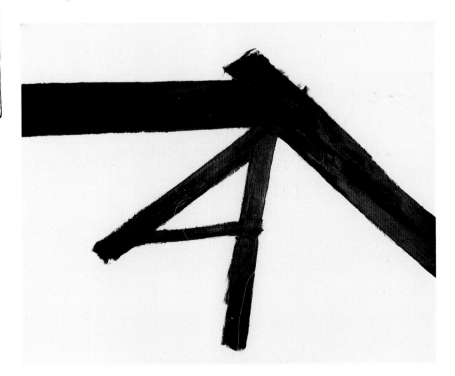

face grittiness and structural toughness in the succession of four one-man shows at Janis. But the change was not continual, and there are large paintings from 1960–61 just as structurally sound and smaller examples just as gritty as his earlier work. Indeed, some of Kline's greatest structural exercises date from 1961: *Zinc Door* (plate 148), *Shenandoah Wall, Le Gros* (plate 141).

Kline had achieved a viable abstract mode by infusing drawing with a painterly scope and touch, all the while working himself away from color. Yet in the 1950s he always had color on his palette and unfinished paintings with color were around the studio.[31] An untitled painting (c. 1950, plate 84) indicates how closely drawing through color planes was bound to spatial articulation. Such give and take of color and space was superseded by integration of black and white. For as well as using black and white in structural ways, Kline engaged their chromatic properties. Never absolutes, they exist across a range of light and dark and in some canvases may play off against intense hues. A concentration of backlighting along the edges of foreground forms is characteristic above all of early black and white works with color underpainting such as *Leda* (1950) and *Buried Reds* (1953, plate 132). (Interestingly, the study for the latter was painted not in black over orange and green but in matte blue black on soft beige white paper.)

Kline's dilemma was how to make color as structurally self-sufficient as black and white. Leo Steinberg has recalled the artist's struggle with color at the time of the 1956 show: "I remember his words to me —almost apologetic about having produced yet another show of mostly black paintings. 'I'm always trying to bring color into my paintings, but it keeps slipping away and so here I am with another black show.' What struck me about the statement was the passivity of the formulation; as though the blackness were happening to him by *force-majeur*—something he had no control over."[32]

Although one of Kline's strongest color paintings, *Green Cross* (c. 1956), began as black strokes in a

Opposite:
132. **BURIED REDS**, 1953
Oil on board, 21 × 15 in.
Frederick Weisman Company

Page 134:
133. **ABSTRACTION**, c. 1955
Ink and pastel collage on paper
13 × 11 in.
Collection of
Mr. and Mrs. I. David Orr

Page 135:
134. **UNTITLED**, 1956
Ink and oil on paper, 11 × 8½ in.
Mr. and Mrs. Lee V. Eastman

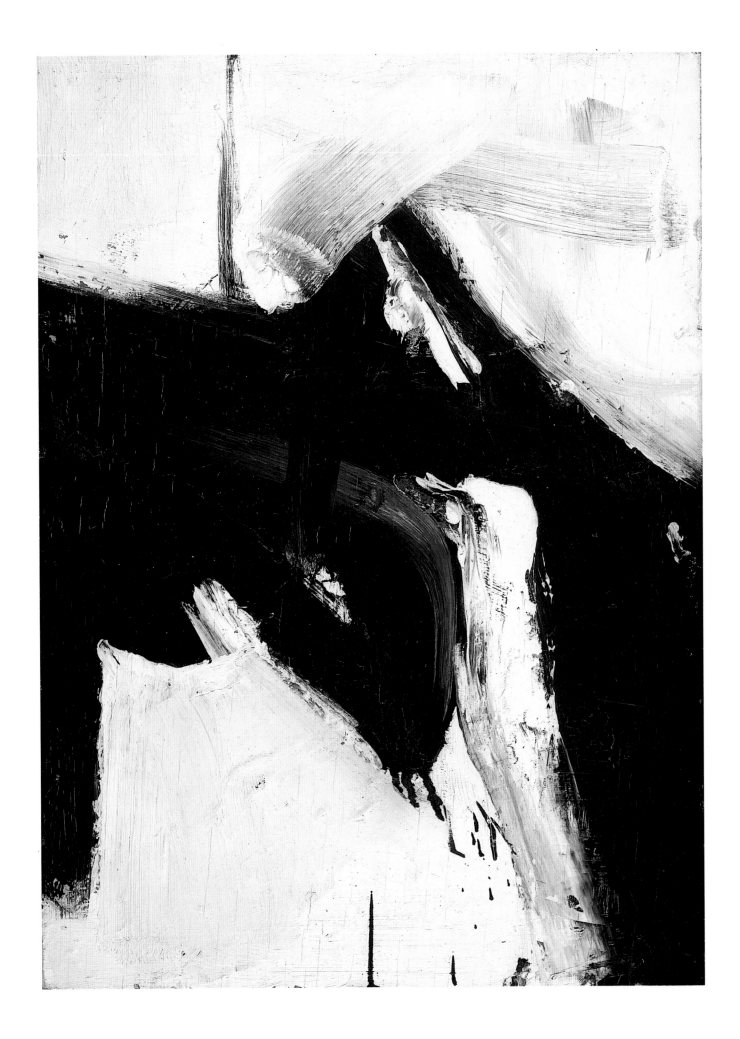

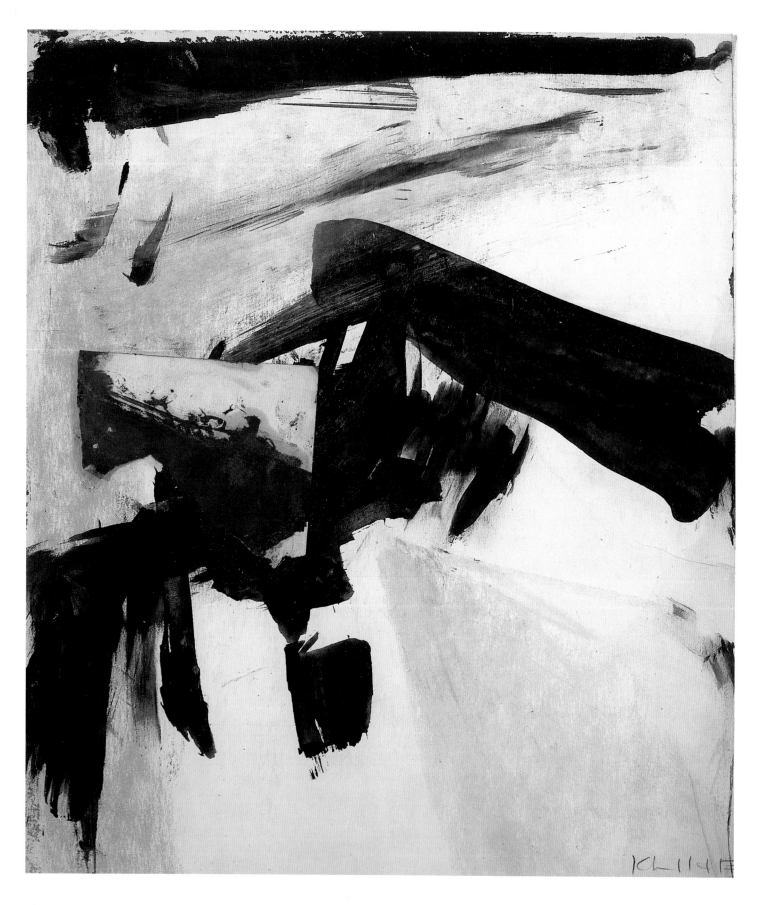

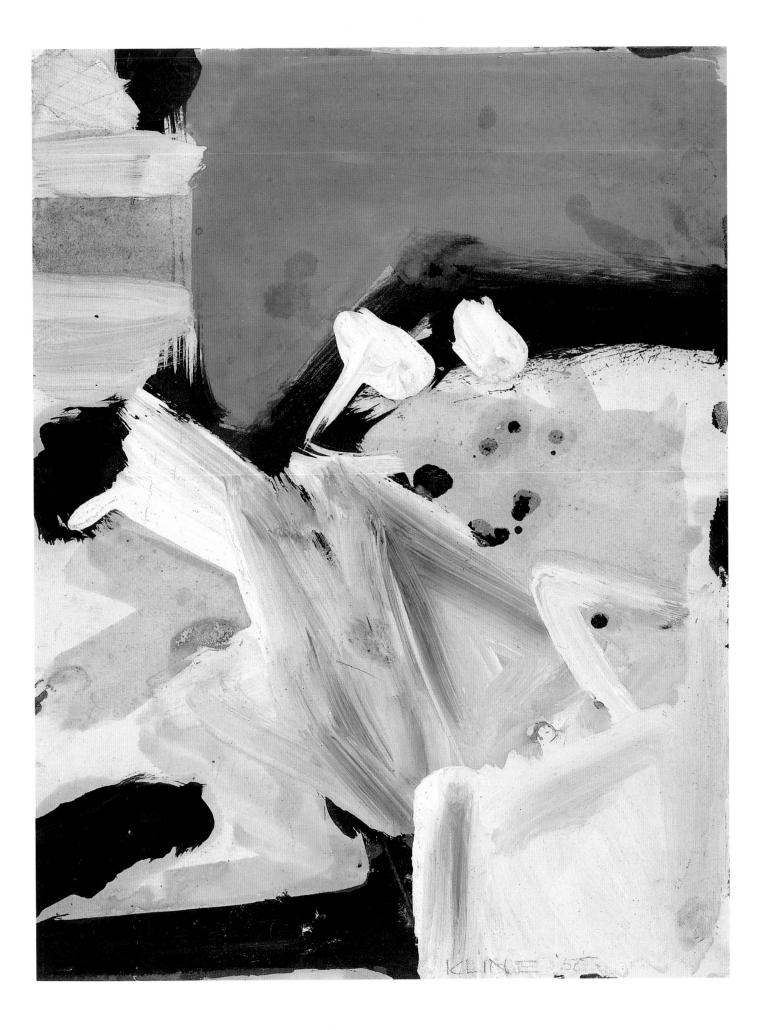

small ink sketch, turning color into structure usually required more than translating black or white into standby hues. *Green, Red, and Brown* (1955, plate 135) is one of the first indications of Kline's equating color with black. Floating black strokes at upper left, related to Kline's signature and date printed on the back, spar with the more structural red orange at lower right, a small-scale variation on the skeletal construct in *Painting No. 11* (1951, plate 97). As if determined to make color work on its own, Kline eliminates nearly all traces of the white paper through overpainting.

Color's potential as participant rather than adjunct to abstraction was realized not only by juxtaposing it to black, but by formulating it in collages, which Kline began making as early as 1947–48. None is more accomplished in meshing black, white, and color as structural coefficients than *Green Oblique* (1956, plate 136). Actually the study for *De Medici*, also of 1956 (plate 137), this well-built collage—one of Kline's largest—confirms his mastery of color's tectonic properties by assigning it to relatively large and loosely brushed planes. Multiple pairings enrich its meaning and help make *Green Oblique* an articulate yet highly compressed statement of both color and collage. The much bigger *De Medici*, on

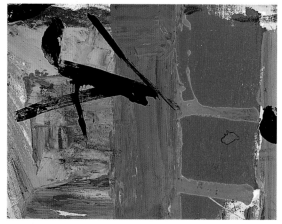

135. **GREEN, RED, AND BROWN**, 1955
Oil on paper, 10 × 13 in.
M. and Mme. Guy de Repentigny,
Montreal

Right:
136. **GREEN OBLIQUE**
(**STUDY FOR "DE MEDICI"**), 1956
Oil on paper, 19¾ × 24¾ in.
Genevieve Arnold

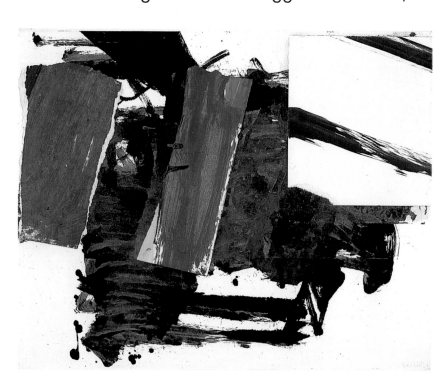

the other hand, deflects its energy across an expanse of white canvas. While conjuring up personages through its elegant upright forms and history-inflected title, *De Medici* may be closer to rigorously pared-down landscape. However, seeking visual correspondences in the natural world for Kline's abstractions is a rich, ongoing experience, and it should never give way to myopically pinning down a painting's "ultimate" source. At any rate, with implications of personage and landscape, *De Medici* approximates total abstraction as well, a tripartite phenomenon encountered repeatedly in Kline's art.

Studying the collages, one readily senses Kline's building technique. *Green Oblique* was made by gluing three pieces of cut and torn paper to another one already covered with an amorphous black configuration. The collage elements snap the entire

137. **DE MEDICI**, 1956
Oil on canvas, 82 × 115¼ in.
Mr. and Mrs. David Pincus

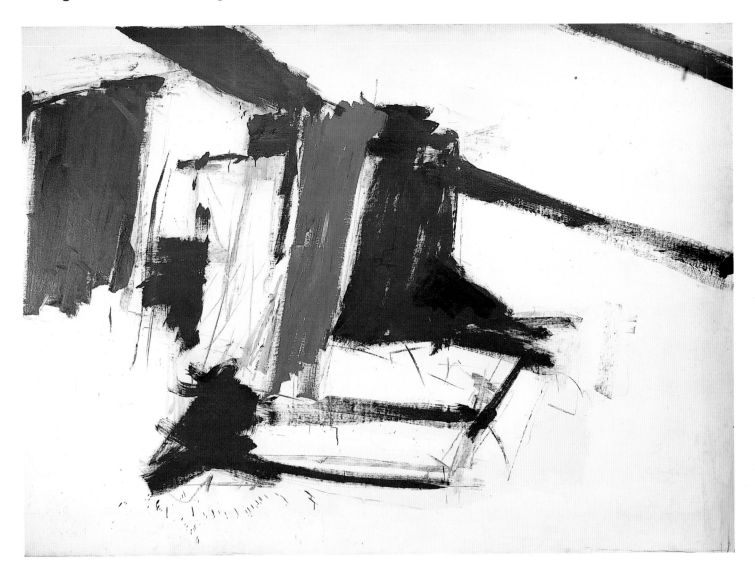

work into focus. Kline's ability to fit compositions to-gether unit by unit and achieve a succinct aggregate of form locked resolutely in space was unique among Abstract Expressionists. Undoubtedly, he was the "architect" of the New York School.

Another collage impressive for its complexity is *Study for "Andrus"* (1961, plate 138), made from five separate pieces of paper. Some scumbled with white and color, others more flatly painted, they retain their individual identities and offer a glimpse of Kline's improvisational technique of juggling an abstraction until it settled in. Arriving at a composition also at times involved reciprocity between color collage and black and white drawing. And occasionally the same pictorial idea was developed in two separate works: one color, one black and white. (There is a black and white drawing for *Andrus* that is roughly the same size as the collage.) Although it establishes the essential composition for *Andrus* (plate 139), the somber collage offers no idea of the painting's intense blue and purple with hot passages of red and orange. As solidly constructed as a late David Smith sculpture, *Andrus* lets fly with a succession of overlapping colored planes. Kline's hedonism, not often up-front in his work, fills this painting with baroque celebration. The title refers to Edwin Cowles Andrus (1896–1978), the distinguished cardiologist who attended Kline during a series of physical examinations in 1961 at Johns Hopkins.[33] Less than six months after his 1961 one-man show—a stalwart array of more than thirty

Left:
138. **STUDY FOR "ANDRUS,"** 1961
Watercolor, ink, and paint collage on paper
7⁷⁄₁₆ × 12⅝ in.
San Francisco Museum of Modern Art
Anonymous gift through
the American Art Foundation

139. **ANDRUS**, 1961
Oil on canvas, 79 × 133 in.
A. M. Kinney, Inc.

paintings largely from that year (including *Andrus*)
—Kline died of an enlarged and weakened heart.

Kline had begun to extend his art through color in 1955–56. Two years later he sought to vary its structure by filling canvases with impermeable atmosphere—sfumato on a grand scale, as in *Siegfried* and *Requiem* (plates 113, 114). At the same time, he produced significant color works: *King Oliver, Green Vertical, Blue Center, Mycenae*.

These latent concerns, however, did not entirely change the course of his art, for highly structured black and white paintings continued. Yet two related interests that appeared in 1958 underscore Kline's determination to extend the range of his art: use of gray and increased surface texture. He never mas-

Opposite:
140. **SLATE CROSS**, 1961
Oil on canvas, 111¼ × 79 in.
Dallas Museum of Art;
Gift of Mr. and Mrs. Algur H. Meadows
and the Meadows Foundation, Incorporated

141. **LE GROS**, 1961
Oil on canvas, 41⅜ × 52⅝ in.
The Museum of Modern Art, New York;
The Sidney and Harriet Janis
Collection, 1967

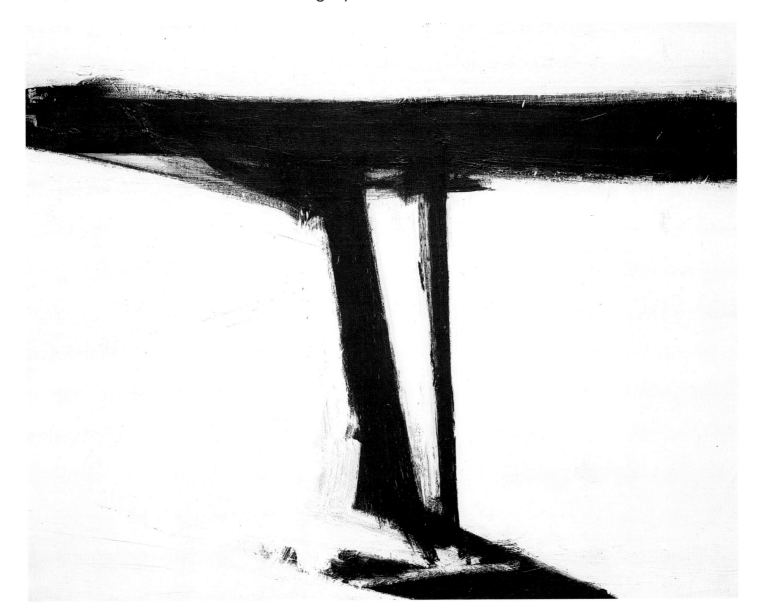

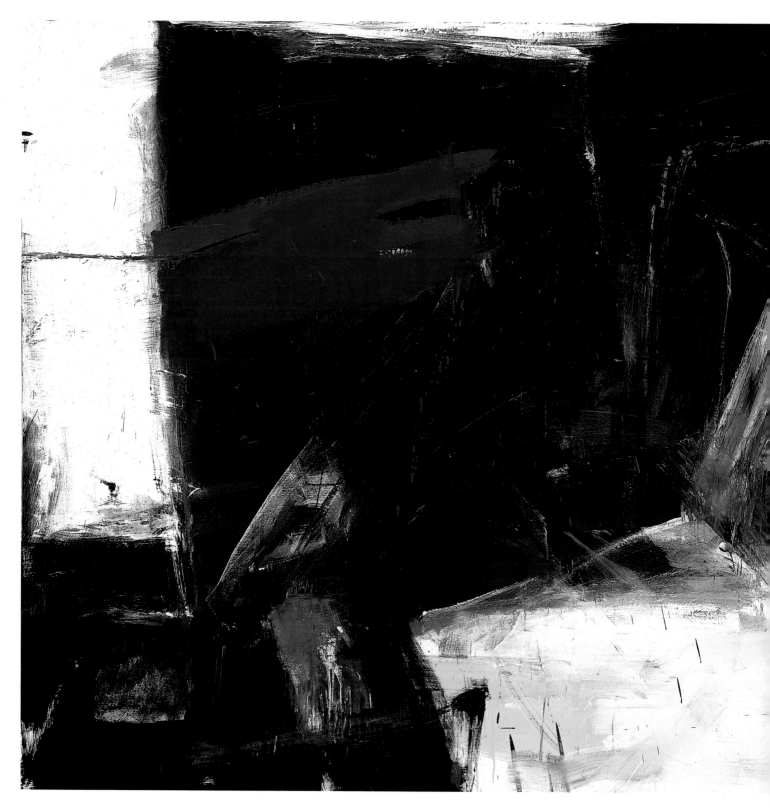

142. **C & O**, 1958
Oil on canvas, 77 × 110 in.
National Gallery of Art,
Washington, D.C.;
Gift of Mr. and Mrs. Burton Tremaine

tered the nuances of gray as thoroughly as Whistler, and occasionally its use yielded ineffectual form and washed-out atmosphere, as in the muddled *Black, White, and Gray* (1959). Kline was more successful when using grays of related value for tectonic configurations clearly set against white. *Slate Cross* (plate 140) stands as a flinty, sharply cut variation on the "crossbar" theme, which had been realized with greater gestural aplomb in *Black and White No. 2* (plate 14). Turned horizontally, this theme reaches its figural essence in *Le Gros* (plate 141), a disquieting painting in which mass-space, black-white, in-out, all oppositional forces cut into each other with the well-honed efficiency of a guillotine. Of course, *Le Gros* lacks any gray to dull its edgy clarity. Kline was most assured when using gray as ancilliary to black and white, as in *Siegfried*'s thunderous clash of structure and atmosphere. Gray also provides alternatives to color in *Horizontal Rust* (plate 1) and *Bigard* (1961). Yet recognizing that gray by itself could not be shaped to his purposes, Kline did not use it repeatedly on a large scale. For the apotheosis of gray one must look to the late paintings of Rothko.

Surface texture had always been one of Kline's interests—even as a figurative artist—but in 1958 he stretched its possibilities even farther in *C & O* (plate 142), a most ambitious painting also incorporating planar color, taut structure, and atmosphere. Scraping through dark areas to reveal white canvas, as well as laying on deep red, blue, green, and yellow, he reworked the surface, initiating an unresolved struggle between structure and color. As adversaries they bring to mind the artist's comment: "There seems to be something that you can do so much with paint and after that you start murdering it."[34] Because of its size and massive dark planes, *C & O* takes on wall-like associations and introduces Kline's 1959–61 sequence of great Wall Paintings: his largest abstractions (except for a 1960 stage backdrop) and, as a group, one of the major monuments of Abstract Expressionism.[35]

With its cataclysmic assault on space behind and in front of the picture plane, *New Year Wall: Night*

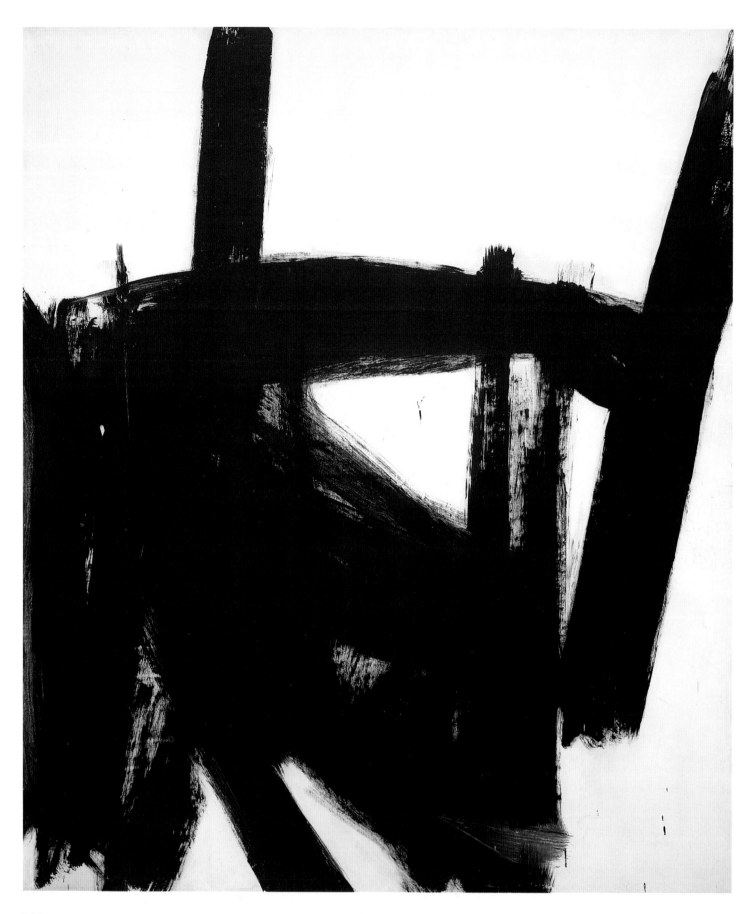

144

(plate 159) dominated Kline's 1960 one-man show.[36] (As in other Wall Paintings, Kline demolished the picture plane in this work by packing the surface with massive forms so physical in effect that they dominate the viewer's own space.) Along with Kline's authoritative use of color, this identification of painting with wall impressed Fairfield Porter: "His [Kline's] forte has always been light, but previously any of his colors could have been exchanged for any other. These paintings, parallel to de Kooning, have a speed and largeness that is inimitable. What holds them in place is not so much the up-and-downness of gravity as that they look like part of the wall."[37]

Another wall-like painting, *Cupola*, was completely repainted between 1958 and 1960 as Kline opened its ominous black field to textural modulation and splinters of light. The composition began as

Opposite:
143. **WEST BRAND**, 1960
Oil on canvas, 93¾ × 79½ in.
Collection of
Mr. and Mrs. Graham Gund

144. **CUPOLA**, 1958–60
Oil on canvas, 78 × 106¼ in.
Art Gallery of Ontario, Toronto;
Gift from the
Women's Committee Fund, 1962

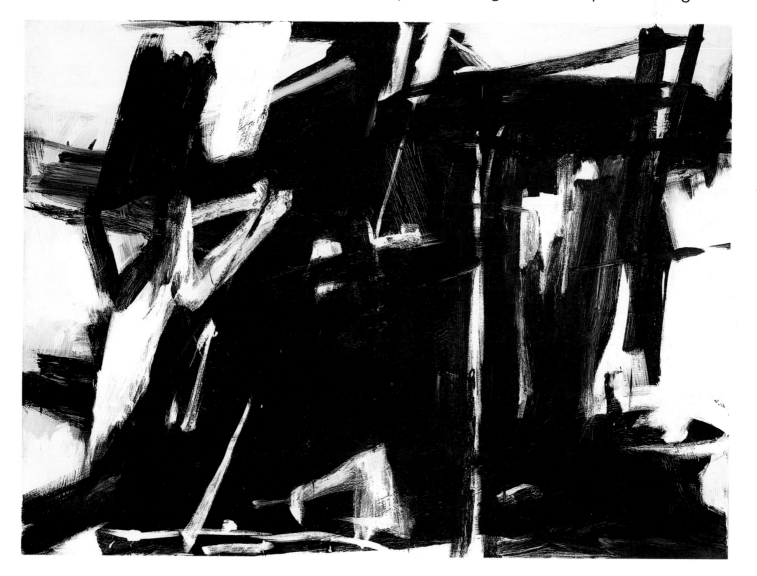

a small black sketch with bits of color. Kline then enlarged the overall configuration on a wall-sized canvas by painting broadly in black and white (plate 145). Sensing, however, that it was unsuccessful, he turned in 1960 to another sketch (plate 146) and moved its configuration to the previously painted canvas (plate 144). One image was superimposed on another with traces of the earlier work visible primarily around the edges. A stillborn image thus metamorphosed into a viable painting activated by white and variegated texture.

Kline continued scraping through black in 1960–61 to admit light and air into otherwise unfathomable spaces. Areas of sized canvas were also left exposed, a practice dating back to the early 1950s and offering yet another "color" alternative to black and white. Exemplifying this surface amalgam, *West Brand* (plate 143) consists of thinly and heavily worked sections; traces of gray where a brush loaded with black was drawn through still-wet white; paint drips, streaks,

145. **CUPOLA** (first stage), 1958

146. **STUDY FOR "CUPOLA"**
(final stage), 1960
Ink on paper, 10⅝ × 14⅛ in.
The Williams Companies Art Collection,
Tulsa, Oklahoma

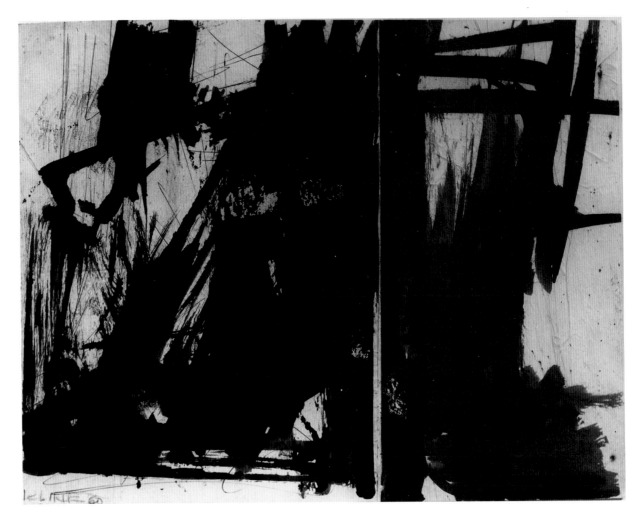

and clots. Kline kept the entire surface malleable while rendering form in a sculptural way. In late works such as *Caboose* and *Riverbed* (both 1961), black paint stands in relief, piled on thickly enough to turn chiaroscuro into tactile rather than illusionistic experience. Shiny blacks set against matte blacks create an uneven skin that sometimes stretches a painting's credibility. The flaw of such works lies not in these uneven surfaces but in Kline's exaggerated concern for paint as veneer rather than substance.

Reviewing the 1961 Janis Gallery show, Donald Judd criticized Kline's late work for various reasons, including surface incongruity:

> The current show has nothing equal to the Klines of the first half of the fifties, few paintings that even simulate their coherence and some that are actually bad.... Instead of using solid black strokes Kline drags the brush so as to produce broken, floating ones which attempt a transition with the white space. The prevailing dogma is that Kline equated white and black; he did not succeed in this but did proximate the two enough to avoid a marked spatiality. The soft brush-strokes cause the relation to fail in the present work.[38]

Actually, more often than not, Kline had deliberately varied paint surface to achieve a cohesion of structure and matière. "He was appalled when he first began to use good tube whites—titaniums, zincs, permalbas, flakes—with their uniformity of surface and lack of body, and, again, he had to evolve a completely different way of working—this time to avoid slickness and ingratiating effects."[39]

Usually remembered for large works in which implied scale exceeds actual scale with transcendent effect, Kline also made small color paintings that affirm through worked surfaces their nature as objects yet imply greater physical scale. Small enough to hold in the hand, they exhibit a capacity for uncanny expansion. Of course, this was one of Kline's major accomplishments: connoting magnitude on a small scale. At times, meaningful color changes were made between study and painting. Yellow—as well as the tone of unpainted paper—provides an aura for the black figural presence in *Untitled (Study for "Sabro*

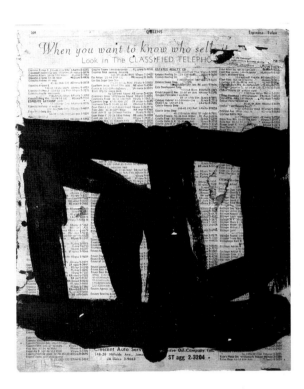

147. STUDY FOR "ZINC DOOR,"
c. 1950–52
Oil on telephone-book page
10¾ × 9 in.
Private collection

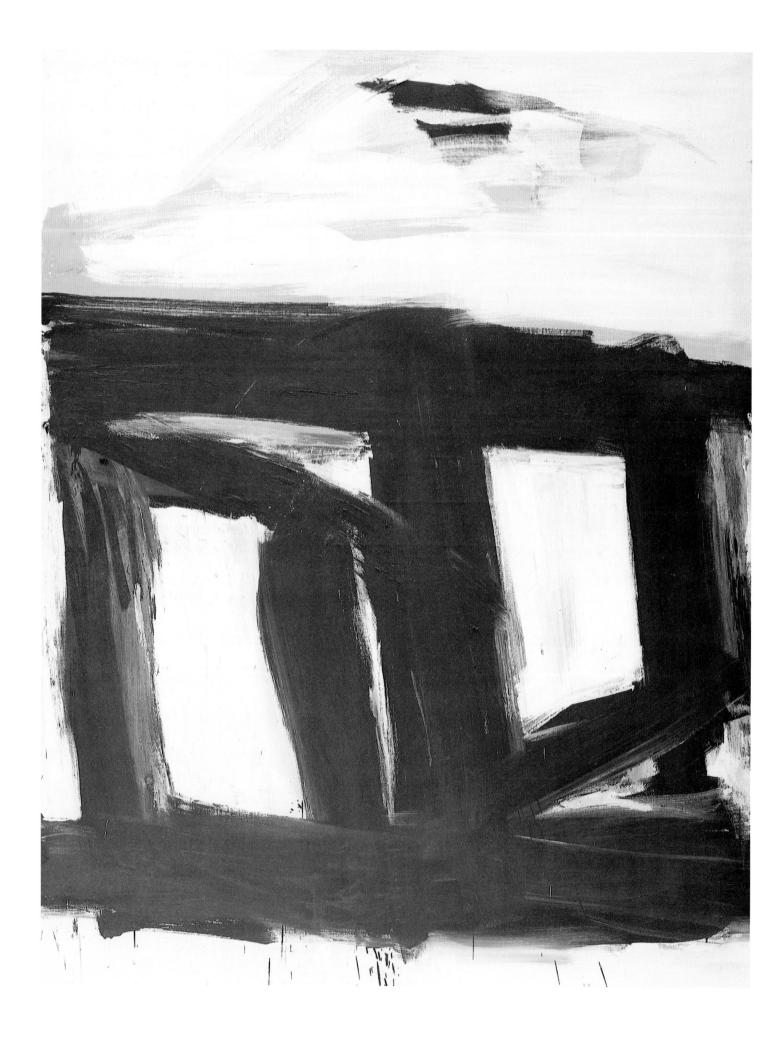

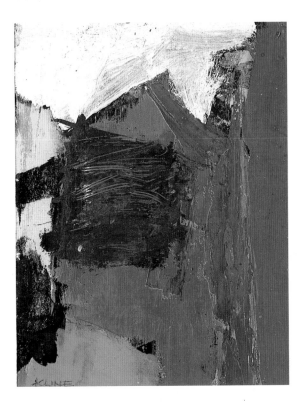

IV") (plate 109). Yet yellow was excluded from the painting. On the other hand, *Zinc Door* (1961) began free of color as a sketch on a telephone-book page in the early1950s, with color introduced only in the painting years later (plates 147, 148).

Other small and moderately sized works have both color weight and translucence. Scratching through a dark gray patch in *Lester* (plate 149),[40] Kline opened it to bright green underpainting; yet the green, along with red and blue, remains opaque. The central rhomboid in *Tragedy* (plate 150), built from wide strokes of red orange, fuchsia, blue, and brown, is densely painted yet seemingly transparent, an ambivalence of color, surface, and planar compression.

In 1967 Robert Goldwater described Kline's colors as "dark greens and blues, purples and reds, hues that almost perversely darken rather than brighten the mood of his paintings."[41] Caustic yellows and oranges could be added to the list, acerbic hues that negate impressionistic preconceptions of color as sweetness and light. Kline's late colors do not charm. They transfix. Or, they wallop like the dark red gesture bounding out of a corner in *Untitled* (1961, plate 153). If, as John Ferren said, de Kooning's "whip-lash line" traveled 94¼ miles per hour,[42] Kline's fast colors hit 95.

Given that Kline painted at least a dozen color

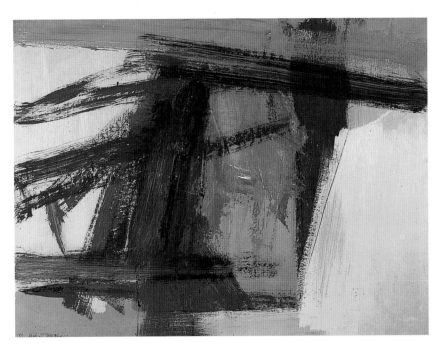

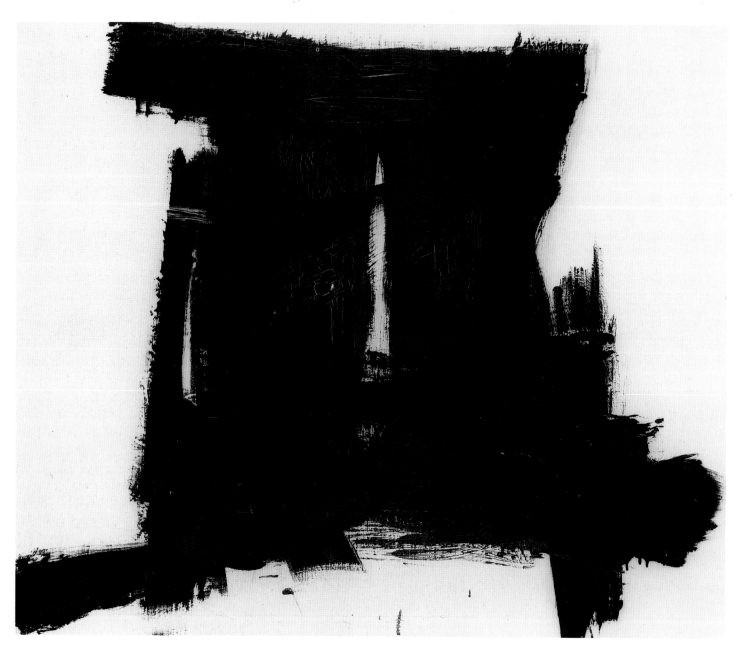

151. **SHAFT**, 1955
Oil on canvas, 23¾ × 29 in.
The Michael and Dorothy
Blankfort Collection

works of extraordinary quality between 1956 and 1961, his clichéd reputation as strictly a black and white artist should be set aside. Two of his greatest paintings are the elegiac blue *Scudera* (plate 2) and the ferocious *Red Painting* (plate 154), both 1961. They were surely regarded by Kline as a pair because of their chromatic opposition, yet closeness in time and scale. He probably thought of *Red Painting* as unfinished; it was in the studio at the time of his death and had not been exhibited. While *Head for Saturn* (plate 128) was the immediate prototype for *Red Painting*, its black portallike image had also appeared in *Shaft*, a more modest canvas from 1955 (plate 151). The motif of two askew rectangles side-

by-side could be traced back to an untitled 1951 work and, from there, to a rudimentary structure in a figurative picture, *Studio with Easel* (1944, plate 152).

Kline's art turned in upon itself as he restructured and refined pictorial ideas invented years earlier. Just as it had taken him more than a decade to arrive at abstraction and then more time to explore black and white after working through color, so certain forms required long gestation before their expressive potential could be fully realized. However, in 1961 Kline had reached a new threshold in color. Structure, atmosphere, even figural, landscape, and mythic references all converged in *Red Painting*. The tragic irony was that Kline died at this moment of change. It was the nagging irony of making it as an artist that he had known before: "If you keep doing the same thing, everybody says, 'Isn't it getting a little boring?' Then, if you try to change they say, 'He didn't mean it in the first place.'"[43]

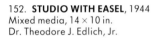

152. **STUDIO WITH EASEL**, 1944
Mixed media, 14 × 10 in.
Dr. Theodore J. Edlich, Jr.

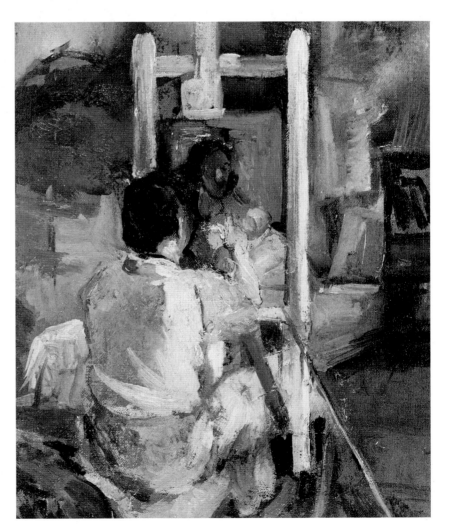

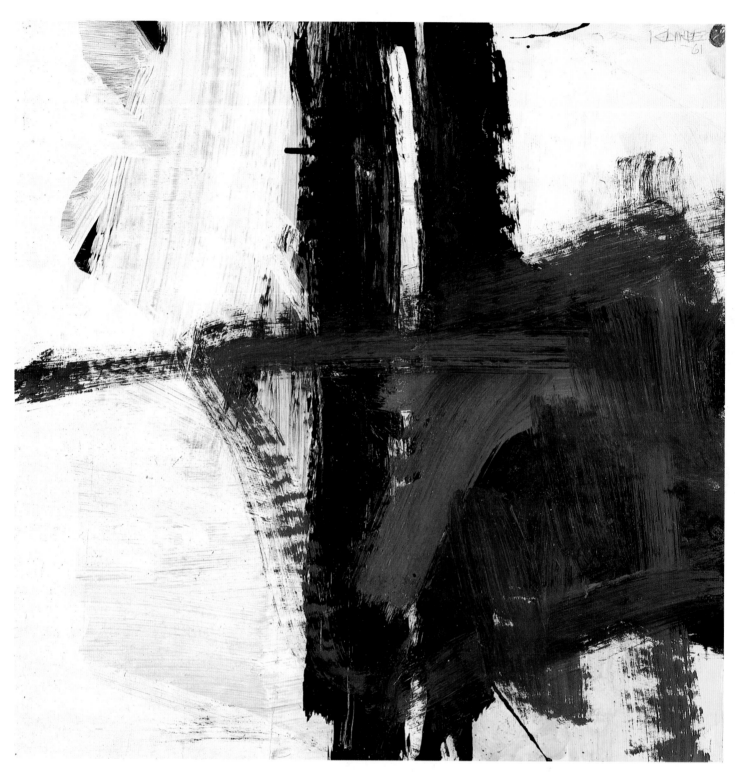

153. **UNTITLED**, 1961
Oil on paper, 18¼ × 18 in.
Richard E. and Jane M. Lang Collection,
Medina, Washington

Opposite:
154. **RED PAINTING**, 1961
Oil on canvas, 110 × 78¼ in.
Collection of Mr. and Mrs. Daniel Schwartz

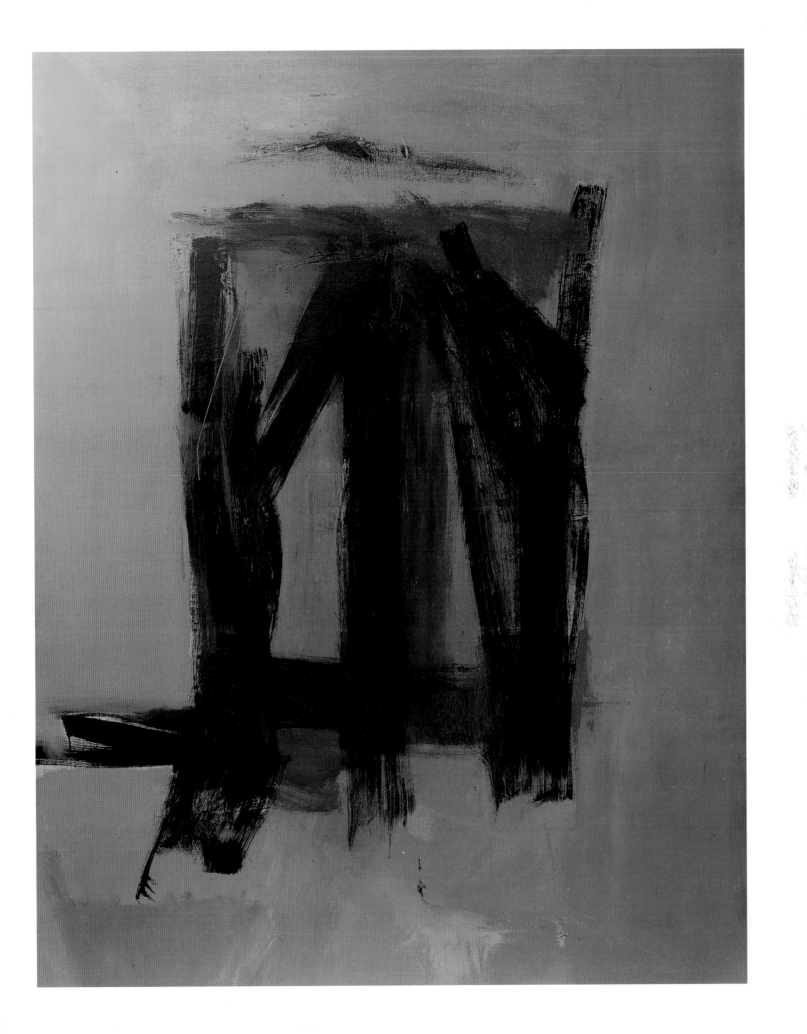

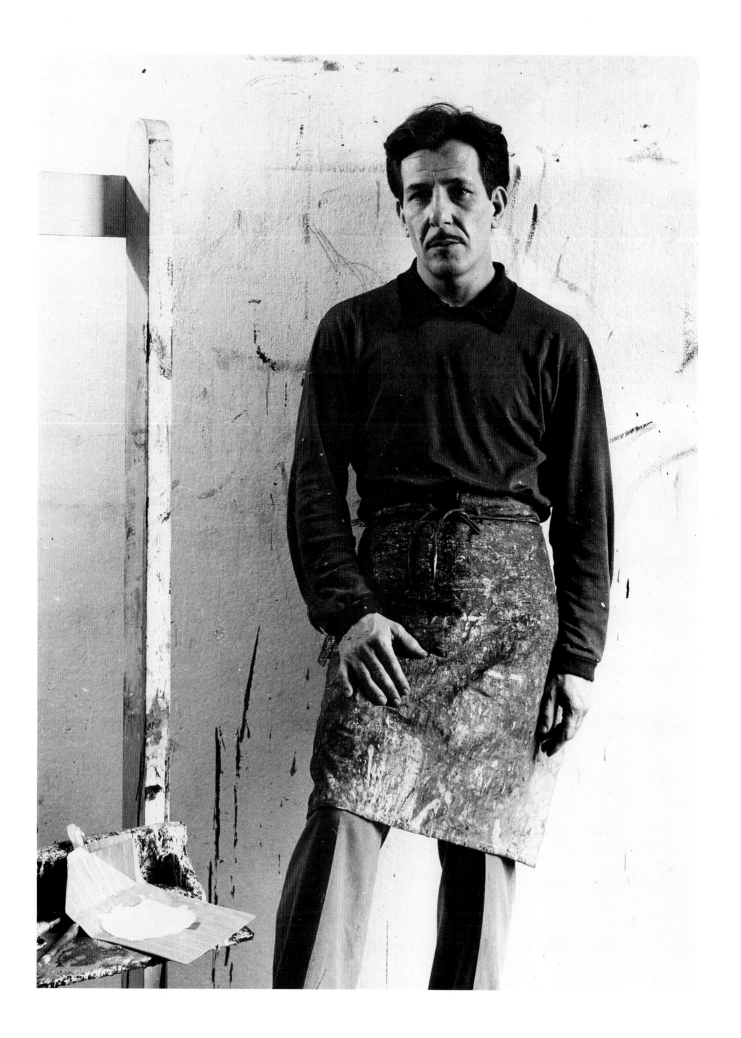

7.

TECHNIQUES
AND
CONSERVATION

When Kline died in 1962, he left an estate of approximately 85 paintings and 475 drawings. When inventoried, his work was split into "Figurative" and "Abstract" categories, an arbitrary distinction that was at times difficult to determine. About three-fourths of the paintings were considered abstract, while nearly five-eighths of the drawings were so classified. Drawings ranged in media from ink on telephone-book pages to oil or pastel on paper, collage, gouache on cardboard, and pencil on paper napkin. Paintings were oil on canvas, homosote, Masonite, canvasboard, wood, or paper. A few were mixed media such as pastel and ink, crayon and oil.

Several of the large abstract paintings had been shown at the Janis Gallery before the artist's death or were included in the gallery's *Kline Memorial Exhibition* in December 1963. Some were part of the show organized for European museums in 1963–64 by Frank O'Hara at the Museum of Modern Art. Others would remain unseen by the public until March 1967, when the Marlborough-Gerson Gallery held the first New York exhibition of estate paintings and drawings.

155. Franz Kline, c. 1956

Making its inventory, Marlborough assigned to each item a *ZP* or *ZD* number: *Z* referred to Elisabeth Ross Zogbaum, executrix of the Kline estate; *P* meant painting, *D* drawing. These inventory numbers were printed on the back of each work; in some cases a *ZD* number was printed in ink directly on the verso of a drawing and, absorbed by the paper, has begun to show through.

Marlborough controlled the Kline market by not releasing all items in the inventory at once,[1] in the expectation that prices would increase year by year. To a certain extent the plan worked, helped by inflation and a growing international interest in Abstract Expressionism. In 1956 Janis had priced Kline paintings at $1,500. After some were sold the price increased to $3,000, then $6,000. When Kline died, major paintings were selling for $18,000 to $20,000.[2] In the late 1960s Marlborough asked $35,000 for important works. Today it is not unusual for an abstract painting of modest size and quality to bring $100,000 or more. Large canvases of high quality exceed $500,000. Two small collages sold at Christie's in November 1984 for $35,200 and $39,600.[3] To be sure, they were of superior quality. At the same sale, a telephone-book page of fair quality brought only $6,600.[4] *Untitled* (1960), a nine-by-six-foot black and white abstraction, sold for $880,000 in May 1985 at Christie's, setting a new Kline record.

Steadily increasing prices, as well as Kline's seemingly uncomplicated, easily recognizable black and white style, have provoked the appearance of fake works in the last four or five years. Black and white drawings, sometimes with color, make up the largest category of fakes, although spurious paintings also appear on the market. (No one has bothered to fake Kline's figurative work, as the financial return would be considerably less.)

The ultimate damage caused by fakes is discredit to the artist, a situation exacerbated if the artist is no longer alive to denounce fraud. At the same time, fake drawings, like paintings, can usually be spotted by someone familiar with the variety of Kline's work. To be taken into consideration, beyond provenance,

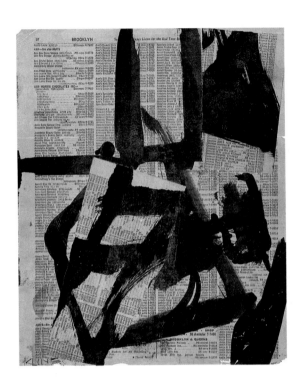

156. **UNTITLED II**, c. 1952
Brush and ink and tempera on paper collage, 11 × 9¼ in.
The Museum of Modern Art, New York; Purchase

are: technical aspects, such as medium and paper; veracity of image, as determined by quality of stroke, density of painted area, and size of the paper; and character of signature and date. By no means did Kline sign and date all drawings, either on front or back. Occasionally, drawings were signed years after being made.[5] Kline's signature also changed over the years; it is possible for a late signature to appear on a much earlier drawing. He even moved his signature. *Untitled II* (c. 1952, plate 156), a telephone-book collage in the Museum of Modern Art, was first signed in pencil at center right. Later, apparently for aesthetic reasons, Kline erased his signature and re-signed the work at lower left.

Questionable collages have also surfaced recently. These generally reveal a much more tentative composition than in a genuine work. In an authentic Kline collage (plate 157) disparate elements—multiple directions of brushstroke; pieces of cut or torn paper; varied media, sometimes with thickly applied pigment and color—lock tightly together. Failing to duplicate Kline's simultaneous bravura of expression and economy of means, fakers turn out slack, long-winded paintings, overextended drawings, and tenuous, dull collages.

The production of fakes is stimulated by a demand for Kline's abstract work far greater than the market can legitimately satisfy. Within the last few years, museums have continued to acquire Kline paintings from private collections, diminishing markedly the availability of major works. For example, in 1982 the Muriel Kallis Steinberg Newman Collection, including two black and white Klines, was given to the Metropolitan Museum of Art (Mrs. Newman retains joint ownership). Sixteen works by Kline in the collection of Count Panza di Biumo, including at least four major paintings, were acquired in 1984 by the new Museum of Contemporary Art in Los Angeles. European and Japanese museums devoted to twentieth-century art also want to add major Klines to their collections. In November 1983 a black and white horizontal painting, *Harleman* (1960), was purchased at Christie's in New York for $506,000—at that time a

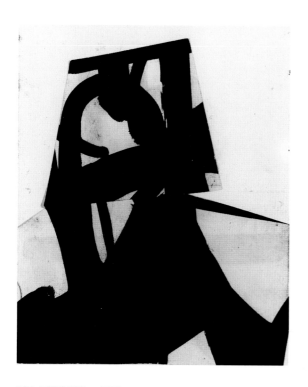

157. **UNTITLED**, c. 1952
Ink on paper collage, 4¾ × 4 in.
Private collection, New York

new Kline auction record—by Shigeki Kameyama, director of the Mountainside Tortoise Company, Tokyo. Kameyama noted that the Kline, plus other examples of Abstract Expressionism, would go to a new museum of contemporary art in Japan.[6] For a number of years, important Kline paintings have been in London's Tate Gallery; Munich's Bayerische Staatsgemäldesammlungen; the Kunstmuseum Basel; and the Kunstsammlung Nordrhein-Westfalen, Düsseldorf.

Because of Kline's choice of media, his layering and reworking of paint, and apparent absence of concern that his art endure, time has dealt severely with his work. His mature black and white abstractions are particularly vulnerable, while earlier figurative paintings and drawings have aged less perilously. Collages and studies on telephone-book pages are fragile. Never intended to last more than a year or two in directories, the pages, some oil-soaked from paint application, have now yellowed. Others were painted in ink that Kline bought in the late 1940s and early '50s for a few cents a bottle at a stationery-surplus store on Eighth Street. The ink had been used by the army for drawing map overlays on transparent plastic and dried with a shiny surface.[7] Even when framed with acid-free materials—about the only way to preserve them—these telephone-book pages are susceptible to deterioration if exposed to high light levels or low humidity. Work on more substantial paper is less threatened.

158. Franz Kline's palette, 1962

As a figurative artist, Kline liked Winsor and Newton oil paints, which he bought in the mid-1940s at Martha Phillips's art supply shop on Christopher Street. He also preferred smooth linen canvas "and any brush he could swipe."[8] After turning to abstraction, he often used commercial paints such as Behlen's zinc white. Buying it in gallon cans, he mixed it with titanium "to give it the right feel."[9] Commercial black paint was thinned with turpentine, making it more fluid and less shiny than the white. Kline's preference in the early 1950s for liquid, rather than artist-quality tube paint, was both financial and technical. Commercial paint was less expensive. It also elimi-

nated the need to keep squeezing paint from tubes. In the late 1950s, after Janis told him to use tube paint and good quality canvas, Kline mixed paint in shallow metal trays before a working session. He purchased materials at this time from Joseph Torch's art supply store, 147 West Fourteenth Street, having known about the firm since the mid-1940s. In business since 1929, Torch sold his own brand of oil paints made to his specifications.[10] (*Torches Mauve*, 1960, in the Philadelphia Museum of Art, is named for Torch's mauve oil paint, which Kline used in painting it.)

Large canvases were painted unstretched, but attached to a painting wall in the studio. Because he pressed brushes hard against canvas, Kline needed a firm backing. He was also able to edit an unstretched canvas while still at work on it, adding or subtracting several inches from the edges if necessary. Upon completion, large canvases were rolled and moved into the Janis Gallery, where they were attached to wooden supports. Some were folding stretchers so that large paintings could be made portable. After a painting had been folded and moved, it was unfolded and reinforcing metal plates were affixed to cuts in the stretcher for "permanent"

159. **NEW YEAR WALL: NIGHT**, 1960
Oil on homosote, 4 panels
120 × 192 in. overall
Bayerische Staatsgemäldesammlungen,
Munich

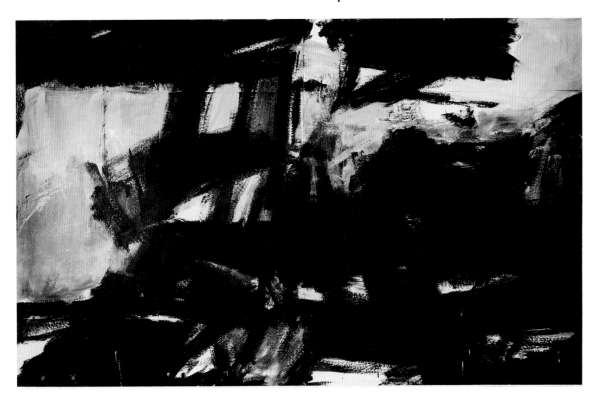

support. In a few cases, such stretching resulted in slightly askew edges—less than perfect rectangles. Paintings on homosote panels presented more substantial transport problems, solved by separating the panels, stacking them on top of the elevator, and moving them in that way up to the Janis Gallery. There, they were reassembled.[11]

Often working from a small study—such as a telephone-book drawing—Kline enlarged it freehand on canvas, at times by first drawing the configuration in charcoal. Yet while many large paintings were based on small studies, many were not. In the 1960 Janis show, for example, five of Kline's eleven large works began as single drawings; five did not. The largest painting, New Year Wall: Night (plate 159), according to the artist, was based on "innumerable small preparatory drawings."[12] By referring to several sketches, Kline synthesized pictorial ingredients while painting alla prima.

Reviewing Kline's first one-man show at the Janis Gallery in 1956, Tom Hess noted that white in the paintings had changed from previous work: "The white paint is whiter, bluer, more snowlike."[13] This was due, at least in part, to Kline's shift to tube whites. His earlier whites, actually oil-based housepaint, have today yellowed. Like the telephone-book pages, commercial housepaint was not made to last for more than a few years. Owing to high oil content, these commercial whites discolor; they will, however, bleach if exposed cautiously to sunlight.

Continuing the 1956 review, Hess noted: "The blacks differentiate themselves as fat and lean pigments—an effect that may be lost a century from now when the oil has completely oxidized."[14] Less than thirty years later, the change is well underway. Unlike white, which has large pigment particles and tends to dry fast, black consists of smaller particles that require more oil to bind them into a workable medium. Black therefore dries more slowly. In a black and white painting, particularly one with reworked areas, bonding problems may occur with age. Layers may begin to separate. At the same time, cracks may appear in the paint surface. A major conservation

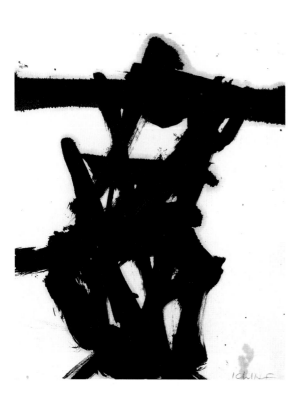

160. **BLACK AND WHITE**, c. 1956
Oil on paper, 12½ × 10 in.
The Cleveland Museum of Art;
Contemporary Collection

concern is maintaining—or returning—such a Kline surface to a plane. This may mean mounting the work, for instance, on a honeycomb panel. Yet that may not stabilize the separating layers adhering to the support (canvas or paper). Lining the back of a canvas—popularly called "relining"—may be achieved by using a heat-table, an adhesive (often wax resin), and pressure. However, the process brings its own problems: thickly painted areas may be flattened and discoloration may result; the weave texture of the canvas support may be emphasized, and the canvas support may become rigid. Advanced thinking among conservators today tends to be conservative, namely the less done to a Kline painting the better. That includes moving an unstable painting, for Klines have been known to shed bits of paint in shipment. To retard conservation problems, minimal movement is generally prescribed.

The inevitable aging process interacting with Kline's combination of black and white pigments is softening the effect of his work. Not only have surfaces cracked, whites yellowed, and bonded layers pulled apart, paintings once intensely black have taken on a flat, hazy appearance. This is quite apparent in early works with large black areas, such as *Wanamaker Block* (plate 162), which has acquired a thin, chalklike cast. White underpainting, more "moisture-loving" than oil-rich black, is actually being drawn through the black surface by humidity in the air. Kline did not varnish his paintings, although some were varnished by conservators during his lifetime. This has also altered the artist's vision of his work by imposing a consistency of surface and diminishing the original range of blacks, some glossy, others matte. At the same time, varnishing may protect a surface and, by sealing it, slow whitening of black areas. Still, most conservators in all likelihood would advise removing varnish in an attempt to return a Kline as close to its original state as possible.[15]

For all its impact, Kline's most celebrated art—his black and white painting—is among the most fragile of our century. In that fateful contrast of appearance vs. physical condition, it truly mirrors the artist.

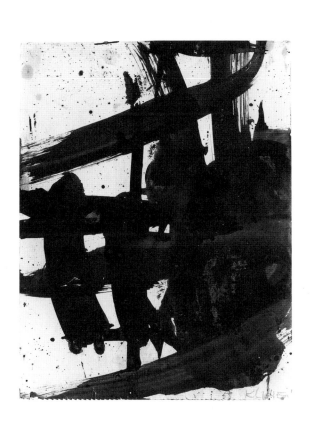

161. **STUDY FOR "TURBIN,"** 1958
Gouache on paper, 11 × 8½ in.
Dr. and Mrs. Donald L. Jacobs

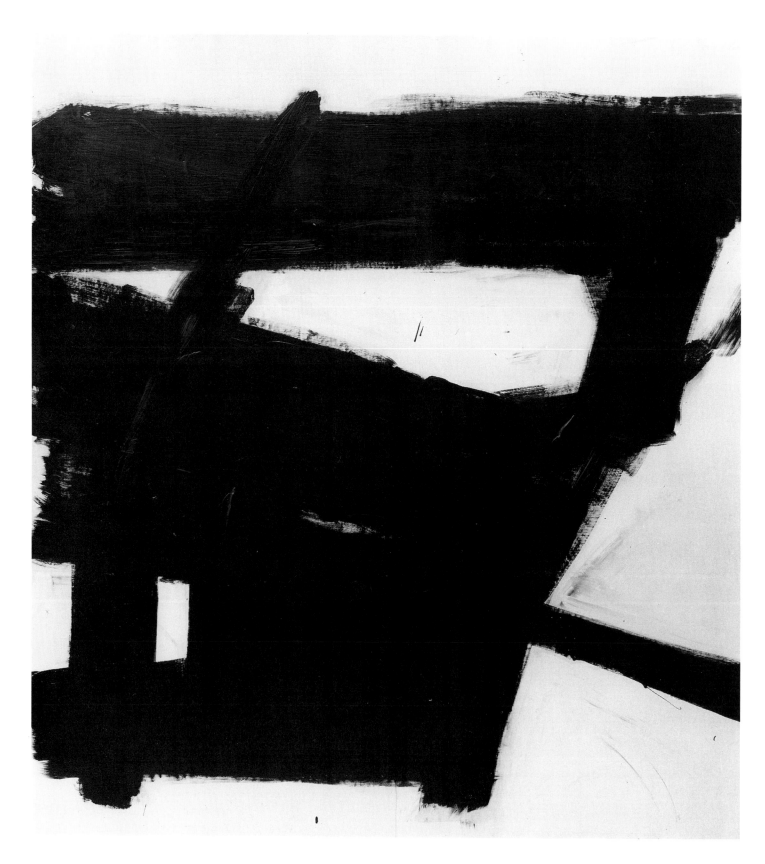

162. **WANAMAKER BLOCK**, 1955
Oil on canvas, 78¾ × 71¼ in.
Yale University Art Gallery,
New Haven, Connecticut;
Richard Brown Baker Collection

NOTES

Introduction (pages 11–23)

1. Elizabeth V. Kline, taped interview by I. David Orr, June 10, 1967.
2. Elaine de Kooning, "Franz Kline: Painter of His Own Life," *Artnews* 61 (November 1962): 30.
3. Kline, quoted in Frank Crotty, "The People Laughed and Were Fascinated," *Worcester Sunday Telegram, Parade* section, May 24, 1964, p. 10.
4. Martha Kinney Baker, interview with author, Salem, New Hampshire, November 9, 1984.
5. Ibid.
6. Mrs. Kline, interview, June 10, 1967.
7. Ibid.
8. Thomas B. Hess, letter to author, February 16, 1968.
9. Lee V. Eastman, interview with author, New York, November 15, 1984.
10. Emmanuel Navaretta, letter to author, November 9, 1967. Kline's 1957 painting *Garcia* owes its title to the 1936 film.
11. Mrs. Kline, interview, June 10, 1967.
12. Elisabeth Ross Zogbaum, interview with author, New York, February 15, 1970. Mrs. Zogbaum was Kline's companion during the last years of his life and the executrix of his estate.

For a discussion of Kline prices, see "Sidney Janis," in Laura de Coppet and Alan Jones, *The Art Dealers* (New York: Potter and Crown, 1984), p. 39.

13. Eastman, interview, November 15, 1984.
14. Grace Hartigan, interview with author, Baltimore, June 16, 1984.
15. Mrs. Kline, interview, June 10, 1967.
16. "I suppose I work fast most of the time, but what goes into a painting isn't just done while you're painting. There are certain canvases here in my studio—the little one over there—that I've worked on for a good six months—painting most of it out and then painting it over and over again." Kline, quoted in Katharine Kuh, *The Artist's Voice* (New York: Harper and Row, 1962), p. 145.
17. Mrs. Kline, interview, June 10, 1967.
18. Elaine de Kooning, interview with author, East Hampton, August 17, 1980.
19. James Brooks, interview with author, New York, March 19, 1970.
20. Baker, interview, November 9, 1984.
21. Clement Greenberg, *Art and Culture* (Boston: Beacon Press, 1961), p. 151. Greenberg's appraisal originally appeared in *Partisan Review*, 1952. An advertisement for Kline's first one-man show included this endorsement: "Most striking new painter in the last 3 years." —Clement Grunberg [*sic*]. *New York Times*, October 29, 1950, p. X9.
22. Clement Greenberg, conversation with author, Saratoga Springs, New York, October 4, 1984.
23. William C. Seitz, *Abstract Expressionist Painting in America* (Cambridge and London: Harvard University Press, for the National Gallery of Art, Washington, D.C., 1983), p. 165.
24. Greenberg, *Art and Culture*, p. 220.
25. Hartigan, interview, June 16, 1984.
26. Two Kline catalogs—for the 1968 Whitney Museum exhibition and the 1977 *Franz Kline: The Early Works as Signals* show at Binghamton—are, respectively, error-filled and conjectural.
27. Particularly eloquent is Thomas B. Hess, "Franz Kline," *Artnews* 60 (January 1962): 46–47, 60–61.

28. Hartigan, interview, June 16, 1984.
29. Frank O'Hara, "Introduction and Interview," in *Franz Kline, A Retrospective Exhibition* (London: Whitechapel Gallery,1964),p.6.
30. Willem de Kooning, conversation with author, East Hampton, August 9, 1971. De Kooning also noted that Kline was a major force in "The Club." The closeness of the Kline-de Kooning relationship was evoked by Edwin Denby in a 1982 interview: "I went to the Cedar once or twice and I remember Bill de Kooning and Franz Kline standing next to each other at the bar drinking....And it was adorable to see them because they were about the same size and they were like two teenagers having an absolutely marvelous time together....The way they made jokes to each other and the intimacy between them, it's still one of my happiest memories." Mark Hillringhouse, "An Interview with Edwin Denby," *Mag City*, Edwin Denby Issue 14 (1983): 113.
31. Quoted in Marcia Tucker, *Joan Mitchell*, exhibition catalog (New York: Whitney Museum of American Art, 1974), pp. 6–7.
32. Hartigan, interview, June 16, 1984. See Paul Schimmel et al., *Action/Precision: The New Direction in New York, 1955–60* (Newport, Calif.: Newport Harbor Art Museum, 1984), pp. 86–89.
33. Ibid., pp. 90–113.
34. *Cy Twombly, Paintings and Drawings: 1952–1984*, exhibition catalog (New York: Hirschl and Adler Modern, 1984), no. 1.
35. Irving Sandler, *Alex Katz* (New York: Harry Abrams, 1979), p. 16.
36. Irving Sandler, *Philip Pearlstein, A Retrospective*, exhibition catalog (Milwaukee: Milwaukee Art Center, 1983), p. 19.
37. Brice Marden, interview with author, New York, November 14, 1984.
38. Dorothy C. Miller, letter to author, April 10, 1984.

1. Studies: Lehighton, Boston, London (pages 25–33)

1. Thomas B. Hess, "Mondrian and New York Painting," in *Six Painters* (Houston: University of St. Thomas Art Department, 1967), p. 12.
2. Kline published cartoon calendars in his 1931 and 1932 high school yearbooks.
3. Kline to Witherbee, November 3, 1930, Franz Kline file (no. 10503), Girard College, Philadelphia. Kline adds stoically: "My football career at Lehighton High is ended."
4. Mrs. Kline was greatly concerned with Franz's education; she also carefully followed his career. Elaine de Kooning has compared her to the strong-willed mothers of Willem de Kooning and Jackson Pollock.
5. Emmanuel Navaretta, interview with author, New York, December 9, 1967.
6. Philip Guston, interview with author, Saratoga Springs, New York, July 24, 1968, and subsequent correspondence. Images of Krazy Kat

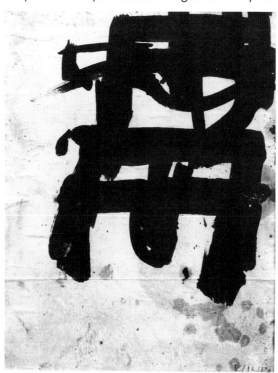

163. **BLACK AND WHITE**, 1951
Oil and ink on paper
10½ × 8½ in.
Private collection

and his brick-throwing nemesis, Ignatz Mouse, stare back at us surreptitiously from a 1951 drawing, *Black and White* (plate 163), which may at first seem totally abstract. Actually, it is a witty conjunction of figure and face, humanoid and animal.

7. Chronology in *The Art of John Held, Jr.* (Washington, D.C.: Smithsonian Institution, 1969), p. 20.
8. He must have studied other cartoonists' and illustrators' work as well, such as figure drawings by James Montgomery Flagg regularly published in *Cosmopolitan*. He may also have seen illustrations by Henry P. Raleigh, whom he spoke of in the 1950s.
9. This is the only course on his university record, which indicates that he did not continue academic courses at B.U. after 1931–32. Kline commented much later that he had gone there "with the ill-conceived notion of getting a college education and painting in my spare time." Quoted in Selden Rodman, *Conversations with Artists* (New York: Capricorn Books, 1961), p. 107.

10. "I think he agreed with most of us, that it [teaching] was a way to pay rent, eat, drink or whatever. It was something you did to get by, no great enthusiasm. I really don't know if he actually enjoyed it." Philip Guston, questionnaire from author, September 14, 1970. Guston taught with Kline at Pratt Institute. Mercedes Matter remembers Kline at Pratt as a "gentle teacher" with great patience. Mrs. Matter, interview with author, New York, November 5, 1971.

11. Frederick Ryan, letter to author, May 31, 1967. Ryan attended the league with Kline and became his close friend. The league closed in 1935.

12. Ibid.

13. Ibid. "[We] spent our evenings either at his place or mine burning a great deal of midnight oil struggling over pen drawings together which we would later show to Mr. Crosman for his criticism." Ryan and Kline also posed for Crosman, and likenesses of them "appeared from time to time as characters of fiction in the leading national magazines. We thought this a real lark!"

14. One book Kline studied was *The Quiet Life*, with reproductions of Abbey's drawings. Frederick Ryan, letter to author, September 2, 1967.

15. Kline to Ryan, August 10, 1936. Collection of Mrs. Frederick Ryan, Santa Clara, California.

16. Frederick Ryan, letter to author, August 4, 1968.

17. After settling for the summer in Provincetown in 1959, Kline visited Hensche. He spoke to his former teacher about abstract art, but Hensche understood very little of it. Henry Hensche, interview with author, Provincetown, Massachusetts, July 19, 1968.

18. Ibid. Hensche remembers teaching painting for about a year at Fenway Studio during the early 1930s. He adds that he received no pay for this work and had to leave because of ill health.

19. Heatherley's advertised regularly in the *London Studio* (also known as *Atelier*) in the 1930s. It is interesting in light of Kline's later statement about hoping to study in Paris that Heatherley's referred to itself as "A Paris School in London for Artists, Painters, Illustrators, and Commercial." Kline knew the *London Studio* from his Boston years and collected old issues. Frederick Ryan, letter to author, May 31, 1967.

20. Katharine Kuh, *The Artist's Voice* (New York: Harper and Row, 1962), p. 153. Kline didn't get to Paris until 1960 en route to the Venice Biennale.

21. A. Gordon Eames, letter to author, November 25, 1966.

22. Frank Hahn, interview with author, New York, April 8, 1970. Hahn and Kline were friends in London, and he was later the best man at Kline's wedding.

23. Kline to Ryan, August 10, 1936. Jerry Milliken had been a student with Kline and Ryan in Boston. Kline considered him an "odd duck." Frederick Ryan, letter to author, September 9, 1968.

24. Willem de Kooning, telephone conversation with author, October 8, 1971.

25. Willem de Kooning, interview with author, August 17, 1980, East Hampton.

26. William Gaunt, "English Painting of Today," *London Studio* 113 (June 1937): 294.

27. A. Gordon Eames, interview with author, Bognor Regis, June 27, 1967. Frank Hahn remembers that en route to England, Kline said he wanted to study with Augustus John. Hahn, interview, April 8, 1970. Kline's regard for Augustus John later diminished. In 1956 he said: "If Picasso had spent his whole life making drawings and portraits capable of standing up beside Ingres's—which he amply demonstrated that he could do—he'd have ended up another Augustus John, a man who did no more than follow the bent of his talent, and not Picasso." Rodman, *Conversations*, p. 109.

28. Kline could have seen paintings in London by such modern masters as Picasso, Braque, and Matisse. A contemporary critic noted: "We have seen plenty of good Matisses and Picassos in London during the past few years, but many of the Braques exhibited have not shown this painter at his best." Douglas Goldring, "Two Galleries," *London Studio* 113 (January 1937): 42–43.

29. Eames, interview, June 27, 1967. Eames noted, however, that during Kline's stay at Heatherley's no formal course in sculpture was offered. Students did only a little modeling in clay as part of drawing and painting classes. Kline would, however, have been instructed in anatomy. A photograph of the "life room" made about three years prior to Kline's enrollment (it stayed essentially the same, according to Eames) shows anatomical drawings on the walls, and students drawing from a nude model, at whose feet stands an *écorché* (plate 20). The model sits on a stool placed on a podium, thus elevating her above students' eye-level—a vantage point evident in Kline's drawings.

30. Elizabeth V. Kline, questionnaire from author, April 28, 1971.

31. Kline to Ryan, August 10, 1936.

32. Ibid. Whistler had also admired Keene's work.

33. Elizabeth V. Kline, interview with author, Cedarhurst, New York, July 25, 1970.

The entry on Phil May by E. V. Lucas in the *Dictionary of National Biography* (London, 1912), second supplement, vol. 2, p. 594, comments: "It is certain that no English draughtsman has ever attained greater vigour or vivacity in black and white."

34. In his letter to Ryan, Kline notes: "By now I have ten books on him [May], some first editions, so you see I still have Old Phil in the blood." One book, *Phil May's ABC* (London, 1897), is dated in Kline's handwriting "October 23, 1935," which indicates how soon after arriving in England he began acquiring May's albums. Several were in Kline's studio at the time of his death in 1962.

35. At Lehighton High School, Miss Roedel had been nicknamed Mars, a name Kline chose for the title of a large 1959 abstraction. The title may also be a play on Mars Black, the name of a pigment.

36. Hahn, interview, April 8, 1970.

37. Mrs. Kline, interview, July 25, 1970.

38. The subjects of the portraits were Mr. and Mrs. William Campbell, grandparents of Kline's future father-in-law, Col. W. F. Parsons.

39. Mrs. Kline, interview, July 25, 1970.

2. New York, Public and Private (pages 35–53)

1. Kline got the job to appease immigration authorities, believing that they would look more favorably on his fiancée's entry into the U.S. if it appeared he had steady work.

2. In summer 1943 Kline spent a couple days in Woodstock at the "Hornet Hovel," taking a lease. He soon left, however, handing the lease over to a girlfriend. David Orr, interview with author, May 23, 1970. Orr has a Kline drawing of "Hornet Hovel."

3. Katharine Kuh, *The Artist's Voice* (New York: Harper and Row, 1962), p. 153.

4. Thomas B. Hess, interview with author, New York, April 7, 1972. Hess noted that most of the "uptown artists" were family men whose wives had attended or graduated from college.

5. Ed Sieveri, interview with author, New York, August 4, 1971.

6. A photograph by Rudolph Burckhardt showing two of the murals in place in the tavern is reproduced in Elaine de Kooning, "Two Americans in Action: Franz Kline, Mark Rothko," *Artnews Annual* 61 (November 1957, Part II): 94. The tavern has been destroyed; the mural panels have been dispersed to various collections.

7. Although she had made her premiere in 1933 in *Esquire*, the Petty Girl was still quite popular at this time. For example, a tennis-playing Petty Girl was the major attraction in a *New York Times* advertisement, August 11, 1940, sec. 8, p. 6.

8. Elizabeth V. Kline, interview with author, Cedarhurst, New York, July 25, 1970. She recalls that Franz knew Throckmorton in 1938; he was one of the first persons she met in the U.S. after she and Kline were married.

9. El Chico's had opened on Sullivan Street in 1925; it moved to Sheridan Square in fall 1927. Dulce C. Braunhut (Collada's niece), letter to author, November 2, 1970, pp. 1–2. Also, Martha K. Phillips, interview with author, New York, July 12, 1971.

10. *Rio Rita* and *Rose of the Rancho* both starred John Boles, an actor featured in 1936 in one of Kline's favorite movies, *A Message to Garcia*. Emmanuel Navaretta, letter to author, November 9, 1967. Kline, incidentally, bore a physical resemblance to Boles.

11. Elizabeth V. Kline, letter to author, October 18, 1970, p. 8.

12. Elaine de Kooning, "Franz Kline, Painter of His Own Life," *Artnews* 61 (November 1962): 28.

13. Mrs. Kline, interview, July 25, 1970; Emmanuel Navaretta, interview with author, New York, December 9, 1967.

14. W. G. Constable, *Canaletto*, vol. 2 (Oxford: Clarendon Press, 1962), no. 420, p. 383. The National Gallery acquired the painting in 1894.

15. Kline to Orr, postmarked June 20, 1945. Kline's address, written on the letter, was 148 West Fourth Street, slightly more than three blocks east of El Chico's.

16. Martin's murals, filled with flamenco dancers and guitarists, are signed "Julio Martin 1945," indicating that they had been painted and were probably in place before the end of that year. Kline's murals, then, could hardly have been on display more than six months. After Kline died in 1962, Collada had the murals uncovered and taken to his apartment (at the same address as El Chico's). In May 1965 El Chico's closed and Collada retired to San Juan, Puerto Rico, taking Kline's paintings with him. They were subsequently sold to Gilbert Di Lucia of New York. Braunhut, letter, Novem-

ber 2, 1970, pp. 2–3. Perhaps Kline should not bear all the blame for the dismal El Chico murals. Orr believes that Kline only completed a commission given to the illustrator Henry Patrick Raleigh. Martha K. Phillips also recalled Kline's taking over the job from another artist. Both Philip Guston and George McNeil remembered Kline's talking about Raleigh in the early 1950s. McNeil noted that Kline said he had worked for Raleigh at one time. Raleigh's illustrations had appeared in such magazines as the *Saturday Evening Post*.

17. David Orr, interview with author, November 1, 1970.

18. A loan from Miss Roedel made this possible. Frank Hahn helped Kline set up the press. Frank Hahn, interview with author, New York, April 8, 1970. Kline kept the press until 1953, when he sold it upon moving out of his Ninth Street studio. Orr, interview, November 1, 1970.

19. The etching was based on an ink drawing nearly identical in composition and details.

Named Kitska by Kline, she was a gift for Elizabeth. In the mid-1940s he gave the cat to some children to take upstate for the summer. However, the cat ran away and Kline made a trip upstate to find her—with no luck. He made at least two Kitska portraits.

20. Mrs. Kline, interview, July 25, 1970. Kline wrote after the move that he and Elizabeth were "both here trying to fix up a top floor with everything the old masters would have loved—cheap rent, lots of room, light—and silence after Macdougal Street." Kline to Ryan, January 21, 1940.

21. David Orr, interview with author, April 27, 1972.

22. Elizabeth V. Kline, letter to author, June 23, 1971.

23. Mrs. Kline, interview, July 25, 1970.

24. David Orr, interview with author, October 15, 1977.

25. Elaine de Kooning, "Franz Kline," pp. 28, 68.

26. Mrs. Kline, interview, July 25, 1970.

27. Dr. and Mrs. Theodore Edlich, Jr., interview with author, New York, September 26, 1970.

28. David Orr, interview with author, August 19, 1984.

29. Suggestion made to the author by Thomas B. Hess during interview.

30. Elizabeth V. Kline, letter to author, April 28, 1971, p. 2.

31. Kline, quoted in Gerald Nordland, *Earl Kerkam, Memorial Exhibition*, exhibition catalog (Washington, D.C.: Washington Gallery of Modern Art, 1966), p. 9.

32. Franz and Elizabeth lived at 150 West Fourth in 1943 and in 1945 he used 148 as a studio after Marca-Relli moved out. Elizabeth V. Kline, letter to author, August 13, 1970.

33. The lettering under the drawing is typically Kline's for this date. "The Major's" shop occupied the two street-level stores in the center and on the right of the sketch. As for the Pepper Pot, Al Jolson, Grace Moore, and Norma Shearer worked there "in various jobs" at one time. Edmund T. Delaney, *New York's Greenwich Village* (Barre, Mass., 1968), p. 107. A photograph taken during the early 1940s and once in Kline's possession is nearly identical to the sketch. He may have referred to it while making the drawing.

34. Dedicated on October 7, 1928, the church was only two blocks south of Kline's studio. Earlier in the 1940s he had drawn another Village landmark, St. Joseph's Roman Catholic Church, a Greek Revival building at the corner of Sixth Avenue and Washington Place.

35. Kline had the painting for quite a while without selling it. He hoped that reducing the size would help secure a sale. Orr, interview, November 1, 1970.

36. Ibid. Kline exhibited *The Playground* in 1945 at the *119th Annual Exhibition* at the National Academy of Design, March 14– April 3.

37. Kline very much admired Soutine's painting. Orr, interview, August 19, 1984. For Soutine's impact on other Abstract Expressionists see Irving Sandler, *The Triumph of American Painting* (New York: Praeger, 1970), pp. 98–99.

38. The drawing appeared in "The Beginning and the End of Sixty Years of the Sixth Avenue 'El,'" *New York Times*, December 5, 1938, p. 3. The drawing was identified as in the J. Clarence Davies Collection, the Museum of the City of New York. It was also reproduced in "Epic of the El," *New York Times*, December 11, 1938, rotogravure sec. 8, p. 2. In all probability, Kline's etching served as the illustration for his Christmas card.

3. Pennsylvania Landscape (pages 55–65)

1. The Truman Prize, awarded to painters under thirty-five, was first given in 1941; its fund was set up by the bequest of Ella W. Everett. Alice G. Melrose (director, National Academy of Design), letter to author, March 9, 1971.

2. It is well known that Kline liked model trains. One that he kept in his studio is visible in the

photograph of his desk reproduced in *Artnews* 66 (March 1967): 40.

3. Kline ordered the Thunderbird in East Hampton on June 16, 1958, and paid for it on July 31. Kline Papers, microfilm roll D206, Archives of American Art. He bought the Ferrari after returning from Europe in July 1960. During the 1957 Christmas holidays, when visiting friends at East Hampton, he drove a vintage Lincoln with rumbleseat and wire wheels, but the car kept breaking down. Elisabeth Ross Zogbaum, interview with author, New York, July 14, 1970.

4. Kline to his mother, stepfather, and stepniece. The letter, dated only "Thursday, P.M.," would have been written on February 18, 1943. Collection of Mrs. Louise K. Kelly, State College, Pennsylvania.

5. Edward Alden Jewell, "Landscape Takes $500 Altman Prize," *New York Times*, February 16, 1943, p. 13. (The Altman prize went to *Tower Street*, a landscape by Antonio Martino.) The exhibition included 248 paintings, 127 prints and drawings, and 72 sculptures.

6. Edward Alden Jewell, "National Academy Annual," *New York Times*, February 21, 1943, sec. 2, p. 11.

7. In 1944 the prize was $250, rather than $300 as in 1943. Another painting, *Lehigh Winter Scene* (1946, Orr Collection), is quite similar to *Lehigh River, Winter* (1944) except that the later work is a snowscape, the only one Kline painted.

8. Kline, letter, February 18, 1943.

9. When visiting their studio in the 1940s, Charles G. Gernerd noticed a cupboard piled high with rolled-up newspapers, which they undoubtedly burned to keep warm. Gernerd, interview with author, Toms River, New Jersey, July 30, 1968.

10. The back of the postcard describes the Black Diamond as "the de luxe daylight train of the Lehigh Valley Railroad between New York and Philadelphia, and Buffalo." The Black Diamond made its first run through Lehighton in May 1896; its last was in May 1959. Richard J. Hoben, *The Story of Lehighton* (Lehighton: Lehighton Centennial Committee, 1966), p. 75.

11. A Lehigh Valley caboose is also the major feature in a 1945 drawing of the Lehighton Freight Station, although Kline was just as interested in the struts supporting the platform's roof as in the caboose or engine down the tracks.

12. Records of American Legion Post 314 state that he received $600 for the painting, $400 of which was paid in advance.

13. As well as the bridge, other details can be identified: the Trinity Evangelical Lutheran Church (pointed spire) and Zion Reformed Church (rectangular tower), the Lehighton cemetery, the borough park with statue of Col. Jacob Weiss (Revolutionary War soldier and park donor). To the left, across from the park on the corner of First and North streets, is the Carbon House, a tavern and hotel built in 1842 by Jacob Metzger and torn down in 1968. Lehighton Memorial Library, letter to author, February 1971. The Carbon House is the subject of another Kline painting, c. 1946–47.

14. The mural is 3½ inches higher and 10 inches wider than the El Chico bullring painting from the previous year. The lively, free-swinging nature of the Lehighton picture, in contrast to the stilted Spanish extravaganza, is obviously attributable in part to Kline's thorough familiarity with his subject in the later work.

15. The city in Luzerne County is spelled Hazleton but all references to the 1957 painting spell it Hazelton. There is no doubt, however, that the source of the title was the name of the town. Kline may have transposed the two letters in the title or it may have been misspelled by someone listing the painting for the Kline exhibition organized by the Museum of Modern Art for European museums in 1964.

16. Philip Guston, telephone interview with author, September 5, 1970. In all probability Kline liked the sound of Mauch Chunk, which is also the name of a mountain and ridge in Schuylkill and Carbon counties. The name was derived from *Machk*, meaning "a bear," and *Wachtschu*, "a hill or mountain." *Mauchtschunk* thus means "at the bear mountain." George P. Donehoo, *A History of the Indian Villages and Place Names in Pennsylvania with numerous notes and references* (Harrisburg, 1928), p. 106.

17. Nicholas Marsicano, interview with author, New York, May 8, 1970. Marsicano is a native of Shenandoah, Pennsylvania.

18. The town's new name was chosen in honor of the great Indian athlete, who died in 1953.

19. The Pennsylvania town and the Olympic athlete were not the only Thorpes that Kline knew. On October 21, 1935, in London, he had bought one of the many Phil May books he would collect: *Phil May, Master-Draughtsman & Humorist, 1864-1903* (London, 1932). James Thorpe was the author. In 1957, while in Chicago to help judge the *Momentum* exhibition, Kline and Guston talked about exchanging paintings, *Thorpe* for *The Clock I* (1957); but they never got around to making the trade.

4. Nijinsky, Self-Portraits, Clowns (pages 67–73)

1. Frank Hahn, interview with author, New York, April 8, 1970. Hahn shared an apartment with Kline in London; Kline showed him a clipping of the photo, saying that he liked it.

2. "Franz eventually loaned, lost, or sold these two books." Elizabeth V. Kline, letter to author, April 28, 1971, p. 3.

3. Ibid., p. 4. Chaney starred in *Laugh, Clown, Laugh*, based on the Pagliacci story, in 1928. Deems Taylor, *A Pictorial History of the Movies* (New York: Simon and Schuster, 1943), p. 207.

4. Another photo taken in 1944 shows him standing proudly beside one of his Nijinsky pictures in Martha K. Phillips's art supply shop at 9 Christopher Street.

5. Elizabeth V. Kline, interview with author, Cedarhurst, New York, July 25, 1970.

6. Elizabeth V. Kline, letter to author, June 5, 1971. She adds: "He was working on a circus composition the first time I posed for him. He had me sit sideways on the arm of an armchair as if I were a circus dancer riding sidesaddle on a horse." This was in London, 1937.

7. David Orr, letter to author, April 24, 1971. Orr estimates that six or eight weeks passed between the time Kline began the painting and completed it.

8. Ibid. This suggests de Kooning's practice in the 1960s of drawing with his eyes closed.

9. Elizabeth V. Kline, letter to author, June 23, 1971. She adds: "Franz 'made faces' at himself in the mirror, sometimes in joke, to 'see what happens to the lines and masses as a face changes expression'—or words to that effect." This brings to mind early self-portraits by Rembrandt, an artist Kline admired. While in England, Elizabeth bought him two volumes on Rembrandt, which he studied.

10. David Orr, interview with author, New York, June 19, 1971.

11. David Orr, interview with author, August 19, 1984.

12. Kline, quoted in Katharine Kuh, *The Artist's Voice* (New York: Harper and Row, 1962), p. 143.

13. David Orr, interview with author, May 23, 1970. Also, Gerald Nordland, *Earl Kerkam Memorial Exhibition*, exhibition catalog (Washington, D.C.: Washington Gallery of Modern Art, 1966), p. 9. Nordland notes that after being evicted from his apartment in spring 1950, "Kerkam arranged to paint in Kline's studio which was adequate for them both" (p. 10). The Nordland essay contains several anecdotes about the Kline-Kerkam friendship. In "Kerkam Paints a Picture," *Artnews* 49 (February 1951): 44–45ff., Elaine de Kooning also mentions that Kerkam had been painting in Kline's studio. The artists differed, however, in working habits. Kline frequently painted at night under artificial light, while Kerkam worked during the day. Mrs. de Kooning quotes Kerkam: "Just so long as the light is cool and even—I can't work where there's a bit of sun—any room will do" (p. 44).

14. Richard Buckle, *Nijinsky* (London: Weidenfeld and Nicolson, 1971), pp. 441–42. See also "Nijinsky Dies at 60 in London Hospital," *New York Times*, April 9, 1950, p. 84, and "Nijinsky Burial Friday," *New York Times*, April 10, 1950, p. 19.

15. Buckle, *Nijinsky*, p. 127.

5. Abstraction (pages 75–103)

1. Willem de Kooning, telephone conversation with author, October 8, 1971.

2. An introduction to those principles is in *Hawthorne on Painting* (New York: Dover, 1965). The book was assembled from students' notes by Mrs. Hawthorne and contains an introduction by Edwin Dickinson and an appreciation by Hans Hofmann.

3. Elizabeth V. Kline, interview with author, Cedarhurst, New York, July 25, 1970.

4. Elizabeth V. Kline, letter to author, June 23, 1971.

5. Using figurative and abstract styles at the same time was not unique to Kline. Gorky and de Kooning, for example, had worked simultaneously in both modes in the late 1930s.

6. Dr. and Mrs. Theodore Edlich, Jr., interview with author, New York, September 26, 1970. One must be cautious, of course, in interpreting Kline's use of *abstract*. The term had a wide range for him, as indicated by his 1943 reference to *Palmerton, Pa.* as "slightly abstract."

7. The painting was named *Rocker* by its owner, William H. Lane, not by Kline. However, Kline did print his monogram and date on the back of the painting.

In 1953, when he was just beginning to collect, Lane acquired eleven paintings, including *Rocker*, from the artist. Lane visited the studio, and Kline showed him a group of "color abstractions" from the late 1940s, pulling them out from a rack at the center of the room. Some had to be patched up, so Lane came back for them a few days later; he got the impression

that Kline would have painted black and white abstractions over them if he hadn't sold them. Kline printed his name or initials on the backs of the paintings and dated them when Lane picked them up. Since the dates were determined only by Kline's memory, it is possible that some are not exact, although there is no reason to doubt the general sequence. All of the "color abstractions" but one were dated 1948 or 1949. William H. Lane, interview with author, Lunenberg, Massachusetts, July 20, 1971.

8. Kline also turned paintings in the 1950s while working on them. Thomas B. Hess, interview with author, New York, April 7, 1972.

9. Elisabeth Ross Zogbaum, interview with author, New York, February 15, 1970. She suggested to Kline that the painting looked better as a vertical, and he agreed.

10. Willem de Kooning, conversations with author, August 9 and October 8, 1971.

11. Elaine de Kooning, "Franz Kline, Painter of His Own Life," *Artnews* 61 (November 1962): 28–31.

12. In her article Elaine de Kooning wrote that it was "one day in '49," but in reflecting on it she said it could have been 1948. Elaine de Kooning, interview with author, New York, April 14, 1972.

13. Willem de Kooning exhibited "largely black-and-white paintings, 1946–48" in his first one-man show at the Egan Gallery, April 12–May 12 (extended into June), 1948. Thomas B. Hess, *Willem de Kooning* (New York: Museum of Modern Art, 1968), p. 119. For the controversy about whether Kline was "instantly converted" to abstraction, see Thomas B. Hess, "The Convertible Oyster," *New York Magazine* 8 (April 7, 1975): 68–69.

14. Richard Diebenkorn, letter to author, February 20, 1985.

15. Philip Guston, letter to author, September 14, 1970. He noted: "I acted as a sort of carpenter's helper; two days did it."

16. Before opening his gallery in February 1946, Charles Egan had been associated with the Ferargil Galleries and the New Art Circle. Frances M. Celentano, "The Origins and Development of Abstract-Expressionism in the United States" (Master's thesis, New York University, 1957), p. 80. Egan had a partnership with Mr. and Mrs. George Poindexter at the time of Kline's one-man shows in 1950 and 1951; it fell through, however, because of financial disagreements. Charles Egan, interview with author, New York, March 11, 1970. Listed on the back of the brochure announcing Kline's

1950 show were these artists, also exhibiting at Egan's: Albers, Cavallon, de Niro, Cornell, de Kooning, Lewitin, Hillsmith, McNeil, Nakian, Noguchi, Siskind, Tworkov.

17. Emmanuel Navaretta, interview with author, New York, December 9, 1967. Kline had his first one-man show at the Janis Gallery in March 1956, after leaving Egan.

18. Egan, interview, March 11, 1970.

19. At this time, Kline was an art instructor at Schroon Crest, a summer resort at Schroon Lake near Pottersville, New York.

20. Elizabeth V. Kline, interview with author, Cedarhurst, New York, July 25, 1970.

21. Clement Greenberg, conversation with author, Saratoga Springs, New York, October 4, 1984.

22. John Ferren, interview with author, New York, April 4, 1967.

23. Thomas B. Hess, "Seeing the Young New Yorkers," *Artnews* 49 (May 1950): 23. Hess remembered that Kline's painting was similar to *Gray Abstraction* (1949), adding that Vicente's was black and white. Hess, interview, April 7, 1972. The exhibition was also reviewed by Welden Kees, "Art," *Nation* 170 (May 6, 1950): 430–31, who noted: "I admired the spirit of the works by Robert Goodnough and Franz Kline."

24. Robert Goldwater, "Franz Kline: Darkness Visible," in *Franz Kline, 1910–1962* (New York: Marlborough-Gerson Gallery, 1967), p. 7.

25. Navaretta, interview, December 9, 1967.

26. Ferren, interview, April 4, 1967.

27. Navaretta, interview, December 9, 1967.

28. The photo was taken after July 16, 1950, the date on the double page from the *New York Times* pinned on the back wall.

29. His painting technique, including reasons for painting on unstretched canvas, is discussed by Robert Goodnough, "Kline Paints a Picture," *Artnews* 51 (December 1952): 36–39ff.

30. Hess, interview, April 7, 1972. This sheet was reproduced on its side in Julien Alvard, "Franz Kline," *Aujourd'hui* 41 (October 1964): 8, where it is mistakenly identified as "Collage, 1954."

31. Navaretta, interview, December 9, 1967. Years before, in England, Kline had also experimented with writing his signature. Mrs. Kline, interview, July 25, 1970. Elaine de Kooning wrote a statement for the brochure but it was not published, because the brochure was too small and a larger one would have cost too much. Part of her statement was included, however, in Kline's section of *12 Americans,*

ed. Dorothy Miller (New York: Museum of Modern Art, 1956), p. 58.

32. Navaretta, interview, December 9, 1967.

33. Elaine de Kooning, interview, April 14, 1972. She discussed this session in "Franz Kline," noting that Kline "talked about everything except painting" (pp. 68–69). Hess mentioned that such communal naming sessions were common among New York artists. Hess, interview, April 7, 1972.

34. Elaine de Kooning, "Franz Kline," p. 68. She also remembers a possible association Kline made between *Cardinal* and a fence.

35. Navaretta, interview, December 9, 1967.

36. Paul Michael, ed., *The American Movies Reference Book, The Sound Era* (Englewood Cliffs, N.J.: Prentice-Hall, 1969), p. 56.

37. John Martin, "The Dance: On the Calendar," *New York Times*, September 17, 1950, sec. II, p. 2.

38. Paintings in Kline's 1950 show were reproduced in Sabro Hasegawa, "The Beauty of Black and White," *Bokubi* (Tokyo) 12 (1951).

39. Ferren, interview, April 4, 1967. Living on the floor below, Ferren would plead with Kline to turn down the music.

40. Solinger provided the funds to buy *Chief* for the museum, which officially accepted it on January 22, 1952. At that time, MoMA's board would not have put up the money for such an abstract painting. David M. Solinger, conversation with author, New York, May 18, 1970.

41. Egan, interview, March 11, 1970.

42. Manny Farber, "Art," *Nation* 171 (November 11, 1950): 445.

43. Kline's early interiors feature squares and rectangles as picture frames hanging on background walls. He loved antique frames, collecting and refinishing them for a few dollars. In the 1940s he designed and lettered a tiny nameplate in the shape of a frame for Martha Phillips's art shop on Christopher Street.

44. For Stella's interest in Kline see Robert Rosenblum, *Frank Stella* (Harmondsworth and Baltimore: Penguin, 1971), p. 57. For Hesse's, see *Art Talk*, ed. Cindy Nemser (New York: Scribner's, 1975), p. 223.

45. Andrew Kagan, "Paul Klee's Influence on American Painting, Part II," *Arts Magazine* 50 (September 1975): 84–85.

46. Angelica Z. Rudenstine, *The Guggenheim Museum Collection, Paintings, 1880–1945,* vol. 2. (New York: Guggenheim Museum, 1976), p. 585.

47. The painting was included in a one-man show at the Kootz Gallery, January 10–30, 1950. The brochure *New Paintings by Adolph Gottlieb* lists it as no. 6.

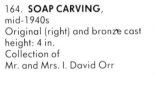

164. **SOAP CARVING**,
mid-1940s
Original (right) and bronze cast
height: 4 in.
Collection of
Mr. and Mrs. I. David Orr

48. Margaret Lowengrund, "Variations on Albers," *Art Digest* 23 (February 1, 1949): 14.

49. Kline, quoted in Frank O'Hara, "Introduction and Interview," *Franz Kline Retrospective Exhibition*, exhibition catalog (London: Whitechapel Gallery, 1964), p. 6.

50. Nicholas Marsicano, interview with author, New York, May 8, 1970.

51. Kline, quoted in Katharine Kuh, *The Artist's Voice* (New York: Harper and Row, 1962), p. 153.

52. A page in Kline's checkbook shows that he spelled the title first *Scudara*, changing it to *Scudera*.

53. David Orr, interview with author, New York, September 30, 1984. Kline considered the painting an important one and offered to sell it to Orr for $175 in the late 1950s.

54. David McKee, conversation with author, New York, September 29, 1984, and Mr. and Mrs. Burton Tremaine, notes to author, December 1965.

55. Author's conversations with Elaine de Kooning, New York, December 2, 1982, and Bonnie Clearwater, New York, October 12, 1984.

56. James K. Monte, *Mark di Suvero* (New York: Whitney Museum of American Art, 1975), p. 13. See also Lawrence Alloway, "Kline's Estate," *Arts Magazine* 41 (April 1967): 40–43.

57. The head, *Portrait of Gloria*, and the man, cut from a bar of Swan soap for David Orr's daughter Sue (plate 164), were private works never intended for exhibition. While a student in Boston, Kline made a drawing of Michelangelo's sculpture Aurora in the Medici Chapel, probably working from a plaster cast.

6. Beyond Abstraction (pages 105–53)

1. Frank O'Hara, "Franz Kline Talking," *Evergreen Review* 2 (Autumn 1958): 58.

2. Dr. Israel Rosen, interview with author, Baltimore, June 14, 1984.

3. Kline, quoted in John I. H. Baur, ed., *The New Decade*, exhibition catalog (New York: Whitney Museum of American Art, 1955), p. 48. John Ferren recalled that Kline avoided discussing his own paintings, perhaps only once or twice relating them to Hans Hofmann's ideas about "push-pull." John Ferren, interview with author, New York, April 4, 1967.

4. Lee V. Eastman, letter to author, November 26, 1984.

5. Cunningham had been at Black Mountain with Kline during summer 1952. Martin Duberman, *Black Mountain, An Exploration in Community* (New York: E. P. Dutton, 1972), p. 346. For Hasegawa's comments about Kline's art see Martica Sawin, "An American Artist in Japan," *Art Digest* 29 (August 1, 1955): 12–13.

6. Philip Guston suggested that the painting's title might be a reference to Harley-Davidson motorcycles. Philip Guston, letter to author, September 14, 1970.

7. Referring to titles, Kline said: "Sometimes it's just that I like the names—the words themselves. For instance, the painting I called Dahlia doesn't have anything to do with a dahlia." Quoted in Katharine Kuh, *The Artist's Voice* (New York: Harper and Row, 1962), p. 152. In fact, *Dahlia* is similar to a small drawing-painting in the Orr Collection of the neoclassical church at Sixth Avenue and Washington Place.

8. Kline, quoted in David Sylvester, "Franz Kline 1910–1962: An Interview with David Sylvester," *Living Arts* 1 (Spring 1963): 10.

9. B. H. Friedman, *Jackson Pollock: Energy Made Visible* (New York: McGraw-Hill, 1972), p. 215. Kline unquestionably admired Pollock, although an early look at reproductions of the poured paintings from 1947–49 puzzled him. "Several friends have discussed the Jackson Pollock article in *Life* and I'm afraid no amount of talking explains the form he seems to have derived from their children's spilling of jam." Kline to Orr, Lehighton, September 1949.

10. Examples are *Monitor* and *De Medici*, 1956; *Garcia* and *August Day*, 1957; *Turbin* and *Charcoal, Black, and Tan*, 1959; *Ravenna* and *Wax Wing*, 1960; *West Brand* and *Polize*, 1961.

11. Leo Steinberg, "Month in Review," *Arts Magazine* 30 (April 1956): 42–43.

12. As Kline said, "I don't paint in series but sometimes there are paintings that are similar, related visually more than in meaning or source." Quoted in Kuh, *Artist's Voice*, p. 152.

13. For example: H. Harvard Arnason et al., *Robert Motherwell*, 2d. ed. (New York: Harry N. Abrams, 1982); Dore Ashton, *About Rothko* (New York: Oxford University Press, 1983); Harry Rand, *Arshile Gorky, The Implications of Symbols* (Montclair, N.J.: Allanheld and Schram, 1981).

14. Kline, quoted in Robert Creeley, "The Art of Poetry X," *Paris Review* 44 (Fall 1968): 173–74.

15. Harold Rosenberg, "Big," in *Artworks and Packages* (New York: Delta, 1971), pp. 113–23.

16. Martha Kinney Baker, interview with author, Salem, New Hampshire, November 9, 1984.

17. The title refers to a row of *V* shapes in the bridge itself.

18. David Orr, interview with author, September 30, 1984.

19. Philip Guston, interview with author, Saratoga Springs, New York, July 24, 1968.

20. Aaron Siskind, letter to the author, March 30, 1971.

21. *Orleans*, of course, may also refer to New Orleans jazz.

22. I am indebted to Professor Creighton Gilbert of Yale for pointing out this anomaly in dialect.

23. Kline, quoted in Kuh, *Artist's Voice*, p. 153.

24. Kline, quoted by Elizabeth V. Kline, taped interview by David Orr, June 10, 1967. Actually, Kline's time away from a permanent home amounted to about eight years (1917–25), but it may have seemed longer. Mrs. Kline also stated in this interview that one reason Franz admired David and Miriam Orr was because they represented the kind of stable home he wished he had known.

25. Kline, quoted in Thomas B. Hess, "Is Today's Artist with or against the Past?" *Artnews* 57 (September 1958): 40.

26. Orr, interview, September 30, 1984.

27. An affinity also exists between Kline's *Black and White Composition* (1955) and Whistler's *Nocturne in Blue and Gold: Old Battersea Bridge* (c. 1872–75).

28. Kline, quoted in Kuh, *Artist's Voice*, p. 144.

29. According to Freer Gallery records, the tray was exhibited February 25, 1956, to March 15, 1957. David Orr remembers that Kline made a trip to Washington, D.C., in the mid-1950s. A 1959 painting in Kline's 1960 one-man show at the Janis Gallery was entitled *Potomac*.

30. Sidney Janis, interview with author, New York, April 8, 1971.

31. Thomas B. Hess, interview with author, New York, April 7, 1972.

32. Leo Steinberg, letter to author, November 16, 1978.

33. I am indebted to Grace Hartigan for identification of Dr. Andrus.

34. Kline, quoted in Sylvester, "Franz Kline," p. 4.

35. This group comprises *Orange and Black Wall* and *Washington Wall* (both 1959); *New Year Wall: Night* (1960); and *Shenandoah Wall* (1961).

36. Summing up her response to the show, Barbara Butler noted: "The exhibition as a whole presents enough pictorial ideas and themes for the lifework of a painter. It is brilliant—and various—and new." "Franz Kline," *Arts Magazine* 34 (April 1960): 55.

37. Fairfield Porter, "Impressionism and Painting To-Day," in *Art in Its Own Terms*, ed. Rackstraw Downes (New York: Taplinger, 1979), p. 113.

38. Donald Judd, "Franz Kline," *Arts Magazine* 36 (February 1962): 44.

39. Elaine de Kooning, "Franz Kline, Painter of His Own Life," *Artnews* 61 (November 1962): 68.

40. The title may refer to Lester Young, the jazz saxophonist. It may also refer to a young man named Lester whom Kline saved from suicide in England. Elizabeth V. Kline, interview with author, Cedarhurst, New York, July 25, 1970.

41. Robert Goldwater, "Franz Kline: Darkness Visible," *Artnews* 66 (March 1967): 43, 77.

42. Thomas B. Hess, *Willem de Kooning* (New York: George Braziller, 1959), p. 26.

43. Kline, quoted by Grace Hartigan, interview with author, Baltimore, June 16, 1984.

7. Techniques and Conservation (pages 155–61)

1. Lawrence Alloway, "Kline's Estate," *Arts Magazine* (April 1967): 40.

2. Laura de Coppet and Alan Jones, *The Art Dealers* (New York: Potter and Crown, 1984), p. 39.

3. Christie's catalog, *Contemporary Art, Part II*, November 2, 1984, nos. 150, 16.

4. Ibid., no. 148.

5. John Ferren, interview with author, New York, April 4, 1967.

6. Richard W. Walker, "The Art Market," *Artnews* 83 (February 1984): 18.

7. Norman Solomon, letter to author, June 16, 1975.

8. Martha Phillips, interview with author, New York, July 12, 1971.

9. Robert Goodnough, "Kline Paints a Picture," *Artnews* 51 (December 1952): 39.

10. Joseph Torch, interview with author, New York, May 29, 1971.

11. Sidney Janis, interview with author, New York, April 8, 1971.

12. Kline, quoted in Katharine Kuh, *The Artist's Voice* (New York: Harper and Row, 1962), p. 153.

13. Thomas B. Hess, "Franz Kline," *Artnews* 55 (March 1956): 51.

14. Ibid.

15. I am indebted to Dana Cranmer, Conservator, Mark Rothko Foundation, for her many insights on conservation throughout this section.

CHRONOLOGY

1910–16 Monday, May 23—Franz Josef Kline, named by his father after the Austrian emperor, is born at 140 West River Street, Wilkes-Barre, Pennsylvania, and baptized October 23 in St. Stephen's Episcopal Church in the same city. He is the second child of An-

165. Anne Rowe Kline

Far right:
166. Anthony Carton Kline

thony and Anne E. Kline (née Rowe), who had been married in St. Stephen's on April 22, 1908.

Anthony Carton Kline was born November 28, 1866, in Wilkes-Barre. Mr. Kline, who was of German background, owned a saloon at 177 South Main Street in Wilkes-Barre in 1910 and by 1911 shared interest in it with his brothers, Frank J. and Joseph; it remained the Kline Brothers Saloon until 1916, when it again came under Anthony's exclusive control.

Franz's mother was born of French and Spanish descent on February 14, 1885, in Ludgvan, a small town in Cornwall, England, north of Penzance; she came to the United States when

seventeen years old. Her strong English tastes were evident in the reproductions of works by Turner and Gainsborough that she hung on the walls of the Kline home. She died on April 10, 1964.

1917–25 August 1917—Anthony Kline commits suicide. An article in the *Wilkes-Barre Semi-Weekly Record* of August 24 describes the shooting and suggests that the victim faced financial pressures. After her husband's death Mrs. Kline studies nursing at St. Luke's Hospital in Bethlehem, Pennsylvania, and later works as a nurse. The children (Frederick, born 1909; Franz; Louise, born 1912; and Jacques, born 1916) go to live at the Episcopal Church Home in Jonestown, Pennsylvania, and with an uncle,

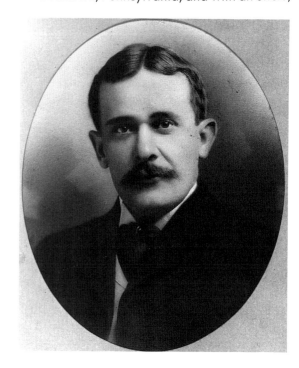

William Rowe of Plymouth, Pennsylvania. March 21, 1919—Franz is admitted to Girard College in Philadelphia, a free boarding-school for fatherless boys. While attending Girard for about six years, he takes courses in English, arithmetic, physical education, and elementary shop, having been assigned to training in

167. Franz Kline (center) with his sister, Louise, and his older brother, Frederick

168. Franz Kline at military camp, summer 1927

foundry work. He is also enrolled in the Battalion of Girard College Cadets from February 1, 1924.

March 1920—Mrs. Kline marries Ambrose D. Snyder of Lehighton, a foreman for the Lehigh Valley Railroad. They establish a household at 300 South Ninth Street in Lehighton (Carbon County, Pennsylvania). June 26, 1925—Kline's mother writes to President Cheesman A. Herrick of Girard notifying him of her intention to withdraw her son from the college; her letter indicates that Franz is doing less than satisfactory academic work. July 1—Franz arrives in Lehighton. Although his mother wants him to attend public school that fall, he lives at home for more than a year and works at the Lehighton dairy.

1926 February 28—Kline is confirmed in All Saints' Episcopal Church, Lehighton. September—he enters Lehighton Junior High; receives an A in an art course taught by Miss Hazel Stauffer.

1927 July 7–August 5—Kline takes basic course of instruction at the Infantry Branch, Citizens' Military Training Camp, Fort Howard, Maryland.

1927–28 During freshman year at Lehighton High School, Kline's highest grades are B in industrial arts and A in manual training—his only A in four years. Throughout high school he draws outside class, frequently at home on large drawing pads. One St. Patrick's Day he paints a green mustache and tie on the bust of Ben Franklin in the school library. When called to account he explains, "But he looked so dead!" Summer—he attends the Citizens' Military Training Camp, Fort Monroe, Virginia.

1928–29 During sophomore year Kline is president of the Art Club.

1929–30 During junior year Kline contributes pen and ink drawings to the yearbook. Summer—he returns to Citizens' Military Training Camp

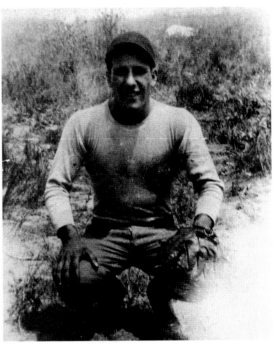

(coast artillery) at Fort Monroe; he is appointed corporal on July 21 and recommended for sergeant.

1930–31 Fall—Kline suffers a knee injury during football practice and has an operation. While recuperating he begins to think about going to art school and specializing in cartooning. As a senior he receives a C in English, history, and civics and a D in math and chemistry. He plays a politician in the senior class play, *To the Ladies*, by George S. Kaufmann, and is a member of the National Athletic Honor Society (he had earned letters in varsity football each year, in baseball two years, and in basketball one year). His contribution to the 1930–31 yearbook is limited to a cartoon calendar. June 5—he graduates from high school, ranked 52nd in a class of 103.

1931–35 1931—Kline moves to Boston's Back Bay and enrolls at Boston University (1931–32). He attends classes at the Boston Art Students League and studies with the illustrator John H. Crosman. Late 1933—Kline is introduced by Frederick Ryan, a fellow art student whom he had met in fall 1931, to Martha Kinney (nicknamed "Nutsy"), another art student. She becomes Franz's constant companion and model, following him to England in 1935. June 1934—with Martha and hometown friend Charles Gernerd, Kline meets John Richard Flanagan, the magazine illustrator, at East Stroudsburg, Pennsylvania. (Flanagan illustrated Sax Rohmer's "Fu Manchu" stories for *Collier's, Cosmopolitan*, and other magazines). Flanagan encourages Kline in a "commercial art" career and gives him two pen and ink drawings. On a trip to Allentown, Martha has *Franz J. Kline* tattooed on her chest.

To earn a little cash, Kline takes odd jobs, such as lettering the windows of a doctor's office overlooking Boston Common. Since this is his first experience with gold leaf, he asks Ryan to help: "The way we muddled through, trying to appear to the watchful M.D. as though we knew what we were doing, might have been a script for the Marx Brothers." Kline is paid $15 for the job but has to buy all his own supplies.

1935 October—Kline travels to England aboard the S.S. Georgic (second class); he meets Frank Hahn on board. Arriving in London (after docking at Southampton on October 13), Kline and Hahn move into a flat with oversize bathtub on Belsize Crescent. They live here until late November, when the landlord forces them to move because they take too many baths at night. Kline and Hahn rent a flat at 28 Queensborough Terrace, London, W2. December—Martha Kinney arrives and moves in with them.

1936 April—Kline, Hahn, and Martha move into a cellar apartment at 121 Westbourne Grove, London, W2. May—Hahn, who works for a crude rubber importing firm, leaves for Singapore; he will not see Kline again until 1938 in New York. Martha is called back to a marriage arranged by her mother, who believes that Kline will "never amount to anything," and Martha returns to the U.S. at Christmas, never to see Franz again (they do correspond briefly in 1938).

Kline goes to museums and galleries, making frequent trips to the British Museum; he always carries a sketchbook, drawing works of art and urban subjects. He attends Heatherley's School of Fine Art, then located at 9 and 11 George Street, London, W1, in the borough of St. Marylebone. Later in 1936 Heatherley's is enlarged to include 13 George Street; the school has three large studios to accommodate increasing numbers of students—about 100 while Kline is there. Several antique shops are in the neighborhood, which he loves to visit, and the Wallace Collection is next door. Kline's teachers at Heatherley's include Frederic Whiting, who is a member of the National Portrait Society and the Royal Society of Portrait Painters; Bernard Adams, member of the Royal Institute of Oil Painters, the Royal Society of Portrait Painters, and a Fellow of the Royal Society of Arts; and Steven Spurrier, head of the Spurrier School of Illustration, which joined Heatherley's in 1936. Students can take classes in painting (portrait or still life) and/or life drawing. The curriculum is not rigidly structured. Kline continues to sketch outdoors. He frequents old-book sellers to collect books on British illustrators—by August he has ten books on Phil May—and phonograph records of Ted Lewis. Late June–early July—Kline is visited by his former high school English teacher, Mathilda A. Roedel; they go to museums, printshops, and booksellers. October—two Kline drawings (a nude and one of Martha Kinney) are published in *The Artist*, which often devoted one or two pages to work by students in London art schools.

1937 January 17—Kline is living at 11A Portchester Road, London, W2. In January he also meets his future wife, Elizabeth V. Parsons, a model in Frederic Whiting's illustration class at Heatherley's. At Kline's request she poses for him outside class, only to learn that he has no money to pay her; she is charmed by him nonetheless and goes out with him for her first Coke. Born in 1907, Elizabeth is the daughter of Col. W. Forster Parsons, a civil servant working in the War Office. She had been presented at Court in June 1925. She studied ballet with Enrico Cecchetti (1921–23), Marie Rambert (1924–26), and Ninette de Valois (1926–28). Her brief professional career as "Elizabeth Vincent" extended from early 1926 to spring 1928. (She was never a member of the Sadler's Wells Ballet—an error perpetuated in Kline chronologies). Elizabeth makes Kline aware of the world of ballet and music, although lack of money keeps them from attending performances.

Kline has an unpublicized one-man show at Heatherley's. August—after school closes for

summer he travels to Wales for a three-week seaside holiday. September 13—Kline is living at 18 Notting Hill Gate, London, W2. He visits the National Gallery with Elizabeth and speaks often of his admiration for Rembrandt, Whistler, Charles Keene, and Phil May; he criticizes Gainsborough as a "thin" painter. He works briefly at Selfridges Department Store.

1938 February 11—Kline leaves for the U.S. After a brief visit home, he works as a display designer for Oppenheim Collins, a women's clothing store in Buffalo. Fired from his job and dissatisfied with Buffalo, Kline soon moves to New York City and shares an apartment with Frank Hahn at 6 Jane Street. Fall—they move to 146 Macdougal Street. Kline works briefly as a window display artist for Arnold Constable, while also trying to sell his illustrations to magazines such as the *New Yorker*. November—Elizabeth arrives from England; Franz meets her at Ellis Island. December 5—they are married in the Church of the Ascension (Episcopal) in New York, with Hahn as best man.

1939 Franz and Elizabeth live at 146 Macdougal. May 23—they attend a gala performance of *Tristan und Isolde* at the Metropolitan Opera, to celebrate Franz's twenty-ninth birthday. Days later Kline buys second-hand records of *Tristan und Isolde* (titles of abstract paintings attributable to Wagner are *Wotan*, 1950; *Siegfried*, 1958; and *Curvinal*, 1961, Kline's spelling of Kurvenal from *Tristan und Isolde*). Spring—he paints a backdrop for a fortune teller in a nightclub, perhaps the Pepper Pot on West Fourth Street. Kline meets the two major patrons of his figurative period: Dr. Theodore J. Edlich, Jr., who calls at the studio-apartment in the spring, and I. David Orr, who is introduced to Kline by Sam Kramer, a Village silversmith who exhibits his work at the Washington Square art shows—as Kline does. In 1939 or '40, through a Village character called "The Major," Kline also meets another patron-friend, Henry F. Bent, who collects art, books, and records.

1940 January—Franz and Elizabeth are evicted from 146 Macdougal for nonpayment of rent; they move to 71 West Third Street, one block south of Washington Square between Thompson Street and West Broadway (now La Guardia Place). Late July and early August —Kline visits Frederick Ryan and his wife at Hopkinton, Massachusetts, and spends his vacation drawing, painting, and attending auctions, buying picture frames for low prices. He returns to New York by August 14 to begin work on murals for the Bleecker Street Tavern. He also paints murals for bars in Brooklyn and Hoboken between 1939 and 1942; their original locations and current status are unknown. Late summer—Kline wins a $10 or $15 prize, awarded by the Whitney Museum of American Art, at the Washington Square art show for a pen and ink drawing. He meets Earl Kerkam, who exhibits work nearby in the show. Kline had been exhibiting at these outdoor shows for four or five years, and after winning this prize he serves on the jury for one of them.

1941 January—Franz and Elizabeth move to 430 Hudson Street, second floor.

1942 *Artist's Wife* (priced at $200 in the catalog) is included in the National Academy of Design's *116th Annual Exhibition*; of the more than 1,300 paintings submitted, 241 (one per artist) are shown. Kline is listed in the April 8 *New York Times* ("Academy of Design Opens Its Art Show," p. 15) as one of the "young painters" whose work had not been shown before at the Academy. He is one of 197 non-members exhibiting. Early summer—Kline works as a filing clerk for the U.S. Army on Governors Island, a job he owes to Col. S. G. Backman, quartermaster for the Third Corps Area. (Kline later painted a caricaturelike "portrait" of Mrs. Backman.) Kline may have held the Army job for only a few weeks, but he boasted during the late 1950s that he had stuck with it for six months. November—Franz and Elizabeth move to 23 Christopher Street, top floor.

1943 February—Franz and Elizabeth move to larger quarters at 150 West Fourth Street. Interested in metalworking, he takes sheets of copper from a scrap-metal pile at the corner of Sixth Avenue and Greenwich; he considers making costume jewelry and cuts a galloping horse out of the copper. He takes a studio at 41 Perry Street (first floor, storefront) until spring or summer 1944. Kline wins the S. J. Wallace Truman Prize ($300) for *Palmerton, Pa.* at the *117th Annual Exhibition* of the National Academy of Design, where he also exhibits a self-portrait. Summer—he is a second lieutenant, reserve corps, at Citizens' Military Training Camp, Fort Monroe. Kline meets de Kooning at Conrad Marca-Relli's studio at 148 West Fourth Street.

1944 Kline again wins the S. J. Wallace Truman Prize in the National Academy's *118th Annual Exhibition*, for *Lehigh River, Winter*.

Mid–1940s After World War II, Kline begins going regularly to the Cedar Bar, an artists' hangout on the west side of University Place, between Eighth and Ninth streets.

1945 Evicted from 150 West Fourth because the real estate manager wants to lease the entire house to one party, Franz and Elizabeth move to the top floor of a four-story walk-up on Hudson Street (north of their previous address on Hudson). By this time Marca-Relli has left 148 West Fourth and Kline uses it as a studio. September—Franz and Elizabeth move to a chauffeur's furnished apartment above the garage on a small estate in Brooklyn. According to Elizabeth, the place was haunted by redcoats from the Revolutionary War. Kline commutes daily to his studio at 148 West Fourth. Mid–December—they move to the studio, which remains their address until fall 1947. Kline paints murals for El Chico's, a Spanish nightclub at 80 Grove Street on Sheridan Square in the Village; the paintings are completed in June.

In the *119th Annual Exhibition* at the National Academy of Design, Kline exhibits *The Playground*. At the *120th Annual* he shows *Green Night* ($500 in the catalog). About two years later, intending to lighten its tones, he paints out the entire picture; this occurs at the Orrs' home, where Kline paints from time to time during the 1940s.

1946 May—Elizabeth enters Central Islip State Hospital for six months. Her recurring mental problems require several hospitalizations throughout the 1940s and '50s; she is finally released in 1960 (she dies in 1984). Late fall —Kline is commissioned by Lehighton's American Legion Post 314 to paint a panorama of the town on a wall behind the bar in the large assembly room; he is paid $600. He paints *The Dancer*, which Kline refers to as his first "abstract" painting.

1947 September—Kline moves to the top floor of a house at 52 East Ninth Street, which had once belonged to Lillian Russell. "Its winding staircase looked exactly like her," noted Tom Hess. John Ferren lives on the third floor; Marca-Relli, the second; a fur business occupies the first. Kline makes "white paintings"; large areas of paper show through some, others have extensive white overpainting and "calligraphic" brushwork.

1948 Kline is listed in *Who's Who in the East*. He shares his apartment with Earl Kerkam for about six months. Kline attends Matisse retrospective at the Philadelphia Museum of Art with

David Orr. At de Kooning's studio, 85 Fourth Avenue, he enlarges some drawings with a Bell-Opticon projector that de Kooning had borrowed for a few days to enlarge some of his own sketches. (According to Elaine de Kooning, this was either 1948 or 1949.)

1949 November or December—Kline builds a partition of two-by-fours and plasterboard for Philip Guston and Bradley Walker Tomlin in their studio-loft on University Place between Twelfth and Thirteenth streets.

1950 Kline shares his loft with Emmanuel Navaretta for about eleven months. (Navaretta, who moved out in January 1951, has recalled that Kline, who usually painted at night, slept on the couch and insisted that his "guest" take the bed. He would not let Navaretta help with the rent.) May—Kline exhibits one abstract painting in *Talent 1950* at the Kootz Gallery, organized by Clement Greenberg and Meyer Schapiro. August—David Orr gets Kline a job as "art instructor" at Schroon Crest, a summer resort at Schroon Lake near Pottersville, New York. Kline has a small studio but little time for his own work; he gives a talk on contemporary art to the guests and receives room and board but no salary. While Kline is away, Charles Egan visits his Ninth Street studio, looks at some black and white paintings, and decides to give him a show that fall. October 16— Kline's first one-man show opens at Egan Gallery.

1951 May 21—the *Ninth Street Show* opens at 60 East Ninth Street; organized by Ferren, Marca-Relli, and Kline, who designs the announcement. Kline's black and white abstraction (now called *Ninth Street*) takes its name from the show. November—Kline's second one-man show opens at Egan Gallery. *Cardinal* and *Chief* are reproduced and discussed by Thomas B. Hess in *Abstract Painting, Background and American Phase* (New York, 1951), pp. 137–39. Kline is one of twenty artists in *American Vanguard Art for Paris Exhibition* at Janis Gallery. The paintings, one by each artist, are shown in February 1952 at Galerie de France; other artists include Albers, de Kooning, Gorky, Gottlieb, Guston, Motherwell, Pollock, Tomlin.

1952 January—Kline is represented in the *Second Annual Exhibition of Painting and Sculpture* at Stable Gallery. Greenberg writes a statement for the announcement-poster; he mentions the *Ninth Street Show*, pointing out that the current exhibition is also organized by the artists themselves. Kline helps paint "Vote for Adlai"

signs for a fund-raising program at the Roosevelt Hotel. April—he receives word from Black Mountain College in North Carolina that he is to teach there that summer. December —"Kline Paints a Picture," by Robert Goodnough, is published in *Artnews*; it focuses on Kline at work on *Abstract Painting* (now entitled *Horizontal II*).

1953 Spring—Kline is evicted with only one month's notice from 52 East Ninth Street, which is to be torn down; he stays until forced to carry his belongings out on the sidewalk. He moves to the top floor of 32 East Tenth, where he stays about nine months. Spring—he exhibits several paintings with Guston, George McNeil, and Jack Tworkov at the Fine Arts Festival, Women's College, University of North Carolina, Greensboro; takes part with Guston and John Opper in a campus panel discussion.

1953–54 Kline teaches non-credit "Basic Drawing and Design" at Pratt Institute's night school, directed by George McNeil; the pay is $25 per session.

1954 January—one-man show of large paintings opens at Institute of Design, Chicago, organized by Hugo Weber; Kline attends the opening. Allan Frumkin Gallery shows drawings and easel-size works in conjunction with it. Kline is on a panel at the institute with Weber, Frumkin, and Katharine Kuh. March 16—"Abstract Art around the World Today," a forum sponsored by American Abstract Artists, is held at the Museum of Modern Art. Kline is on the panel with Josef Albers, Alfred H. Barr, Jr., Sabro Hasegawa, George L. K. Morris, and Aline Saarinen. April 13—his third one-man show opens at Egan Gallery, now at 46 East Fifty-seventh Street. Summer—Kline stays at the "Red House" in Bridgehampton with the de Koonings, Ludwig Sander, and Nancy Ward. For entertainment they watch Fu Manchu movies on a television that elongates the figures. "We rolled on the floor in hilarity," recalls Elaine de Kooning.

1955 Kline lives on Avenue B, Tompkins Square. This area reminds him of England, but (as he explains to Dorothy C. Miller) he doesn't like it because it closes down early in the evening and is too far from the Village. After a three-month stay he moves to East Tenth Street, just east of Third Avenue, where he lives for four or five months. He adds brown to his essentially black and white palette in *The Bridge* and *Shenandoah*.

1956 Sidney Janis becomes Kline's dealer. March 5—first one-man show at Janis Gallery opens. Kline uses significant color in a large black and white abstraction (*De Medici*) and in smaller works such as *Yellow, Red, Green, Blue*. Kline's work is shown at the Venice Biennale. Summer—he is in Provincetown with Al Leslie. November 30—"The Club" has a memorial session, "An Evening for Jackson Pollock": Kline participates with James Brooks, Clement Greenberg, Frederick Kiesler, de Kooning, and Marca-Relli; Harold Rosenberg is moderator.

1957 Kline lives for about six months at 473 Sixth Avenue. May 15—with Elisabeth Ross Zogbaum, Kline attends the members' preview of *Contemporary Art—Acquisitions 1954–1957* at the Albright-Knox Gallery, Buffalo. He signs a three-year lease (July 1–June 30, 1960) for a studio at 242 West Fourteenth Street; rent is $160 per month. This remains his New York studio until his death. August—Kline paints in John Little's barn, East Hampton; he pays his "rent" by giving Mr. and Mrs. Little a black and white painting, *Untitled* (1957). Kline is a juror for the *Exhibition Momentum '57*, Chicago; other jury members are Sam Hunter and Philip Guston. At the opening Kline is on a panel with Hunter, Guston, and Joshua Taylor, moderator. Hunter recalls: "Kline was hilarious, once he was recovered from a neighborhood tavern and positioned upright on stage. He was also very keen and inspired at moments." While in Chicago, Kline, Guston, and Aaron Siskind visit Calumet City "for an all-night spree," in Guston's words. They get about $200 from Noah Goldowsky to finance their adventure and upon returning to New York each sends him a drawing as "repayment."

1958 January 29—Kline writes to friends: "The Village has changed so much with the blocks being remodeled and modern apartment buildings taking the place of the Italian section, Mark Twain's house and everywhere you look; it's just like being uptown now! My new studio [242 West Fourteenth] is wonderful; spacious and loft-like only on the second floor." March 18—solo exhibition, including small drawings, opens at Galleria del Naviglio, Milan. May 19—one-man show opens at Janis Gallery. June 16—Kline orders a black Thunderbird; when it arrives he looks inside and remarks: "It looks just like a washing machine." Kline makes "sfumato" paintings: *Siegfried* and *Requiem*.

1959 January 10—Kline buys No. 15 Cottage Street, Provincetown, with occupancy by May 1; he and Elisabeth Ross Zogbaum drive from New York to Provincetown to look over the property before completing the sale. Summer —Siskind visits Kline at Provincetown. Kline is included in Part 2 of "The Varied Art of Four Pioneers," *Life*, November 16; article by Dorothy Sieberling, photos by Bert Stern. Stern does a series of photos of Kline in preparation for the feature; at one session, he is photographed making a painting on glass.

1960 Kline appears briefly in *Sketchbook No. 1: Three Americans*, a film with de Kooning, Herman Cherry, and Harold Rosenberg. Paints a backdrop for "Queen of Hearts," a dance performed by Merle Marsicano at the Hunter College Playhouse, March 23; this is the largest painting that Kline ever does: 20 by 18 feet. Kline selects one of his earlier drawings on a telephone-book page as the "model sketch." He complies with Merle Marsicano's request and puts a single slash of red paint through the center of the painting. March 7—one-man show opens at Janis Gallery.

June—Kline takes trip to Europe, accompanied by Elisabeth Ross Zogbaum. June 7—they fly from New York to Paris. Although at first Kline does not want to visit the Louvre, he is persuaded by George McNeil; they spend about an hour in the major Italian gallery with the Mona Lisa. June 13—flies to Venice by way of Milan and Rimini, arriving in Venice that night. June 14—attends the critics' opening at the XXX Biennale. Other American artists in the Biennale are Guston, Hans Hofmann, Theodore Roszak. Kline wins the Italian Ministry of Public Instruction Prize (equivalent to $1,613). June 17—visits the Peggy Guggenheim collection. June 19—engages a driver and leaves Venice by car. Stops in Vicenza, visits the Teatro Olimpico and takes a guided tour through the Villa Malcontenta. (Vicenza is the birthplace of Palladio, architect of the Teatro Olimpico and Villa Malcontenta.) In 1961 Kline entitles a large painting *Palladio*. Stays overnight in Verona. June 20—stops in Padua; visits the Arena Chapel; stays overnight in Ferrara. June 21–22—visits Ravenna. Monuments such as the Tomb of Galla Placidia impress Kline greatly; he chooses *Ravenna* and *Placidia* as titles for paintings in 1961. June 23—visits Assisi. June 24–25—visits Orvieto. Mrs. Zogbaum is ill; Kline gets homesick and writes postcards. A postcard addressed to Dan Rice, but not postmarked and with writing crossed out, reads: "Takes an awful lot of separation and seeing here is like that—beyond belief—Not like Indiana—like the endless loneliness that I know you know—Best—Franz." June 26–July 1—en route to Florence visits Perugia, Urbino, Gubbio, and passes by San Gimignano. In Florence attends "Calcio in Costume," a night festival and soccer game in Piazza della Signoria. July 2—visits Siena to see the Palio delle Contrade, a festival and horse race in Piazza del Campo. July 3—travels from Siena to Rome by train; visits catacombs, Vatican Museum, and briefly the Sistine Chapel. A group of Italian artists including Afro and Piero Dorazio give a party in Kline's honor at a trattoria. He and Mrs. Zogbaum return to Siena to look at paintings before catching a flight from Rome to New York on July 8. Upon return they go to Provincetown for the summer. Kline buys a silver gray Ferrari. He is included in *Who's Who in Art* (London).

1961 Kline's 1940 Bleecker Street Tavern paintings and portrait drawings from the Minetta Tavern are shown at the Collector's Gallery, New York. April 13—he enters Johns Hopkins Hospital for examinations and tests, which last about a week and reveal a rheumatic heart. April 25—exhibition of paintings, sculptures, and prints by members of New York City Bar Association opens at 42 West Forty-fourth Street. Kline helps to hang show, receives honorarium of $200, and at close of exhibition is guest at dinner and party. End of May—he attends thirtieth reunion at Lehighton High School. June 21—he buys a brick townhouse at 249 West Thirteenth Street, which adjoins back of his Fourteenth Street studio. December 4—one-man show opens at Janis Gallery.

1962 February—Kline has first heart attack and goes to St. Clare's Hospital. March 9—he goes to stay with Elisabeth Ross Zogbaum, 461 West Eighteenth Street; he is put on strict regimen and must be weighed daily. He is unable to continue painting. May 4—he enters New York Hospital. May 13—Kline dies. May 16— funeral is held at St. Bartholomew's Protestant Episcopal Church, Park Avenue at Fifty-first Street. May 17—after services in the Lehighton Episcopal Church, he is buried in Hollenback Cemetery, Wilkes-Barre, overlooking the Susquehanna River. May 23—a memorial tribute at Grace Church, New York, is organized and attended by artist-friends; this would have been Kline's fifty-second birthday.

EXHIBITIONS

Solo Exhibitions

1950 *Franz Kline*, Charles Egan Gallery, New York, October 16–November 4.

1951 *Franz Kline*, Charles Egan Gallery, November–December.

1952 *Franz Kline*, Margaret Brown Gallery, Boston, November 17–December 6.

1954 *Franz Kline*, Institute of Design, Chicago, January.

Franz Kline, Allan Frumkin Gallery, Chicago, January.

Franz Kline, Charles Egan Gallery, April 13–May 8.

1956 *Franz Kline*, Sidney Janis Gallery, New York, March 5–31.

1958 *Franz Kline*, Galleria del Naviglio, Milan, March 18–28.

Franz Kline, Sidney Janis Gallery, May 19–June 14.

1960 *Franz Kline*, Sidney Janis Gallery, March 7–April 2.

1961 *Franz Kline*, The Collector's Gallery, New York, February 6–25.

Franz Kline, New Arts Gallery, Atlanta, April 16–May 26.

Franz Kline, Sidney Janis Gallery, December 4–30.

Franz Kline, Arts Club of Chicago, December 8–January 9, 1962.

1962 *Franz Kline Memorial Exhibition*, Gallery of Modern Art, Washington, D.C., October 30–December 27, and tour to Baltimore Museum of Art and Poses Institute of Fine Arts, Brandeis University, Waltham, Massachusetts.

1963 *Franz Kline*, Dwan Gallery, Los Angeles, March 3–30.

Franz Kline, Stedelijk Museum, Amsterdam, September 20–October 20, and tour to Galleria Civica d'Arte Moderna, Turin; Palais des Beaux-Arts, Brussels; Kunsthalle Basel; Museum des 20. Jahrhunderts, Vienna; Whitechapel Gallery, London; Musée d'Art Moderne, Paris. Organized by the Museum of Modern Art, New York.

Franz Kline, La Tartaruga, Galleria d'Arte, Rome, opened November 16.

Kline Memorial Exhibition, Sidney Janis Gallery, December 3–28.

1967 *Franz Kline Estate: Paintings and Drawings*, Marlborough-Gerson Gallery, New York, February 28–April 1.

1968 *Franz Kline*, Whitney Museum of American Art, New York, October 1–November 24, and tour to Dallas Museum of Fine Arts; San Francisco Museum of Art; Museum of Contemporary Art, Chicago.

1974 *Franz Kline: Selected Works*, Allan Stone Gallery, New York, February–March.

1975 *Franz Kline*, David McKee Gallery, New York, March 7–April 5.

1976 *Homage to Franz Kline*, Bell Art Gallery, List Art Center, Brown University, Providence, September–October.

1977 *Franz Kline: The Early Works as Signals*, State University of New York, Binghamton, March 14–April 18, and tour to Neuberger Museum, State University of New York, Purchase.

Kline: Works on Paper, Mayor Gallery, London, March 29–May 14.

1979 *Franz Kline: The Color Abstractions*,

Phillips Collection, Washington, D.C., February 17– April 8, and tour to Institute for the Arts, Rice University, Houston; Los Angeles County Museum of Art; Seattle Art Museum.

1984 *Kline: Paintings and Drawings*, Marisa del Re Gallery, New York, May 2–June 9.

Selected Group Exhibitions

1942 *116th Annual Exhibition*, National Academy of Design, New York, April 8–May 16. Included *Artist's Wife* (1940).

1943 *117th Annual Exhibition*, National Academy of Design, February 17–March 9. *Palmerton, Pa.* (1941) won S. J. Wallace Truman Prize.

1944 *118th Annual Exhibition*, National Academy of Design, March 29–April 25. *Lehigh River, Winter* (1944) won S. J. Wallace Truman Prize.

1945 *119th Annual Exhibition*, National Academy of Design, March 14–April 3. Included *The Playground* (1944).

120th Annual Exhibition, National Academy of Design, December 4–21. Included *Green Night* (1945).

1950 *Talent 1950*, Kootz Gallery, New York, April 25–May 15. Included one Kline abstraction.

Young Painters in U.S. and France, Sidney Janis Gallery, New York, October 22–November 11. Included *Nijinsky* (1950).

1951 *Ninth Street Show*, 60 East Ninth Street, New York, May 21–June 10.

American Vanguard Art for Paris Exhibition, Sidney Janis Gallery, December 26–January 5. Included one painting by Kline.

1953 *Second Annual Exhibition of Painting and Sculpture*, Stable Gallery, New York, January 11–February 7.

Fine Arts Festival, Women's College, University of North Carolina, Greensboro, spring.

1954 *15 Artists of the Region*, East Hampton Guild Hall, July 24–August 11. Included five paintings by Kline, listed in catalog as *No. 1* (1952), *No. 2* (1952), *No. 3* (1953), *No. 4* (1951), *No. 5* (1953).

1955 *The New Decade: 35 American Painters and Sculptors*, Whitney Museum of American Art, New York, May 11–August 7.

1956 *12 Americans*, Museum of Modern Art, New York, May 29–September 9. Included nine paintings by Kline.

XXVIII Venice Biennale, June–September.

Recent Paintings by Seven Americans, Sidney Janis Gallery, September 24–October 20. Included *Figure* (1956) and at least one other painting by Kline.

1957 *Eight Americans*, Sidney Janis Gallery, April 1–20. Included *Garcia* (1957).

Executive House, New York, April 3–May 4. Included *Tower* (1953), *Ilza* (1955), *Laureline* (1956).

1958 *The New American Painting*, April 19– March 23, 1959. Tour to Basel, Milan, Madrid, Berlin, Amsterdam, Brussels, Paris, and London. Organized by the International Program of the Museum of Modern Art. Included *Chief* (1950), *Cardinal* (1950), *Accent Grave* (1955), *Wanamaker Block* (1955), *Garcia* (1957).

Carnegie International Exhibition, Pittsburgh, December 5–February 8, 1959. Included *Siegfried* (1958).

1959 *Eight American Painters*, Sidney Janis Gallery, January 5–31. Included *Delaware Gap* (1958).

1960 *60 American Painters 1960: Abstract Expressionist Painting of the Fifties*, Walker Art Center, Minneapolis, April 3–May 8. Included *Mahoning* (1956).

Nine American Painters, Sidney Janis Gallery, April 11–23. Included *Turbin* (1959).

XXX Venice Biennale, June 18–October. Included *Nijinsky* (1950), *New Year Wall: Night* (1960), and eight others.

Guggenheim International Award Exhibition, Solomon R. Guggenheim Museum, New York, November. *New Year Wall: Night* received honorable mention.

1961 *Sixty-fourth American Exhibition*, Art Institute of Chicago, January. *Sawyer* (1959) won the Flora Mayer Witknowsky Prize.

Ten American Painters, Sidney Janis Gallery, May 8–June 3. Included *Contrada* (1960).

Franz Kline and Philip Guston, Dwan Gallery, Los Angeles.

1962 *Continuity and Change, 45 American Abstract Painters and Sculptors*, Wadsworth Atheneum, Hartford, Connecticut, April 12–May 27. Included a 1941 pencil drawing of David Orr, *Probst* (1961), and four other works by Kline.

Ten American Painters, Sidney Janis Gallery, May 7–June 2. Included *Scudera* (1961).

Eleven Abstract-Expressionist Painters, Sidney Janis Gallery, October 7–November 2. Included *Caboose* (1961) and *Red Painting* (1961).

SELECTED BIBLIOGRAPHY

Interviews and Statements

Kuh, Katharine. *The Artist's Voice*. New York: Harper and Row, 1962. Interview.

O'Hara, Frank. "Franz Kline Talking." *Evergreen Review* (Autumn 1958): 58–64. Interview. Reprinted as "Introduction and Interview" in *Franz Kline, A Retrospective Exhibition*, exhibition catalog, London: Whitechapel Gallery, 1964.

Rodman, Selden. *Conversations with Artists*. New York: Devin-Adair, 1957, and New York: Capricorn Books, 1961. Interview.

Sylvester, David. "Franz Kline 1910–1962: An Interview with David Sylvester." *Living Arts* 1 (Spring 1963): 3–13. Interview.

Monographs and Solo-Exhibition Catalogs

Boime, Albert, and Mitchell, Fred. *Franz Kline: The Early Works as Signals*, exhibition catalog. Binghamton and Purchase: State University of New York, 1977.

Dawson, Fielding. *An Emotional Memoir of Franz Kline*. New York: Pantheon, 1967.

Franz Kline, exhibition catalog. New York: David McKee Gallery, 1975.

Franz Kline, Memorial Exhibition, exhibition catalog. Washington, D.C.: Washington Gallery of Modern Art, 1962. Includes Elaine de Kooning, "Franz Kline, Painter of His Own Life."

Franz Kline, 1910–1962, exhibition catalog. New York: Marlborough-Gerson Gallery, 1967. Includes Robert Goldwater, "Franz Kline: Darkness Visible."

Franz Kline, 1910–1962, exhibition catalog. London: Mayor Gallery, 1977. Includes Thomas Hess, "Editorial."

Gaugh, Harry. *Franz Kline: The Color Abstractions*. Washington, D.C.: Phillips Collection, 1979. Includes Robert Motherwell, "Homage to Franz Kline." Japanese translation of Gaugh essay published in *Mizue* (Tokyo) 11, November 1979.

Gordon, John. *Franz Kline, 1910–1962*, exhibition catalog. New York: Whitney Museum of American Art, 1968.

Kline, exhibition catalog. New York: Sidney Janis Gallery, 1960.

Kline, exhibition catalog. New York: Sidney Janis Gallery, 1961.

Kline Memorial Exhibition, exhibition catalog. New York: Sidney Janis Gallery, 1963.

Periodicals, Books, and Group-Exhibition Catalogs

Alloway, Lawrence. "Signs and Surface: Notes on Black and White Painting in New York." *Quadrum* 9 (1960): 49–62.

_____. "Franz Kline's Estate." *Arts Magazine* 41 (April 1967): 40–43.

Alvard, Julien. "Franz Kline." *Aujourd'hui* 47 (October 1964): 4–9.

Ashton, Dore. "Art." *Arts and Architecture* 73 (April 1956): 3, 10–12.

_____. "Art." *Arts and Architecture* 75 (July 1958): 10, 31–33.

_____. *The New York School: A Cultural Reckoning*. New York: Viking, 1973.

Barr, Alfred H., Jr. *The New American Painting*, exhibition catalog. New York: Museum of Modern Art, 1958.

Baur, John I. H., ed. *The New Decade*, exhibition catalog. New York: Whitney Museum of American Art, 1955.

Breeskin, Adelyn D., and Sawyer, Kenneth B. *Quattro Artisti Americani: Guston, Hofmann, Kline, Roszak*, exhibition catalog. Venice: XXX Biennale, and Baltimore: Baltimore Museum of Art, in association with the International Council, Museum of Modern Art, New York, 1960.

Butler, Barbara. "Franz Kline." *Arts Magazine* 34 (April 1960): 55.

_____. "Franz Kline in Retrospect." *Arts Magazine* 37 (January 1963): 30–33.

Celant, Germano. *Das Bild einer Geschichte 1956/1976; Die Sammlung Panza di Biumo*, exhibition catalog. Düsseldorf: Kunstsammlung Nordrhein-Westfalen, Kunstmuseum und Kunsthalle, 1980.

Celentano, Frances M. "The Origins and Development of Abstract-Expressionism in the U.S." Master's thesis, New York University, 1957.

Conley, Tom. "Accent Grave, Kline and Blanchot." *Sub-Stance* 14 (1976): 77–91.

Creeley, Robert. "A Note on Franz Kline." *Black Mountain Review* 1 (Winter 1954): 23–32.

_____. "The Art of Poetry X." *Paris Review* 44 (Fall 1968): 173–74.

Crehan, Hubert. "Inclining to Exultation." *Art Digest* 28 (May 1, 1954): 15, 33.

Crotty, Frank. "The People Laughed and Were Fascinated." *Worcester Sunday Telegram*, May 24, 1964, *Parade* section, p. 10.

de Kooning, Elaine. "Two Americans in Action: Franz Kline, Mark Rothko." *Artnews Annual* 56 (November 1957, Part II): 88–97.

_____. "Franz Kline, Painter of His Own Life." *Artnews* 61 (November 1962): 28–31, 64–69. Reprinted in *Franz Kline, Memorial Exhibition*.

Farber, Manny. "Art." *Nation* 171 (November 11, 1950): 445.

Gaugh, Harry F. Review. *Art Journal* 28 (Fall 1969): 124–26. Review of Fielding Dawson, *An Emotional Memoir of Franz Kline*.

_____. "Kline's Transitional Abstractions, 1946–50." *Art in America* 64 (July–August 1974): 43–47.

_____. "Franz Kline's Romantic Abstraction." *Artforum* 13 (Summer 1975): 28–37.

_____. "Franz Kline at University Art Gallery, SUNY." *Art in America* 65 (September–October 1977): 123. Review of exhibition at State University of New York, Binghamton.

Goldwater, Robert. "Reflections on the New York School." *Quadrum* 8 (1960): 17–36, 77.

_____. "Franz Kline: Darkness Visible." *Artnews* 66 (March 1967): 38–43. Reprinted in *Franz Kline, 1910–1962*, New York: Marlborough-Gerson Gallery, 1967.

Goodnough, Robert. "Kline Paints a Picture." *Artnews* 51 (December 1952): 36–39.

Greenberg, Clement. *Art and Culture*. Boston: Beacon Press, 1961.

Hasegawa, Sabro. "The Beauty of Black and White." *Bokubi* (Tokyo) 12 (1951).

Hess, Thomas B. "Seeing the Young New Yorkers." *Artnews* 49 (May 1950): 23.

_____. *Abstract Painting, Background and American Phase*. New York: Viking, 1951, pp. 137–39.

_____. "Franz Kline." *Artnews* 55 (March 1956): 51.

_____. "Is Today's Artist with or against the Past?" *Artnews* 57 (September 1958): 40, 58.

_____. "Franz Kline." *Artnews* 60 (January 1962): 46–47, 60–61.

_____. "Editorial." *Artnews* 61 (Summer 1962): 23, 53. Obituary.

_____. "Mondrian and New York Painting." In *Six Painters*, exhibition catalog. Houston: University of St. Thomas Art Department, 1967.

_____. "The Convertible Oyster." *New York Magazine* 8 (April 7, 1975): 68–70.

"How They Got That Way." *Time* 79 (April 13, 1962): 94–99. Review of group exhibition *Continuity and Change* at Wadsworth Atheneum.

Hopkins, Budd. "Franz Kline's Color Abstractions: Remembering and Looking Afresh." *Artforum* 17 (Summer 1979): 37–41. Review of exhibition at the Phillips Collection.

Judd, Donald. "Franz Kline." *Arts Magazine* 36 (February 1962): 44.

Kagan, Andrew. "Paul Klee's Influence on American Painting, Part II." *Arts Magazine* 50 (September 1975): 84–90.

Kees, Welden. "Art." *Nation* 170 (May 6, 1950): 430–31.

Kingsley, April. "Conflict in Color." *Newsweek* 94 (August 6, 1979): 78–79. Review of exhibition at the Phillips Collection.

Kline, Elizabeth V. "Letter to the Editor." *Artnews* 61 (January 1963): 6.

Kramer, Hilton. "Franz Kline: Turning Art into Academic History." *New York Times*, October 6, 1968, sec. II, p. 35.

Langsner, Jules. "Franz Kline, Calligraphy and Information Theory." *Art International* 7 (March 1963): 25–29.

McBride, Henry. "No Exit at the Whitney." *Artnews* 51 (April 1952): 36–37, 64.

McDarrah, Fred W. *The Artist's World in Pictures.* New York: E. P. Dutton, 1961.

Miller, Dorothy C., ed. *12 Americans*, exhibition catalog. New York: Museum of Modern Art, 1956. Includes statement by Elaine de Kooning, 1950.

Oeri, Georgine. "Notes on Franz Kline." *Quadrum* 12 (1961): 93–102.

Porter, Fairfield, "Franz Kline." *Artnews* 50 (December 1951): 46.

———. *Art in Its Own Terms.* Edited by Rackstraw Downes. New York: Taplinger, 1979.

Rodman, Selden. "Important Abstractionist." *Cosmopolitan* 146 (February 1959): 66–69.

Russell, John. "Kline's Effulgent Abstractions." *New York Times,* March 18, 1979, Arts and Leisure, p. 31. Review of exhibition at the Phillips Collection.

———. "Art: Franz Kline Show." *New York Times,* May 11, 1984, sec. C, p. 20. Review of exhibition at Marisa del Re Gallery.

Sandler, Irving. *The Triumph of American Painting.* New York: Praeger, 1970.

———. The New York School: The Painters and Sculptors of the Fifties. New York: Harper and Row, 1978.

Sawin, Martica. "An American Artist in Japan." *Arts Digest* 29 (August 1, 1955): 12–13.

Schimmel, Paul, et al. *Action/Precision: The New Direction in New York, 1955–60*, exhibition catalog. Newport: Newport Harbor Art Museum, 1984.

Schuyler, James. "As American as Franz Kline." *Artnews* 67 (October 1968): 30–33, 58–59.

Seitz, William C. *Abstract Expressionist Painting in America.* Cambridge and London: Harvard and the National Gallery of Art, Washington, D. C., 1983.

Sieberling, Dorothy, and Stern, Bert. "The Varied Art of Four Pioneers," part 2. *Life*, November 16, 1959.

Steinberg, Leo. "Month in Review." *Arts Magazine* 30 (April 1956): 42–44. Review of exhibition at Janis Gallery.

Tannous, David. "Report from Washington." *Art in America* 67 (July 1979): 24–25. Review of exhibition at the Phillips Collection.

Wright, Martha McWilliams. "Washington Letter." *Art International* 23 (September 1979): 81. Review of exhibition at the Phillips Collection.

Film

Franz Kline Remembered. Produced by Courtney Sale Ross; directed by Carl Colby. Cort Production financed by the Masco Corp. and Atlantic Richfield Co., New York, 1982. 30 minutes, color, 16mm.

169. Franz Kline and two friends in his studio at 52 East Ninth Street, c. 1947

PUBLIC COLLECTIONS

Albany, New York, Empire State Art Collection

Austin, Texas, Archer M. Huntington Art Gallery, University of Texas

Baltimore, Maryland, Baltimore Museum of Art

Basel, Switzerland, Kunstmuseum Basel

Boston, Massachusetts, Museum of Fine Arts

Buffalo, New York, Albright-Knox Art Gallery

Cambridge, Massachusetts, Fogg Art Museum, Harvard University

Chicago, Illinois, Art Institute of Chicago

Cincinnati, Ohio, Cincinnati Art Museum

Cleveland, Ohio, Cleveland Museum of Art

Cologne, West Germany, Museum Ludwig

Dallas, Texas, Dallas Museum of Art

Detroit, Michigan, Detroit Institute of Arts

Düsseldorf, West Germany, Kunstsammlung Nordrhein-Westfalen

Hartford, Connecticut, Wadsworth Atheneum

Helena, Montana, Montana Historical Society

Houston, Texas, Museum of Fine Arts

Kalamazoo, Michigan, Kalamazoo Institute of Arts

Kansas City, Missouri, Nelson-Atkins Museum of Art

Lincoln, Massachusetts, DeCordova Museum

Lincoln, Nebraska, Sheldon Memorial Art Gallery, University of Nebraska

London, England, Tate Gallery

Los Angeles, California, Los Angeles County Museum of Art

Los Angeles, California, Museum of Contemporary Art

Munich, West Germany, Bayerische Staatsgemäldesammlungen

New Haven, Connecticut, Yale University Art Gallery

New York, New York, Metropolitan Museum of Art

New York, New York, Museum of Modern Art

New York, New York, Solomon R. Guggenheim Museum

New York, New York, Whitney Museum of American Art

Norfolk, Virginia, Chrysler Museum

Northampton, Massachusetts, Smith College Museum of Art

Philadelphia, Pennsylvania, Philadelphia Museum of Art

Pittsburgh, Pennsylvania, Museum of Art, Carnegie Institute

Princeton, New Jersey, Art Museum, Princeton University

Raleigh, North Carolina, North Carolina Museum of Art

Richmond, Virginia, Virginia Museum of Fine Arts

Saint Louis, Missouri, Washington University Art Gallery

San Francisco, California, Museum of Modern Art

Toronto, Canada, Art Gallery of Ontario

Tucson, Arizona, Museum of Art, University of Arizona

Utica, New York, Munson-Williams-Proctor Institute

Washington, D.C., Hirshhorn Museum and Sculpture Garden, Smithsonian Institution

Washington, D.C., National Gallery of Art

Washington, D.C., National Museum of American Art, Smithsonian Institution

Washington, D.C., The Phillips Collection

Worcester, Massachusetts, Worcester Art Museum

ACKNOWLEDGMENTS

The roots of this study reach back to 1965 and graduate work at Indiana University with Professor Albert Elsen. He and Professor Creighton Gilbert who, years before, introduced me to art history, have offered models of inspired scholarship. For insights into Kline as man and artist, my deep appreciation goes to: Dr. Theodore J. Edlich, Jr.; Mrs. Louise K. Kelly; David, Miriam, and Sue Orr; and to Mrs. Elisabeth Ross Zogbaum, executrix of the Kline estate. Special thanks for crucial help go to: Dana Cranmer and Bonnie Clearwater, Mark Rothko Foundation, New York; Willem de Looper, The Phillips Collection, Washington, D.C.; David and Renee McKee, David McKee Gallery, New York; Cora Rosevear, Department of Painting and Sculpture, the Museum of Modern Art, New York; and to Brice Marden for his enthusiastic devotion to Kline's art. I am also grateful to Rudolph Burckhardt and Eric Pollitzer for their interest in Kline, as well as for their considerable help in photographing his work.

I am profoundly indebted to these individuals, who knew Kline and were willing to share their memories: Dore Ashton, Martha Kinney Baker, James Brooks, Peter Busa, Elaine and Willem de Kooning, Richard Diebenkorn, Lee V. Eastman, Charles Egan, Daniel I. Ferren, Clement Greenberg, Frank Hahn, Grace Hartigan, Ben Heller, Henry Hensche, Sam Hunter, Sidney Janis, Josephine Little, Nicholas and Merle Marsicano, Mercedes Matter, George McNeil, Dorothy C. Miller, Emmanuel A. Navaretta, Dr. and Mrs. Israel Rosen, Beatrice Ryan, Aaron Siskind, Norman Solomon, and Leo Steinberg.

These persons have helped in more ways than they realize: Henry Adams and Vicky Clark, Museum of Art, Carnegie Institute, Pittsburgh; Martha Baer, Christie's, New York; Joan Banach, curator for Robert Motherwell; Vivian Barnett, Solomon R. Guggenheim Museum, New York; Donald M. Blinken, New York; Laura Catalano, Albright-Knox Art Gallery, Buffalo; Eileen W. Coffman, Dallas Museum of Art; Donald B. Doe, Sheldon Memorial Art Gallery, University of Nebraska, Lincoln; Fred DuBose, Alexander Gallery, Atlanta; Geraldine Duffy, Lehighton Memorial Library; Paul Faberson, International Minerals & Chemical Corporation; Herbert Ferber, New York; Jay Fisher, Baltimore Museum of Art; Xavier Fourcade, New York; Steve Germann and Patty Dean, Montana Historical Society, Helena; Robert H. Halff, Beverly Hills; Frank O. Hamilton, San Francisco; Patricia Hendricks, Huntington Art Gallery, University of Texas, Austin; B.C. Holland, Chicago; Michael Komanecky, Yale University Art Gallery, New Haven; Pierre Levai, Marlborough Gallery, New York; Claude Logan and Glenn McMillan, Marisa del Re Gallery, New York; Janice Lyle, Palm Springs Desert Museum; Duncan MacGuigan, Acquavella Galleries, New York; Terrence Mahon and Richard Tooke, Museum of Modern Art, New York; James W. Mahoney, formerly Hirshhorn Museum and Sculpture Garden, Smithsonian Institution, Washington, D.C.; James Mayor, London; Peter Morrin, High Museum of Art, Atlanta; Lelde Muehlenbachs, Edmonton, Alberta; Judith McCandless, formerly Museum of Fine Arts, Houston; Donald McKinney, Hirschl & Adler Modern, New York; Dr. Roald Nasgaard, Art Gallery of Ontario, Toronto; Mr. and Mrs. Stephen D. Paine, Boston; Stella Paul, formerly Los Angeles County Museum of Art;

170. Franz Kline, late 1950s

Christina F. Petra, Graham Gund Collection; Mr. and Mrs. Gifford Phillips, New York; Leslie Prouty, Sotheby Parke Bernet, New York; Hannah Robson, The Williams Companies, Tulsa; Richard S. Rosenzweig, Playboy Enterprises, Los Angeles; Elizabeth A. T. Smith, Museum of Contemporary Art, Los Angeles; Katheryn Votaw and Nina Pruitt, Weiner Oil Properties Trust, Fort Worth; Veronica Whittaker, Seattle; Karen Wilkin, Toronto; Dr. Barbara A. Wolanin, James Madison University, Harrisonburg, Virginia; Joan Wolff, Allan Stone Gallery, New York; Francie Woltz, Hirshhorn Museum and Sculpture Garden, Smithsonian Institution, Washington, D.C.; and Virginia Wright, Seattle.

Kline research at a preliminary stage was funded by the Samuel H. Kress Foundation and the Noble Foundation. During 1984 my activities as curator of the exhibition and author of the book were supported by generous grants from Skidmore College and the Ludwig Vogelstein Foundation. These made it possible for me to devote full time to the project.

Ultimately, I am most grateful to Mrs. Denny T. Young, curator of painting at the Cincinnati Art Museum, who gave me the chance to organize this exhibition and who has worked on it with care, resolve, and dedication to excellence. Nancy Grubb, my editor at Abbeville Press, deserves special thanks too. Her clarity of vision and expression is demanding *and* humane.

Of course, no retrospective could take place unless private collectors and public institutions were willing to share their Kline paintings and drawings. To all who have contributed works to this exhibition, my deepest appreciation.

H. F. G.

LENDERS TO
THE EXHIBITION

Donald C. Aberfeld
Albright-Knox Art Gallery, Buffalo
Mr. and Mrs. Harry W. Anderson Collection
Genevieve Arnold
Art Gallery of Ontario, Toronto
The Baltimore Museum of Art
Michael and Dorothy Blankfort Collection
The Chrysler Museum, Norfolk, Virginia
Cincinnati Art Museum
The Cleveland Museum of Art
Dallas Museum of Art
DeCordova Museum, Lincoln, Massachusetts
Collection of Mr. and Mrs. Lee V. Eastman
Dr. Theodore J. Edlich, Jr.
Mr. Robert Gersh
Solomon R. Guggenheim Museum, New York
Collection of Mr. and Mrs. Graham Gund
Hirshhorn Museum and Sculpture Garden,
 Smithsonian Institution, Washington, D.C.
Archer M. Huntington Art Gallery, University
 of Texas at Austin
International Minerals & Chemical Corporation
Dr. and Mrs. Donald L. Jacobs
Sidney Janis Gallery, New York
Norman P. Joondeph
Kalamazoo Institute of Arts, Kalamazoo,
 Michigan
Mr. and Mrs. Robert Kardon
A. M. Kinney, Inc.
Mr. and Mrs. Gilbert H. Kinney
Richard E. and Jane M. Lang Collection
Brice Marden

The Donald B. Marron Collection
Dr. and Mrs. Edward Massie
The Metropolitan Museum of Art, New York
Montana Historical Society, Helena
Museum of Art, Carnegie Institute, Pittsburgh
The Museum of Fine Arts, Houston
The Museum of Modern Art, New York
National Gallery of Art, Washington, D.C.
National Museum of American Art, Smithsonian
 Institution, Washington, D.C.
The Nelson-Atkins Museum of Art, Kansas City,
 Missouri
Collection of Mr. and Mrs. I. David Orr
Mr. and Mrs. David Pincus
John H. Pinto
M. and Mme. Guy de Repentigny
San Francisco Museum of Modern Art
Collection of Harold Shapinsky
Betty and Stanley K. Sheinbaum
Sheldon Memorial Art Gallery, University of
 Nebraska, Lincoln
Allan Stone Gallery, New York
The Tate Gallery, London
Suzanne Vanderwoude
Wadsworth Atheneum, Hartford, Connecticut
Frederick Weisman Company
Marcia S. Weisman/Weisman Family Collection
Whitney Museum of American Art, New York
Yale University Art Gallery, New Haven,
 Connecticut
Anonymous lenders

INDEX

PHOTOGRAPHY CREDITS